STRUCTURAL PACKAG

VERPACKUNGSFORMGEBUNG

DESENHOS DE ESTRUTURAS PARA EMBALAGENS

DISEÑOS DE ESTRUCTURAS PARA EMBALAJES

DESIGN STRUTTURALE DELLA CONFEZIONE

MODÈLES STRUCTURAUX DE CONDITIONNEMENT

構造パッケージデザイン

結構包裝設計

THE PEPIN PRESS / AGILE RABBIT EDITIONS

AMSTERDAM • SINGAPORE

The Pepin Press/Agile Rabbit Editions
P.O. Box 10349
1001 EH Amsterdam, The Netherlands

Tel +31 20 4202021
Fax +31 20 4201152
mail@pepinpress.com
www.pepinpress.com

Concept, design and texts by Pepin van Roojen

ISBN 978 90 5768 044 1

10 9 8
2010 09 08 07

Manufactured in Singapore

Contents

Free CD-Rom in the inside back cover

Introduction in English

Cutting, scoring and perforation die-mould for the package on page 299

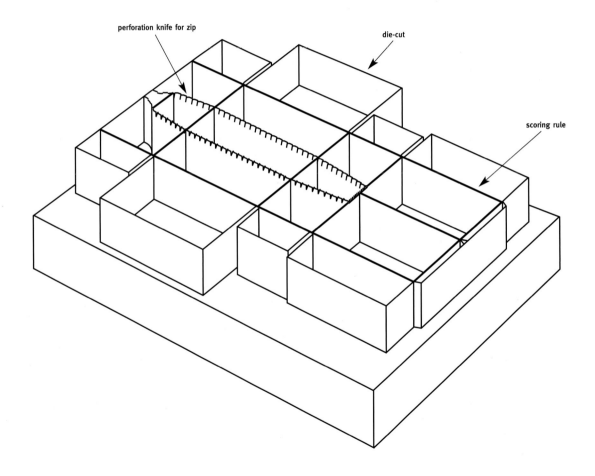

perforation knife for zip

die-cut

scoring rule

Introduction in English

Structural Package Design

Packaging is a key factor in practically all forms of trade: it is crucial to protect, store and ship goods, and, in many cases, the design of a package is the first a customer sees when confronted with any type of product. Consumers react immediately to package shapes, and are influenced by them when making buying decisions. Different product categories are often easy to recognize by their characteristic form, for example chocolate boxes or milk cartons. On the other hand, a manufacturer of an exclusive product, such as jewellery or perfume, may deliberately choose an unusual, eye-catching form.

At the same time, packages serve to protect, store and transport goods, and so must be both strong enough to hold their contents and yet efficient in size and shape.

Good packaging, therefore, is crucial, both from a logistical and a marketing point of view. This book serves as a reference for structural design. All designs have been selected because of their functional relevance and acceptability, and can be easily modified to suit specific requirements. Each design idea is presented in an easily understandable way: on the left-hand page is the flat pattern, all in die-cut outline, and on each right hand page is the finished product. Folding lines are indicated with long dots, perforation lines with small dots, and die-cuts within the model with thin, straight lines.

For technical information such as basic structures, locking methods, and terminology, diagrams are given on pages 54–71.

The CD-ROM

The die-cut form of each design is stored on the accompanying CD-ROM in eps vector format, both for Mac and Windows. Software programs in which images can be imported, will allow you to access, scale and print the designs from the CD-ROM.

However, the greatest flexibility for working with the designs digitally is offered by illustration programs such as Adobe Illustrator, Freehand and others, as these allow you to adapt the dimensions of the digital files completely to your own specific requirements.

Although the designs in this book and on the CD can be used freely to develop new packaging solutions, the images themselves cannot be used for any type of commercial application – including all types of printed or digital publications – without prior permission from The Pepin Press/Agile Rabbit Editions (see address on page 2 and the CD label).

The CD-ROM comes free with this book, but is not for sale separately. The publishers do not accept any responsibility should the CD not be compatible with your system.

Types of Corrugated Cardboard (Fibreboard)

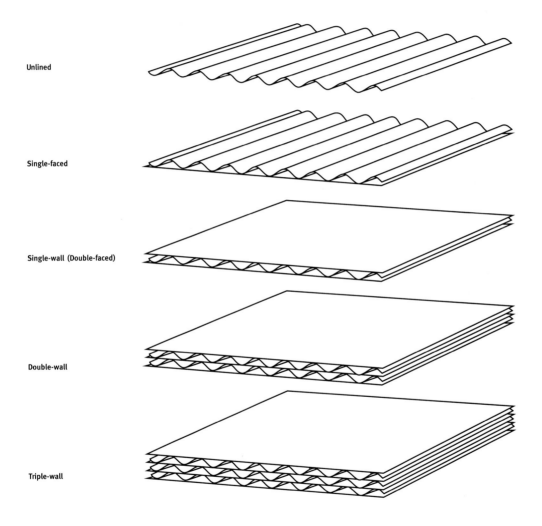

Unlined

Single-faced

Single-wall (Double-faced)

Double-wall

Triple-wall

Packaging material

Papers and boards are available in many variations. For use in a retail environment, coated (one side or double-sided) paperboard or card is the material of choice. The grammage or thickness of the material depends, naturally, on the size of the package and the weight of the contents. However, grammages between 230 and 410 gsm (grammes per square metre) are common.

For wholesale packaging and shipping, a stronger material must be used. The most common material for this purpose is corrugated fibreboard. Although there are many variations available, the most common types are: single-faced corrugated board, which is flexible and can be wrapped around a product, and in ascending order of strength and rigidity single-, double-, and triple-wall corrugated board. The walls (or liners) can be made of simple recycled brownish pulp, or more expensive material, such as calendered or coated paper, kraft, or foil.

Also frequently used for packaging is chipboard, which is made from waste paper and mostly grey in colour. The flexibility of the chipboard depends on its thickness, but generally this material is more likely to crack when folded than corrugated fibreboard of comparable thickness. Because of its colour and rough, absorbent surface, it is not very suitable for printing.

Printing

Coated paperboard up to 410 gsm can be printed easily on most modern offset machines in the same way normal paper is printed. And this material can be further protected and embellished by varnishing or lamination.

Corrugated board and chipboard cannot be printed as easily, but as a rule, the requirements are also much more modest. Usually, for wholesale packaging, simple information such as product codes and quantities, preferably in large type, are sufficient. This can be printed by letterpress or flexography. These techniques suffice, as well, for simple, bold symbols ('this side up', 'fragile', 'heavy', etc.). It is, however, possible to have more complex printing on a corrugated carton by printing the outer wall before the corrugated sheet is glued together. This method is often used for heavy or fragile goods that are delivered to the customer in their shipping carton, such as computers and kitchen appliances.

Die-cutting and scoring (creasing)

Naturally, the outline of a package design needs to be

Cutting, scoring and perforation knives

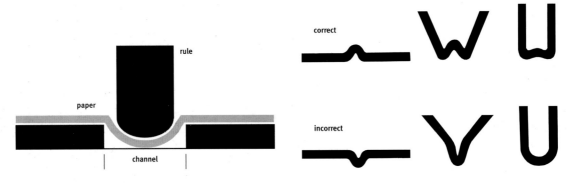

The principle of scoring

Correct and incorrect folding after scoring

die-cut. However, often a design needs further cutting or perforating inside the outline.

Furthermore, to reduce the stress that folding puts on paperboard, it must be scored (or creased) before being folded. Scoring also helps to reduce the risk of cracking, and for some types of board scoring is necessary to create a clean, well-defined fold.

There are some variations to full cuts and scores: the partial cut which does not penetrate completely through the board; the skip score, which involves cutting completely through the board, but not continuously; and the cut-crease, in which cutting and creasing are alternated.

For the die-cutting and scoring of paperboard, a die must be made, consisting of cutting knives and scoring rules.

Basic structures

For decades, standard styles have been used in the packaging industry for specific packaging forms. Some of these are illustrated on pages 62–67. In recent times,

packaging design has become more and more customised to specific needs, and these standard styles by no means cover the whole range of possibilities.

Nevertheless, basic structures as illustrated on pages 56–61 are the point of departure for most structural design. The same applies to the locking methods shown on pages 68–71.

Production

When in the process of designing a package, it is essential that you consult with your printer, bindery, and possibly material suppliers, regarding the technical aspects of producing your design. Apart from cutting, scoring and folding, pay attention to printing bleed requirements (see page 54), and to glueing. Before production, it is strongly recommended that you have a mock-up made, using the final material, with the exact measurements of the final work.

Einführung auf deutsch

Modell für Schneiden, Ritzen und Perforation der Verpackung auf Seite 299

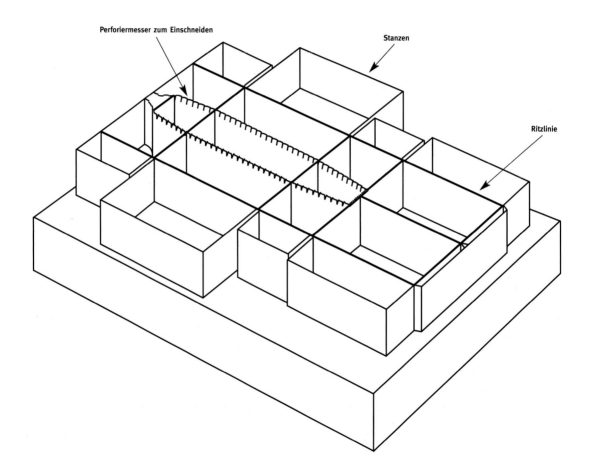

Perforiermesser zum Einschneiden

Stanzen

Ritzlinie

Verpackungsformgebung

Die Verpackung ist ein Schlüsselfaktor für nahezu alle Arten des Handels: Sie ist von entscheidender Bedeutung für den Schutz, die Lagerung und den Versand von Waren. Darüber hinaus ist das Verpackungdesign für den Kunden das erste augenfällige Merkmal, wenn er einem beliebigen Produkt gegenübersteht. Der Verbraucher reagiert unmittelbar auf die Gestaltung einer Verpackung und wird von dieser bei seiner Kaufentscheidungen beeinflusst. Unterschiedliche Produktklassen können häufig leicht an ihrer charakteristischen Form erkannt werden. Andererseits kann der Herstellers eines exklusiven Produkts wie Schmuck oder Parfüm ganz gezielt eine Verpackungsform wählen, die dadurch zum Blickfang wird. Gleichzeitig dienen Verpackungen zum Schutz, zur Lagerung und zum Transport von Waren und müssen daher außreichend stabil sein, um den Inhalt zu schützen, sowie Effizienzkriterien hinsichtlich Größe und Form erfüllen.

Eine gute Verpackung ist somit von grundlegender Bedeutung sowohl aus logistischer Sicht als auch im Hinblick auf das Marketing. Dieses Buch ist ein Referenzwerk für die Formgebung. Alle aufgeführten Designs wurden aufgrund ihrer funktionellen Bedeutung und Akzeptanz ausgewählt und können spezifischen Anforderungen angepasst werden. Jedes Formenkonzept ist auf leicht verständliche Weise dargestellt: Auf der linken Seite finden sich die Schablonen, jeweils als gestanzte Umrisse, und auf der rechten Seite ist das fertige Produkt abgebildet. Falzlinien sind strichliert angezeigt, Perforierlinien

mit kleinen Punkten und Stanzlinien innerhalb des Modells mit dünnen, geraden Linien.

Zu technischen Informationen wie Grundformen, Verschlusstechniken und Terminologie wurden Übersichten auf den S. 54–71 zusammengestellt.

Die CD-ROM

Die Stanzform eines jeden Designs ist auf der zugehörigen CD-ROM im EPS-Vektorformat – für Mac und für Windows – gespeichert. Software-Programme, in die die Abbildungen importiert werden können, erlauben Ihnen den Zugriff, das maßstabsgerechte Übertragen und das Ausdrucken der Formen von der CD. Die größte Flexibilität jedoch zur digitalen Bearbeitung der Designs bieten Grafikprogramme wie Adobe Illustrator, Freehand u.a., da diese es gestatten, die Dimensionen der digitalen Dateien an Ihre spezifischen Anforderungen anzupassen.

Wenngleich die Designs in diesem Buch und auf der CD frei zur Entwicklung neuer Verpackungslösungen genutzt werden können, dürfen die Abbildungen selbst ohne vorherige Genehmigung durch The Pepin Press/Agile Rabbit Editions (siehe Adresse auf S. 2 und Aufkleber auf der CD) in keiner Weise – einschließlich aller Arte gedruckter oder digitaler Veröffentlichungen – kommerziell verwendet werden.

Die CD-ROM wird kostenlos zu dem Buch mitgeliefert, ist allerdings nicht separat zu erwerben. Die Herausgeber

Wellpappenarten

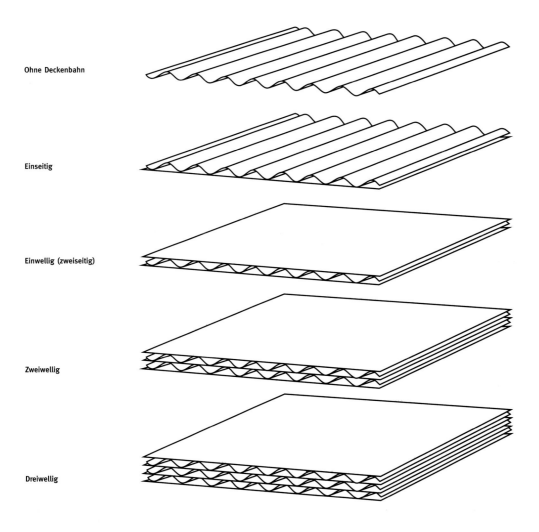

Ohne Deckenbahn

Einseitig

Einwellig (zweiseitig)

Zweiwellig

Dreiwellig

übernehmen keinerlei Haftung, falls die CD mit Ihrem System nicht kompatibel sein sollte.

Verpackungsmaterial

Papier und Pappe stehen in zahlreichen Varianten zur Verfügung. Im Einzelhandel wird beschichtete (ein- oder zweiseitige) Pappe oder Karton als Material bevorzugt. Das notwendige Flächengewicht bzw. die Stärke des Materials hängen selbstverständlich von der Verpackungsgröße und dem Gewicht ihres Inhalts ab. Üblich sind dabei Flächengewichte von 230 bis 410 g/m².
Für Verpackungen und Versand im Großhandel muss ein stärkeres Material gewählt werden. Für diesen Zweck ist die Verwendung von Wellpappe am geläufigsten. Die am häufigsten eingesetzten Typen sind: einseitige Wellpappe, die flexibel ist und um ein Produkt herumgewickelt werden kann, und in aufsteigender Reihenfolge nach Stärke und Festigkeit ein-, zwei- und dreiwellige Wellpappe. Die Deckenbahnen können aus einfachem recyceltem bräunlichem Rohpapier oder teureren Materialien wie satiniertem oder gestrichenem Papier, Kraftliner oder Folie bestehen. Ebenfalls häufig für Verpackungen benutzt wird Graukarton, der aus Altpapier hergestellt wird und meist grau ist. Seine Flexibilität hängt von seiner Stärke ab. Im Allgemeinen ist jedoch die Wahrscheinlichkeit, dass dieses Material beim Falten bricht, größer als bei Wellpappe von vergleichbarer Stärke. Aufgrund seiner Farbe und seiner rauhen, saugenden Oberfläche eignet er sich nicht sonderlich gut für den Druck.

Druck

Beschichtete Pappe bis zu 410 g/m2 kann auf den meisten modernen Offset-Maschinen problemlos bedruckt werden. Das Material kann im Weiteren durch Lackierung oder Beschichtung geschützt oder verschönert werden.

Das Bedrucken von Wellpappe und Graukarton ist nicht ganz so simpel; im Allgemeinen sind hier jedoch die Anforderungen auch wesentlich bescheidener. Bei Großhandelsverpackungen sind normalerweise einfache Informationen wie Produktcodes und Mengenangaben ausreichend. Der Druck kann hier durch Hoch- oder Flexodruck erfolgen. Diese Verfahren sind auch für einfache, fett gedruckte Symbole („Oben", „Zerbrechlich", „Schwer" etc.) geeignet. Es ist jedoch auch möglich, komplexere Drucke auf Wellpappe vorzunehmen, indem die äußere Deckenbahn bedruckt wird, bevor das Verkleben mit der gewellten Papierbahn erfolgt. Diese Methode findet häufig bei schweren oder zerbrechlichen Waren ihre Anwendung, die beim Endverbraucher in ihrem Versandkarton ausgeliefert werden, so z. B. Computer oder Küchengeräte.

Schneide-, Ritz- und Perforiermesser

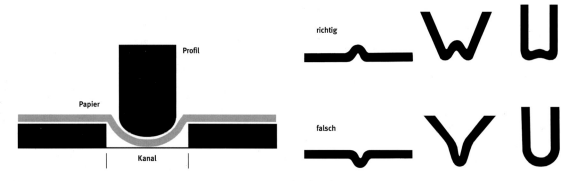

Das Prinzip des Ritzens	Richtiges und falsches Falten nach dem Ritzen

Stanzen und Ritzen (Rillen)

Selbstverständlich muss der äußere Umriss einer Verpackungsform gestanzt werden. Allerdings ist eine Form innerhalb des Umrisses oftmals weiter zu beschneiden oder zu perforieren. Außerdem muss, um die durch das Falten auf die Pappe wirkende Spannung zu reduzieren, die Pappe vor dem Falten geritzt (oder gerillt) werden. Es gibt einige Abweichungen gegenüber durchgehenden Schnitten und Ritzen: den Teilschnitt, der nicht vollkommen durch die Pappe geht; das versetzte Ritzen, bei dem der Schnitt die Pappe völlig durchtrennt, jedoch nicht ununterbrochen verläuft; und Schneiden/ Rillen, bei dem Schneiden und Rillen einander abwechseln.
Für das Stanzen und Ritzen von Pappe benötigt man einen Schneidetisch mit Schneidemessern und Ritzlinien.

Grundformen

Jahrzehntelang wurden in der Verpackungsindustrie Standardmodelle für spezifische Verpackungsformen verwendet. Einige davon sind auf den S. 62–67 dargestellt.

In jüngster Zeit wird das Verpackungsdesign zunehmend auf die besonderen Anforderungen des Kunden zugeschnitten, und die genannten Standardmodelle decken bei weitem nicht die große Vielfalt der Möglichkeiten ab. Trotzdem sind die auf den S. 56–61 abgebildeten Grundformen Ausgangspunkt für die meisten Formgebungsprozesse. Dasselbe gilt für die auf den S. 68–71 zusammengestellten Verschlusstechniken.

Produktion

Während der Entwurfsphase für eine Verpackung ist es von grundlegender Bedeutung, dass Sie sich mit Ihrer Druckerei, Buchbinderei und mit Ihren Materiallieferanten hinsichtlich der technischen Aspekte der Umsetzung Ihres Entwurfs beraten. Neben dem Schneiden, Ritzen und Falten sind auch die Anforderungen hinsichtlich des Durchschlagens beim Druck (siehe S. 54) und in Bezug auf das Verkleben zu beachten. Vor der Produktionsaufnahme wird daher dringend empfohlen, einen Prototypen aus dem definitiven Material und mit den genauen Abmessungen der endgültigen Verpackung herzustellen.

Introduction en français

17

Matrice de découpage, de rainage et de perforation pour le conditionnement présenté p. 299

lame de perforation pour dispositif de fermeture

outil de découpage à l'importe-pièce

outil de rainage

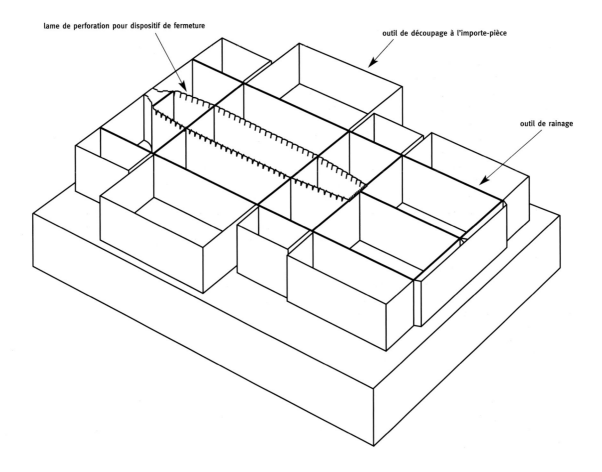

Modèles structuraux de conditionnement

Le conditionnement est un élément clé dans la majorité des formes d'activités commerciales : son rôle dans le domaine de la protection, de la conservation et de l'expédition n'est plus à démontrer. Quel que soit le type de marchandise qu'il abrite, c'est souvent son aspect lui qui interpelle en premier lieu le consommateur. La réaction immédiate qu'il suscite participe à influencer l'acte d'achat lui-même. D'une part, différentes catégories de marchandises sont facilement identifiables par la forme caractéristique de leur conditionnement, telles que les tablettes de chocolat ou les briques de lait par exemple. Par ailleurs, le fabricant d'un produit de luxe, bijoutier ou parfumeur, choisira délibérément un emballage original, inédit. Parallèlement, la protection, la conservation et l'expédition des marchandises soumettent l'emballage à une double contrainte : celle de la résistance et de l'ergonomie. Le conditionnement se doit de répondre à ces impératifs sur un plan aussi bien logistique que marketing. Ce livret propose un échantillonnage de structures de conditionnements, sélectionnées pour leur pertinence en matière de fonctionnalité, d'acceptabilité et d'adaptabilité. Chaque modèle fait l'objet d'une présentation claire et détaillée. Sur la page de gauche, le gabarit à plat, marqué de ses contours de découpe, sur la page de droite le produit fini. Les lignes de pliage sont figurées par de longs tirets, celles de perforation par des pointillés et les découpes intérieures par de fins traits continus. Pour toutes informations techniques sur les structures de base, les méthodes de fermeture et la terminologie, se reporter aux schémas des pages 54 à 71.

Le CD

Le CD d'accompagnement regroupe les gabarits de découpe de chaque modèle sous la forme de fichiers EPS, compatibles Mac et Windows. Les logiciels autorisant l'importation de ces images permettent d'ouvrir, de redimensionner et d'imprimer tous les modèles archivés sur le CD. Pour une plus grande souplesse d'utilisation, on retiendra certains logiciels de création et de retouche d'image comme Adobe Illustrator, Freehand et d'autres encore, plus à même de répondre à des besoins spécifiques en facilitant les modifications d'échelle des gabarits vectorisés. Si les modèles présentés dans le livret et sur le CD sont libres d'exploitation et peuvent servir de base à la conception de nouvelles structures de conditionnement, les images quant à elles ne peuvent être utilisées à des fins commerciales – y compris à des publications sur support papier ou numérique – sans l'autorisation préalable de Pepin Press/Agile Rabbit Editions (voir adresse p. 2 du livret et pochette du CD).

Le CD fourni gratuitement avec ce livret ne peut être vendu séparément. Les éditeurs déclinent toute responsabilité quant aux problèmes d'incompatibilité du CD avec votre système d'exploitation.

Types de carton ondulé

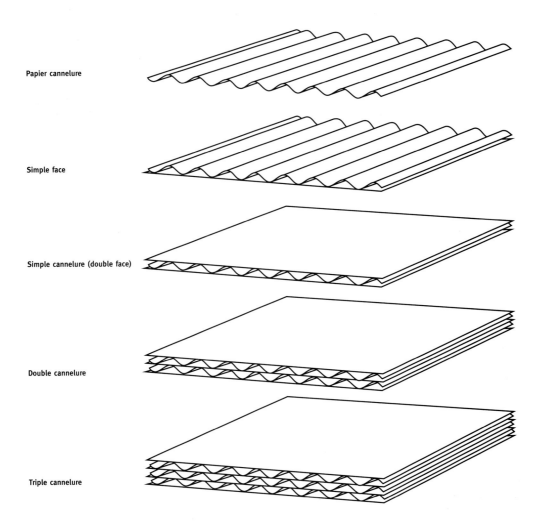

Papier cannelure

Simple face

Simple cannelure (double face)

Double cannelure

Triple cannelure

Introduction en français

Les matériaux de conditionnement

Papiers et cartons se déclinent en une large gamme. Le commerce de détail fait traditionnellement appel au papier-carton ou au carton couché (simple ou double face). Le grammage (masse par unité de surface) ou épaisseur du matériau varie bien entendu en fonction de la taille de l'emballage et du poids du contenu. Les grammages les plus sollicités sont compris entre 230 et 410 g/m².

Le commerce de gros et l'expédition privilégient les matériaux plus résistants, comme le carton ondulé. Le produit présente de nombreuses variantes mais les échantillons les plus représentatifs du genre restent le carton ondulé simple face, flexible et facilement enroulable autour de la marchandise, et, par ordre de force et de rigidité, les cartons ondulés simple, double et triple cannelure. Le papier ondulé ou papier cannelure peut être fabriqué à partir d'une pâte brune de papier recyclé ou à partir de matières premières plus onéreuses comme le papier couché ou papier calandré, le kraft ou encore le papier d'aluminium.

Autre matériau souvent utilisé dans le conditionnement, le carton gris, élaboré à partir de papier de récupération. Sa flexibilité varie selon son épaisseur, mais soumis au pliage, il s'avère généralement plus sensible aux déchirures que le carton ondulé, et ce à grammage égal. Sa couleur et le haut pouvoir absorbant de sa surface rugueuse limitent les possibilités d'impression.

Impression

Le papier carton couché inférieur à 410 g/m² se prête aussi facilement que le papier ordinaire à l'impression offset. Le matériau peut même faire l'objet de traitements de protection et esthétiques plus poussés tels que le vernissage ou le calandrage.

Carton ondulé et carton gris sont plus difficilement imprimables, mais en général les exigences en la matière s'avèrent plus modestes. Dans le domaine du commerce de gros, le conditionnement se satisfait de quelques informations, code du produit et quantité, indiquées de préférence en grands caractères. L'impression par typographie ou flexographie suffisent également pour le marquage de symboles simples tels que « haut », « fragile », « lourd », etc. Il est toutefois possible d'imprimer le carton ondulé de marquages plus élaborés en commençant par imprimer le plat du papier de couverture avant collage de la feuille de cannelure. Méthode généralement utilisée pour les emballages de marchandises lourdes ou fragiles livrés au consommateur dans leur carton d'origine, comme les ordinateurs ou les éléments de cuisine par exemple.

Outils de découpage, de rainage et de perforation

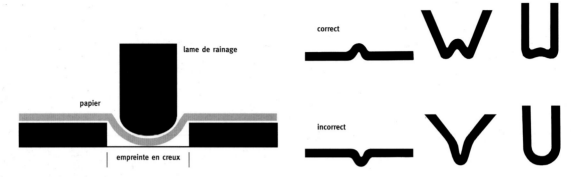

lame de rainage	correct
papier	
empreinte en creux	incorrect
Principe de rainage	**Pliage correct et incorrect après rainage**

Découpage à l'emporte-pièce et rainage

Les contours d'un gabarit sont en principe découpés à l'emporte-pièce. Mais bien souvent, les gabarits exigent des découpes et des perforations supplémentaires.

Afin de réduire les tensions appliquées au papier-carton lors des opérations de pliage, un rainage préalable s'avère nécessaire. Cette opération réduit le risque de déchirure et, pour certains types de carton, reste incontournable pour la réalisation d'un pliage propre et net.

On distingue différentes méthodes de découpage et de rainage : la découpe à mi-chair qui ne traverse pas complètement le carton, la découpe à fond sélective qui traverse le carton, mais de façon discontinue, et enfin la découpe-rainage alternant découpe à fond et rainage. Le découpage à l'importe pièce et le rainage du papier-carton passent par l'élaboration d'une matrice qui consiste de lames de découpe et de règles de rainage.

Structures de base

Durant des décennies, l'industrie du conditionnement s'est attachée à mettre en place des normes relatives aux différents types d'emballage. Quelques-uns d'entre eux sont présentés aux pages 62 à 67. Plus récemment, les concepteurs se sont appliqués à proposer des conditionnements de plus en plus adaptés aux besoins spécifiques et il va sans dire que les classiques du genre sont loin d'épuiser les possibilités.

Néanmoins, les structures de base présentées des pages 56 à 61 constituent le point de départ de la plupart des modèles structuraux, tout comme les dispositifs de fermeture illustrés des pages 68 à 71.

Production

La conception d'un emballage passe par la consultation préalable d'un imprimeur, d'un façonneur et de fournisseurs de matériaux qui prendront en compte les aspects techniques de la réalisation du modèle. Outre le découpage, le rainage et le pliage, il conviendra de prévoir les marges d'impression (voir p. 54) et le collage. Enfin, avant de passer à l'étape de la production, il est fortement conseillé de faire réaliser une maquette à partir du matériau final et ayant les dimensions exactes de l'objet fini.

Introducción en español

**Molde de corte, hendido y perforación para el embalaje
de la página 299**

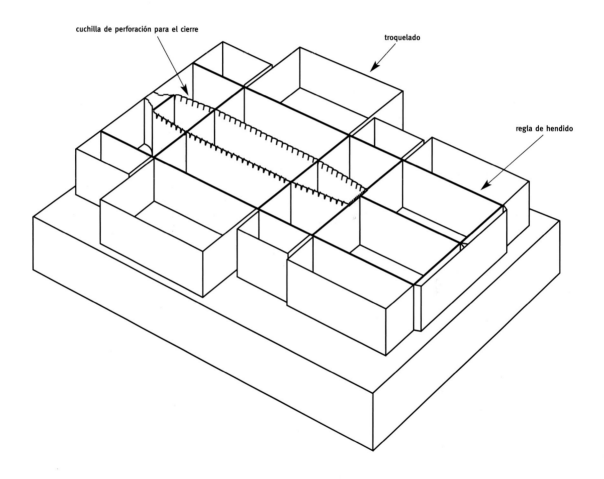

cuchilla de perforación para el cierre

troquelado

regla de hendido

Diseños de estructuras para embalajes

El embalaje es un factor clave en casi todas las formas de comercio, ya que resulta esencial para proteger, almacenar y enviar productos y, en muchos casos, el diseño de un paquete es lo primero en lo que se fija el cliente. Los consumidores reaccionan inmediatamente a las formas de los paquetes, y éstas influyen en sus decisiones de compra. Las distintas categorías de productos suelen reconocerse fácilmente por su forma característica, por ejemplo las tabletas de chocolate o los cartones de leche. Por orto lado, un fabricante de un producto exclusivo, como una joya o un perfume, puede elegir intencionadamente una forma inusual y llamativa.

Al mismo tiempo, los paquetes sirven para proteger, almacenar y transportar productos, y por ello deben ser lo suficientemente fuertes como para soportar el peso del contenido y ser eficientes tanto en cuestión de tamaño como de forma.

El embalaje de artículos es fundamental tanto desde el punto de vista logístico como de *marketing*. Este libro sirve como referencia para el diseño estructural. Todos los diseños se han seleccionado por su relevancia funcional y su aceptabilidad, y pueden modificarse para adaptarse a necesidades concretas. Cada idea de diseño se presenta de forma fácilmente comprensible: en la página de la izquierda está el diseño plano en el que aparecen marcadas las líneas de troquelado, y en la página de la derecha se encuentra el producto terminado. Las líneas de pliegue se indican con rayas; las líneas de perforación, con puntos; y las líneas de troquelado del interior del modelo, con líneas continuas.

Para cuestiones de información técnica, como estructuras básicas, métodos de cierre y terminología, consulte los diagramas de las páginas 54–71.

El CD-ROM

El CD adjunto contiene la forma troquelada de cada diseño en formato de vector EPS y es compatible tanto con Mac como con Windows. Los programas de software de importación de imágenes le permitirán acceder, ampliar, reducir e imprimir los diseños del CD.

Sin embargo, la máxima flexibilidad para trabajar con los diseños digitalmente se consigue con programas de dibujo, como Adobe Illustrator, Freehand y otros, que le permiten modificar las dimensiones de los archivos digitales para adaptarlos a sus necesidades concretas. Aunque los diseños de este libro y del CD pueden utilizarse para crear nuevas soluciones de embalaje, las imágenes no pueden utilizarse para ningún tipo de aplicación comercial (incluido todo tipo de publicación impresa o digital) sin el consentimiento previo de The Pepin Press/Agile Rabbit Editions (*véase* la dirección en la página 2 y en la etiqueta del CD).

El CD se adjunta gratuitamente a este libro y no puede venderse por separado. Los editores declinan toda responsabilidad si el CD no es compatible con su sistema.

Tipos de cartón corrugado (tablero aglomerado)

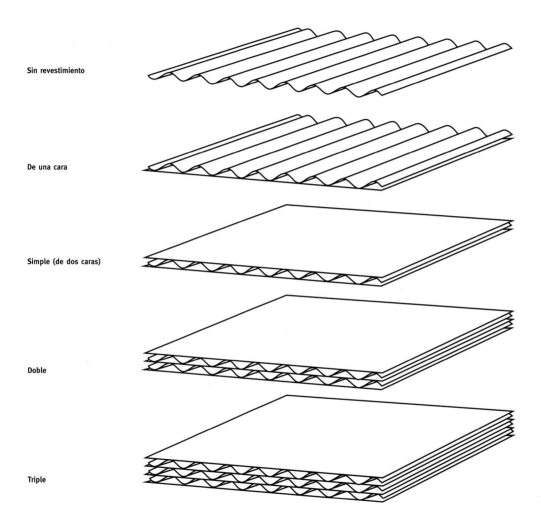

Sin revestimiento

De una cara

Simple (de dos caras)

Doble

Triple

Material de embalaje

Existe una gran variedad de papeles y cartones. En el comercio minorista, el material más utilizado es la cartulina estucada (por una cara o por las dos). El gramaje o el grosor del material depende, naturalmente, del tamaño del paquete y del peso del contenido. Sin embargo, los más habituales son los gramajes de entre 230 y 410 g/m².

Para el embalaje y el envío al por mayor, puede utilizarse un material más resistente. Para tal fin, el material más utilizado es el cartón corrugado. Aunque existen muchas variaciones, los tipos mas comunes son: el cartón corrugado de una cara, que es flexible y puede utilizarse para envolver un producto; y, en orden ascendente de resistencia y rigidez, cartón corrugado simple, doble y triple. Las paredes (elementos planos) pueden ser de pulpa marrón reciclada, o de otro material más caro, como papel satinado o estucado, papel kraft o papel metalizado.

También se usa frecuentemente en el embalaje el cartón ordinario, hecho a partir de papel desechado y que suele ser de color gris. La flexibilidad del cartón ordinario depende de su grosor, pero generalmente este material es más propenso a romperse que el cartón corrugado de grosor similar cuando se dobla. Debido a su color y a su superficie áspera y absorbente, no es muy adecuado para la impresión.

Impresión

El papel estucado de hasta 410 g/m² puede imprimirse fácilmente en la mayoría de los sistemas *offset* modernos de la misma forma que se imprime el papel normal. Dicho material puede, además, protegerse o embellecerse mediante barnizado o laminado.

El cartón corrugado y el cartón ordinario no pueden imprimirse con tanta facilidad pero, por lo general, los requisitos también son mucho más modestos. Normalmente, para el embalaje al por mayor, basta con poca información, como los códigos y las cantidades del producto, impresa preferiblemente en grandes caracteres. Esto puede hacerse mediante impresión tipográfica o flexografía. Estas técnicas también son suficientes para símbolos sencillos y llamativos («arriba», «frágil», «pesado», etc.). Sin embargo, se puede realizar una impresión más compleja sobre cartón corrugado imprimiendo la cara exterior antes de pegar la lámina corrugada. Este método suele utilizarse en el caso de artículos pesados o frágiles que se entregan al cliente en su embalaje, como los ordenadores y los electrodomésticos.

Cuchillas de corte, hendido y perforación

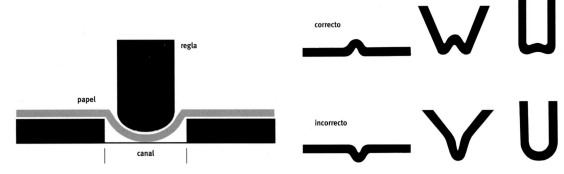

El principio del hendido

Pliegues correctos e incorrectos tras el hendido

Troquelado y hendido (doblado)

Como es lógico, hay que troquelar el contorno del diseño de un paquete. Sin embargo, a veces es preciso realizar cortes o perforaciones en el interior del contorno. Además, para reducir la tensión que los pliegues ejercen en el cartón, éste debe hendirse (o doblarse) antes de plegarse. El hendido también reduce el riesgo de agrietamiento y, en el caso de algunos cartones, el hendido es necesario para crear un pliegue limpio y nítido. Existen distintos tipos de corte y hendido: el corte parcial, que no atraviesa completamente el cartón; el hendido discontinuo, que conlleva el corte completo pero de forma no continua; y el corte-doblado, que consiste en alterrnar ambas técnicas.

Para troquelar y hendir un cartón, debe hacerse una hendidura, utilizando cuchillas y reglas de hendido.

Estructuras básicas

Durante décadas, se han utilizado estilos estándar en la industria del embalaje para formas concretas de paquetes. Algunos de esos estilos aparecen en las páginas 62–67. Últimamente, el diseño de paquetes se ha ido personalizando para adaptarlo a necesidades concretas y los estilos estándar ya no cubren todas las posibilidades.

En cualquier caso, las estructuras básicas de las páginas 56–61 constituyen el punto de partida de la mayoría de diseños estructurales. Lo mismo sucede con los métodos de cierre de las páginas 68–71.

Producción

Durante el proceso de diseño de un paquete, es esencial consultar con el impresor, el encuadernador y, posiblemente, con los proveedores de material, los aspectos técnicos del diseño. Además del corte, el troquelado y el plegado, tenga en cuenta los requisitos de sangrado de la impresión (*véase* la página 54) y el pegado. Antes de realizar la producción, se recomienda elaborar una maqueta utilizando el material final y que tenga las medidas exactas del trabajo definitivo.

Introduzione in italiano

**Forma per fustellatura, cordonatura e perforatura
della confezione di pagina 299**

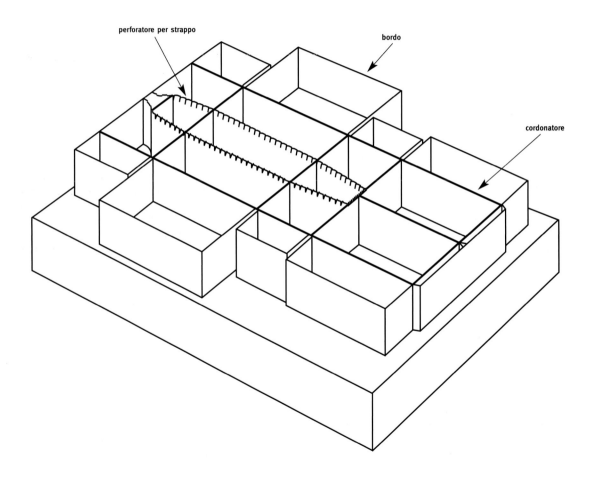

perforatore per strappo

bordo

cordonatore

Design strutturale della confezione

L'imballaggio è un processo fondamentale praticamente per tutti i settori del commercio: è imprescindibile per proteggere, immagazzinare e spedire le merci e, in molti casi, il design di un astuccio stabilisce il primo approccio che il cliente ha con qualsiasi tipo di prodotto. I consumatori vengono condizionati immediatamente dalla forma dell'imballo e ne sono influenzati al momento dell'acquisto. Spesso alcune categorie di prodotti sono facilmente riconoscibili per la loro forma caratteristica, come nel caso delle scatole di cioccolatini o dei contenitori per il latte. D'altra parte, il fabbricante di un prodotto esclusivo, come gioielli o profumi, può optare deliberatamente per una forma insolita e vistosa.

L'imballaggio deve proteggere la merce in magazzino e allo stesso tempo durante il trasporto e pertanto deve avere una resistenza sufficiente per contenere il prodotto ed avere anche una forma e delle dimensioni efficienti.

Un buon imballaggio è quindi importantissimo sia da un punto di vista logistico che di marketing. Il presente libro vuole essere un punto di riferimento per la realizzazione della forma strutturale. Tutti i modelli sono stati scelti in base alle loro caratteristiche di funzionalità ed accettabilità e possono essere modificati per rispondere ad esigenze specifiche. Ogni profilo viene presentato in un modo facilmente comprensibile: sulla pagina di sinistra è raffigurato il disegno del modello con le tracce dei bordi mentre sulla pagina destra c'è il prodotto finito. Le linee di cordonatura sono indicate da trattini lunghi, quelle di perforatura da trattini brevi mentre i tagli all'interno del profilo vengono rappresentati da linee continue e sottili. Le informazioni tecniche, come ad esempio le strutture di base, i metodi di chiusura e la terminologia, sono riportate nei diagrammi di pagina 54–71.

Il CD-ROM

Il CD-ROM che accompagna il libro contiene le immagini della struttura di ogni modello in formato EPS per Macintosh e Windows. Con un qualsiasi software per l'edizione di immagini si potrà accedere ai modelli del CD per ingrandirli e stamparli. Ad ogni modo, programmi come Adobe Illustrator, Freehand ed altri, offrono una maggiore flessibilità per l'edizione digitale dei modelli, giacché permettono di adattare le dimensioni contenute nei file ad ogni esigenza specifica.

Le proposte presentate nel libro e sul CD possono essere utilizzate liberamente per sviluppare nuove soluzioni di imballaggio. Tuttavia le immagini non possono essere utilizzate a scopo commerciale, includendo qualsiasi tipo di pubblicazione stampata o digitale, senza previa autorizzazione della The Pepin Press/Agile Rabbit Editions (vedi indirizzo a pagina 2 e sull'etichetta del CD).

Il CD-ROM è gratuito e indivisibile dal libro e non può essere venduto separatamente. Il produttore si esime da ogni responsabilità qualora il CD non sia compatibile con il sistema informatico del cliente.

Tipi di cartone ondulato

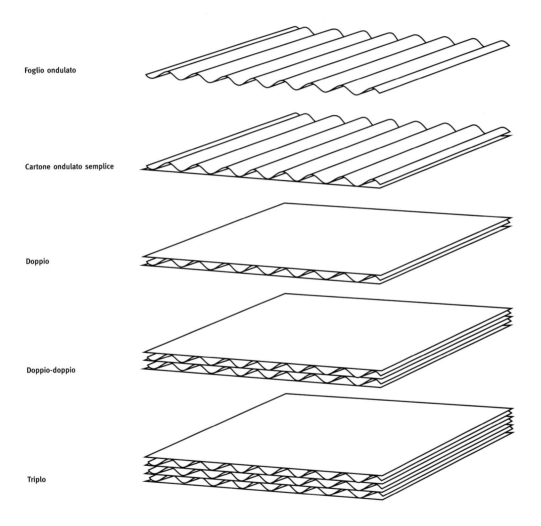

Foglio ondulato

Cartone ondulato semplice

Doppio

Doppio-doppio

Triplo

Materiali per l'imballaggio

La carta ed il cartone sono disponibili sotto diverse forme. Nel campo della vendita al minuto i materiali più utilizzati sono la carta rivestita (da un lato o da entrambi) ed il cartoncino. La grammatura e lo spessore dei materiali dipende, naturalmente dalle dimensioni della confezione e dal peso del contenuto. Ad ogni modo la grammatura più comune è compresa tra i 230 ed i 410 g/mq (grammi per metro quadrato).

Nel campo della vendita all'ingrosso e per il trasporto si dovranno adoperare dei materiali più resistenti. Il materiale più comunemente utilizzato a questo scopo è il cartone ondulato. Sebbene ne esistano diversi tipi, quelli più usati sono: il cartone ondulato semplice, che è flessibile e può essere avvolto attorno al prodotto, ed in ordine ascendente di resistenza e rigidità, il cartone ondulato doppio, doppio-doppio e triplo. I fogli ondulati possono essere composti da semplice pasta bruna riciclata o da materiali più cari come la carta calandrata o rivestita, la kraft, o l'alluminio.

Anche il cartone riciclato, fatto con carta da macero e dal colore grigiastro, viene usato spesso nel settore dell'imballaggio. La sua flessibilità dipende dallo spessore, ma in generale questo materiale si spezza più facilmente, se sottoposto a flessione, rispetto a un cartone ondulato dello stesso spessore. A causa del colore e della sua superficie ruvida ed assorbente, non è particolarmente adatto alla stampa.

Stampa

La carta rivestita fino ai 410 g/mq di grammatura, può essere facilmente stampata con la maggior parte delle macchine offset moderne con lo stesso metodo che si applica alla carta normale. Può essere poi verniciata o laminata per proteggerla o abbellirla ulteriormente.

Il cartone ondulato e quello riciclato non possono essere stampati altrettanto facilmente anche se, di regola, le esigenze di stampa sono molto più modeste. Normalmente per l'imballaggio di merci all'ingrosso sono sufficienti delle informazioni semplici, come il codice del prodotto e le quantità, preferibilmente a caratteri grandi, che possono essere stampate con sistema tipografico o flessografico. Queste tecniche valgono anche per stampe brevi e grandi ('alto', 'fragile', 'pesante', etc.). È comunque possibile ottenere delle forme più complesse sul cartone ondulato applicando la stampa sulla copertina prima che venga accoppiata agli altri elementi. Questo metodo viene spesso utilizzato per le merci pesanti o fragili che vanno consegnate al cliente nei contenitori di spedizione, come i computer e gli elettrodomestici.

Filetto di taglio, cordonatore e perforatore

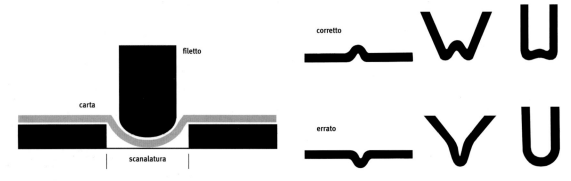

Le basi della cordonatura

Piegatura corretta ed errata dopo la cordonatura

Taglio e cordonatura

Naturalmente i bordi del profilo di un contenitore devono essere fustellati. Tuttavia, il modello deve essere spesso fustellato o perforato all'interno dei bordi.

Inoltre, per evitare grinze al momento di piegarlo, il cartone deve essere prima cordonato. La cordonatura riduce anche il rischio di rotture ed è necessario eseguirla su alcuni tipi di cartone per ottenere una piega nitida e ben definita.

Esistono alcune varianti nella fustellatura e nella cordonatura: il mezzo taglio, un taglio parziale che non penetra completamente nel cartone; il taglio completo ma non continuo lungo il cartone e l'alternanza di taglio e cordonatura.

Per il taglio e la cordonatura del cartone, si deve preparare una fustella con filetti di taglio e filetti cordonatori.

Strutture di base

Per decenni nel settore dell'imballaggio sono stati applicati degli standard stilistici per produrre delle forme determinate di imballaggio. Alcune di loro sono illustrate a pagina 62–67. In tempi più recenti, il formato si è andato adattando sempre più alle esigenze specifiche, e questi formati standard non coprono affatto l'intera gamma di possibilità.

Tuttavia, le strutture di base delle pagine 56–61 rappresentano un punto di partenza per la maggior parte delle forme strutturali. Stesso discorso per i metodi di chiusura mostrati nelle pagine 68–71.

Produzione

Al momento di progettare un formato, è essenziale chiedere consigli in tipografia, in legatoria ed ai possibili fornitori dei materiali, riguardo gli aspetti tecnici della produzione della confezione. Oltre alla fustellatura, la cordonatura e la piegatura, bisogna considerare i dettagli della stampa al vivo (vedi pagina 54) e l'incollatura. Prima di dar via alla produzione è conveniente farsi preparare un modello, utilizzando i materiali scelti, delle stesse misure del prodotto finale.

Introdução em português

**Corte, marcação e molde de perfuração das embalagens
apresentadas na página 299**

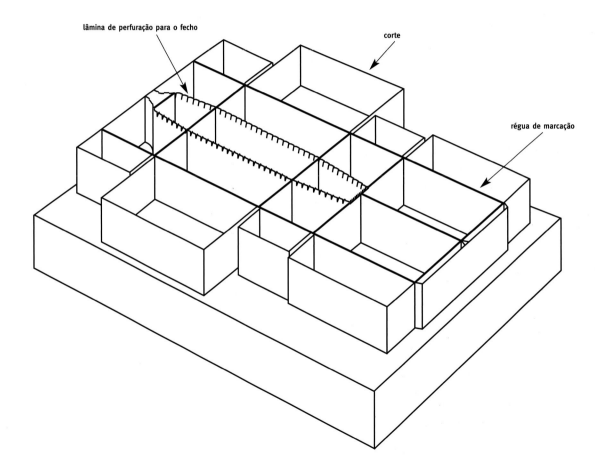

lâmina de perfuração para o fecho

corte

régua de marcação

Introdução em português

Desenho de Estruturas para Embalagens

A embalagem é um factor chave em praticamente todas as formas de comércio: é fundamental para proteger, guardar e enviar produtos, e, em muitos casos, o desenho da embalagem é o primeiro elemento que o consumidor observa ao entrar em contacto com um determinado produto. Os consumidores reagem imediatamente à forma das embalagens e são influenciados por essa forma no momento de decidir sobre a compra do produto. É frequente encontrar determinados tipos de produtos fáceis de reconhecer pela sua forma característica, como caixas de chocolates ou pacotes de leite. Por outro lado, um fabricante de produtos exclusivos, tais como jóias ou perfumes, poderá escolher uma embalagem pouco comum para atrair a atenção do consumidor. Paralelamente, as embalagens servem para proteger, guardar e transportar produtos e deverão portanto ser suficientemente fortes para suportar o seu conteúdo e ao mesmo tempo eficientes no que toca ao tamanho e à forma. Uma boa embalagem é pois fundamental tanto do ponto de vista logístico como de marketing. Todos os desenhos apresentados neste livro foram seleccionados com base na sua importância funcional e aceitação, podendo ser modificados para adaptar-se a exigências específicas. Cada desenho é apresentado de forma facilmente compreensível: na página do lado esquerdo encontra-se o modelo do desenho no plano, apresentado com o perfil de corte; na página do lado direito apresenta-se o produto final. As linhas das dobras estão indicadas por meio de pontos grandes, as linhas de perfuração por pontos mais pequenos e os cortes a realizar no modelo por linhas rectas e finas. Os diagramas nas páginas 54-71 apresentam informação técnica adicional, por exemplo sobre estruturas básicas, métodos de fecho e terminologia.

O CD-ROM

A forma do perfil de corte de cada desenho está guardada em formato EPS vector no CD que acompanha este manual, compatível com Mac e com Windows. Os programas destinados a importar imagens permitir-lhe-ão aceder, aumentar ou reduzir e imprimir os desenhos do CD. No entanto, consegue-se a maior flexibilidade utilizando programas de ilustração tais como Adobe Illustrator, Freehand e outros, os quais permitem adaptar as dimensões dos ficheiros às suas exigências específicas. Apesar dos desenhos apresentados neste livro e no CD poderem ser utilizados livremente para criar novas soluções no campo da embalagem, as imagens em si não poderão ser utilizadas em nenhum tipo de aplicação comercial – incluindo qualquer tipo de publicação impressa ou digital – sem prévia autorização de The Pepin Press/Agile Rabbit Editions (consulte a morada na pág. 2 ou na etiqueta do CD). O CD acompanha gratuitamente este livro e não poderá ser vendido separadamente. Os editores não assumem qualquer responsabilidade caso o CD não seja compatível com o seu sistema operativo.

Tipos de cartão ondulado (fibreboard ou cartão de fibras de madeira)

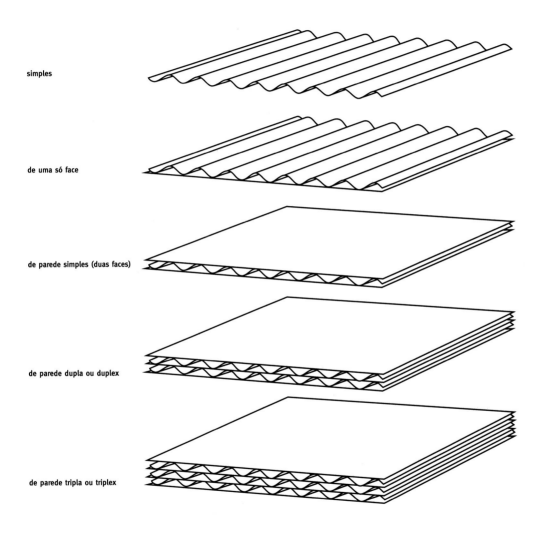

simples

de uma só face

de parede simples (duas faces)

de parede dupla ou duplex

de parede tripla ou triplex

Material de embalagem

Existem muitos tipos de papel e cartão. Para aplicações em vendas a retalho, o cartão e o papelão com revestimento (num só lado ou em ambos) são os materiais mais frequentemente escolhidos. A gramagem ou a espessura do material depende do tamanho da embalagem e do peso do seu conteúdo, embora as gramagens mais comuns se situem entre 230 e 410 g/m².

Os materiais a utilizar em vendas de grandes quantidades ou para o transporte deverão ser mais robustos. O material mais comum para este tipo de aplicações é o cartão ondulado de fibras de madeira. Apesar de existirem muitos tipos disponíveis, os mais comuns são: o cartão ondulado de uma só face, flexível e que se pode usar para envolver um produto, e, por ordem de robustez e rigidez, o cartão ondulado de parede simples, dupla e tripla. As paredes (ou revestimentos exteriores) podem ser de pasta de papel simples reciclada ou estar fabricadas com um material mais caro, como papel calandrado ou papel com revestimento, papel kraft ou uma fina folha de metal.

Para a confecção de embalagens utilizam-se também placas de madeira compensada, preparadas a partir de resíduos de papel. A flexibilidade destas placas depende da sua espessura, mas este material é mais susceptível de se fracturar ao dobrar do que os cartões ondulados de fibras de madeira de espessura similar. Devido à sua cor, aspereza e absorvência, as placas de madeira compensada não são muito adequadas para ser impressas.

Impressão

Um cartão de até 410 g/m², pode ser facilmente impresso na maioria das mais modernas máquinas impressoras em offset, de forma análoga à impressão do papel comum. Além disso, o cartão pode ser protegido e adornado com um verniz ou com um processo de laminação.

O cartão ondulado e as placas de madeira compensada não se podem imprimir tão facilmente, se bem que, por norma geral, se utilizam em aplicações mais modestas. Nas embalagens destinadas à venda em grandes quantidades, é suficiente uma informação simples, como os códigos e a quantidade do produto. Este tipo de impressão pode ser feito por impressão tipográfica ou por flexografia. Estas técnicas são suficientes para imprimir símbolos vulgares e em grandes letras ('este lado para cima', 'frágil', 'pesado', etc.). É porém possível realizar impressões mais complexas numa embalagem de cartão ondulado imprimindo a parede exterior antes de a colar à folha ondulada. Este método utiliza-se para artigos frágeis ou pesados, tais como computadores e electrodomésticos, que são enviados ao consumidor numa caixa de cartão.

Corte, marcação e lâminas de perfuração

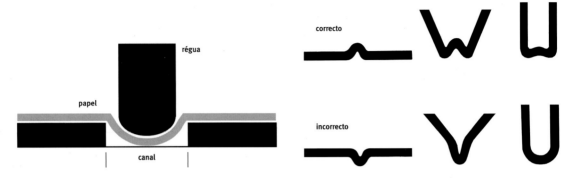

Princípio básico da marcação | **Dobragem correcta e incorrecta depois da marcação**

papel, régua, canal, correcto, incorrecto

Corte e marcação (vinco)

Antes de a fabricar, é necessário cortar o perfil do desenho de uma embalagem. No entanto, frequentemente o desenho necessita ser sujeito a outras operações de corte ou perfuração no interior desse perfil. Além disso, para reduzir as tensões introduzidas no cartão ao dobrá-lo, este deve ser marcado (ou vincado) antes de ser dobrado para obter uma dobra limpa e bem definida.

Existem variações quanto ao tipo de corte e de marcação: o corte parcial que não penetra completamente no cartão, a marcação descontínua que corta o cartão atravessando-o completamente mas de forma descontínua e o corte-vinco que corta e vinca o cartão alternadamente.

Para as operações de corte e de marcação de um cartão é necessário ter uma forma apropriada que consiste em lâminas de corte e réguas de marcação.

Estruturas básicas

Durante décadas foram utilizados na indústria da embalagem estilos tradicionais com formas específicas. Algumas delas são apresentadas nas páginas 62–67. O desenho de embalagens tem-se tornado cada vez mais dirigido às necessidades específicas, pelo que hoje os estilos tradicionais não cobrem todas as possibilidades. Apesar disso, as estruturas básicas, tais como as apresentadas nas páginas 56–61, constituem o ponto de partida no qual se baseia a maioria dos desenhos actuais de estruturas para embalagens. O mesmo se pode dizer dos métodos de fecho que se apresentam nas páginas 68–71.

Produção

Durante o processo de desenho de uma embalagem é fundamental que consulte o seu impressor, encadernador e possivelmente os seus fornecedores de matérias primas sobre os aspectos técnicos relacionados com a produção do modelo. Além de cortar, marcar e dobrar, deve-se prestar atenção aos requisitos de escorrimento da impressão (consulte a página 54) e à colagem. Antes da produção, recomenda-se vivamente construir uma imitação do modelo a produzir, utilizando o mesmo material final e com as medidas exactas do trabalho final.

日本語での紹介

カッティング、スコアリング、パーフォレーションダイモールド
(299 ページ記載のパッケージ用)

ジッパー用パーフォレーションナイフ

ダイカット

スコアリングルール

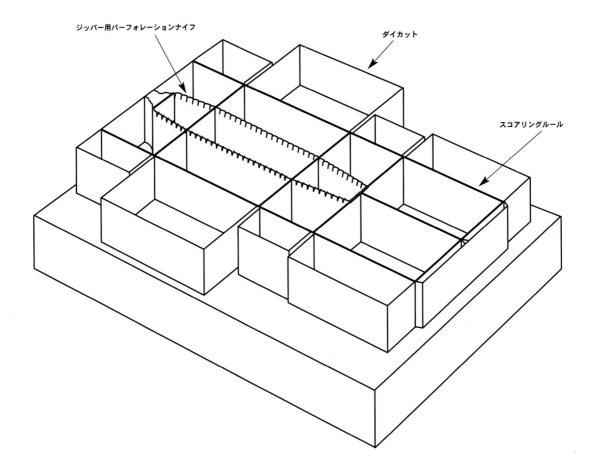

構造パッケージデザイン

パッケージはほぼすべての商業取引において重要な役割を
果たすもので、商品の保護、保管、出荷に欠かせません。
また多くの場合、製品のタイプにかかわらず、カスタマー
が最初に目にするのがパッケージのデザインです。消費者
はパッケージ形状にすぐに反応を示し、パッケージの形に
左右されて購入を決めます。製品の種別によっては、チョ
コレートの箱や牛乳の容器など、独特の形状で簡単に認識
されるものがあります。それに対して、宝石類や香水など
の高級品メーカーは、人目をひく珍しい形のパッケージを
意図的に選ぶことがあります。

同時に、パッケージは商品の保護、保管、輸送に必要なも
のであり、中身を保持できるだけ強く、しかもサイズと形
状において効率的であることが求められます。

そこで、ロジスティックとマーケティングの両観点から、
優れたパッケージが重要性を帯びてきます。本書は、構造
デザインに際しての参考にご利用いただけます。収録デザ
インはすべて、機能面からの妥当性と受容性に基づき紹介
するもので、特定のニーズに合わせて簡単に変更を加える
ことができます。各デザインとも、左ページにダイカット
の外形で示した平面図、右ページに最終製品を記載して、
分かりやすく紹介しています。フォールディングラインは
長い点線、パーフォレーションラインは短い点線、タイプ
別のダイカットは細い直線で示してあります

基本構造、固定方法、用語などのテクニカルインフォメー
ションについては、54 ～ 71 ページに図解があります。

CD-ROM

付属の CD-ROM（Windows ／ Macintosh 対応）には、EPS ベ
クトルフォーマットで各デザインのダイカットフォームが
収録されています。画像をインポートできるソフトウェア
を使用すれば、CD-ROM のデザインにアクセスして、寸法を
測り、印刷することができます。

ただし、デジタル方式でデザインを使用する際に最大限の
フレキシビリティが発揮されるのは、Adobe Illustrator や
Freehand などのイラストレーション用ソフトウェアを使用
した場合です。こうしたソフトウェアでは、独自の仕様に
合わせて、デジタルファイルの寸法を変えることができま
す。

本書ならびに CD に収録されているデザインは、新しいパ
ッケージの考案に際して自由にご利用いただくことができ
ますが、画像そのものは、The Pepin Press ／ Agile Rabbit
Editions（住所は 2 ページと CD のラベルに記載）の事前の
許可なしに、種類を問わず、あらゆる形体の印刷物、デジ
タル出版物をはじめとする商業用アプリケーションに使用
することはできません。

CD-ROM は本書の付属品であり、別売されておりません。
CD がお客様のシステムと互換性を持たなかった場合、発行
者は責任を負わないことをご了承ください。

段ボール紙（繊維板）の種類

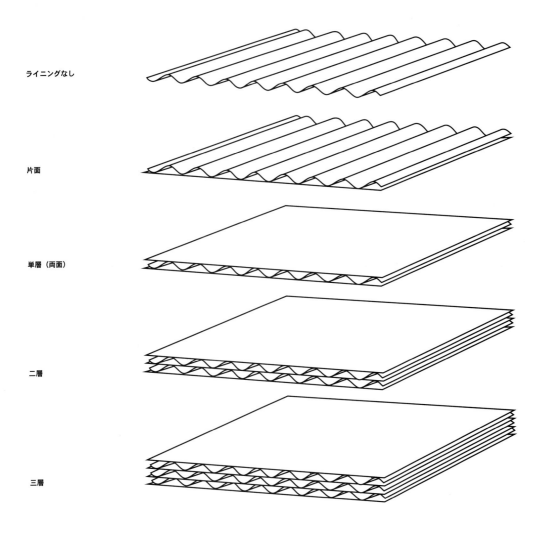

ライニングなし

片面

単層（両面）

二層

三層

日本語での紹介

パッケージ材料

紙やボール紙には様々なタイプのものがあります。小売用には、コーティング処理を施した（片面または両面）厚紙が適しています。言うまでもなく、材料の質量（厚さ）は、パッケージのサイズと中身の重量によって異なってきます。しかし、質量230〜410 gsm（平方メートル当りのグラム数）が一般的です。

卸売用パッケージと出荷には、より強靭な材料を使う必要があります。最も一般的な材料は段ボール紙です。様々なタイプがありますが、最も一般的なのは、曲げやすくて製品を包装できる片面段ボール紙で、単層、二層、三層の順に段ボール紙の強度と剛性が高まります。ライナーには、簡素な茶色がかった再生パルプや、艶付けされたカレンダー紙、クラフト紙、ホイルなどのより高価な材料を使用できます。

また、古紙で作ったほとんど灰色のボール紙が使用されることもよくあります。こうしたボール紙の弾力性は厚さによって異なりますが、一般的にこの材質は、似たような厚さの段ボール紙に比べて、折り曲げたときに裂け目が生じやすくなります。色と粗くて吸湿性のある表面特質から、印刷にはあまり適していません。

印刷

410 gsm までのコーティング厚紙は、普通の紙に印刷するのと同じように、大部分の最新オフセット印刷機で簡単に印刷ができます。この素材は、ワニスやラミネーションでさらに保護したり、装飾を行うことができます。

段ボール紙やボール紙への印刷はそれほど簡単ではありませんが、概して、印刷ニーズも適度なものです。一般に卸売用パッケージには、製品コードや数量などの単純な情報を、できれば大きな字体で印刷すれば十分です。これは、活版印刷やフレキソ印刷で処理できます。こうした印刷技術は、シンプルな目立つシンボル（「this side up ／天地無用」、「fragile ／こわれもの注意」、「heavy ／持ち運び注意」など）にも十分対処できます。しかし、段ボール箱の外層に印刷を行ってから段ボール紙を貼り合わせるという、さらに複雑な印刷処理を行うことも可能です。この方法は、コンピューターやキッチン器具など、出荷カートンに入れてカスタマーに配送される重量がかさむか壊れやすい商品に使用されることがよくあります。

ダイカッティングとスコアリング（溝線付け処理）

言うまでもなく、パッケージデザインの外形はダイカットする必要があります。しかしデザインには、その中でさら

カッティング、スコアリング、パーフォレーションナイフ

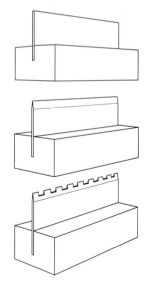

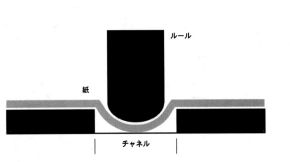

ルール

紙

チャネル

スコアリングの原理

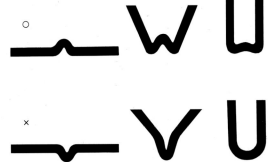

○

×

スコアリング処理後の正しいフォールディングと正しくないフォールディング

にカッティングやパーフォレーションが必要となることが
よくあります。
また、フォールディングによって厚紙に加わる力を少なくす
るために、フォールディング前にスコアリングと呼ばれる溝
線付け処理が必要となります。スコアリングは紙が裂ける危
険を減らすのに役立ち、きちんとしたフォールディングを行
うにはスコアリングを必要とするタイプの厚紙もあります。
フルカッティング、フルスコアリングの変形として、カッ
ティングが厚紙を貫通しないパーシャルカッティング、カ
ッティングが不連続に厚紙を貫通するスキップスコアリン
グ、カッティングとスコアリングが交互に行われるカッテ
ィング／スコアリングがあります。
厚紙のダイカッティングとスコアリングに際しては、カッ
ティングナイフとスコアリングルールから成るダイを作る
必要があります。

基本構造

パッケージ業界ではこれまで長年にわたり、特定のパッケ
ージ形状に対しては標準スタイルが用いられてきました。

その一部を 62 〜 67 ページに図解してあります。しかし最
近では、特定のニーズに合わせてパッケージデザインのカ
スタム化が進んでおり、こうした標準スタイルは、もはや
考えられるあらゆる種類のパッケージをカバーできなくな
っています。
とは言うものの、構造デザインではたいていの場合、56 〜
61 ページに記載した基本構造がその出発点となるでしょう。
68 〜 71 ページに記載した固定方法に関しても、同じこと
が当てはまります。

生 産

パッケージをデザインする際には、印刷業者、製本業者、
場合によってはパッケージ材料の供給業者も含めて、デザ
インの生産に関る技術的な側面について相談することをお
勧めします。カッティング、スコアリング、フォールディ
ング以外にも、印刷の裁ち切り図版の要件（54 ページ参照）
や糊付け作業にも注意を払ってください。生産を開始する
前に、最終的な材料を使い、最終製品の正確な測定寸法で、
原寸模型を作ることを強くお勧めします。

中文簡介

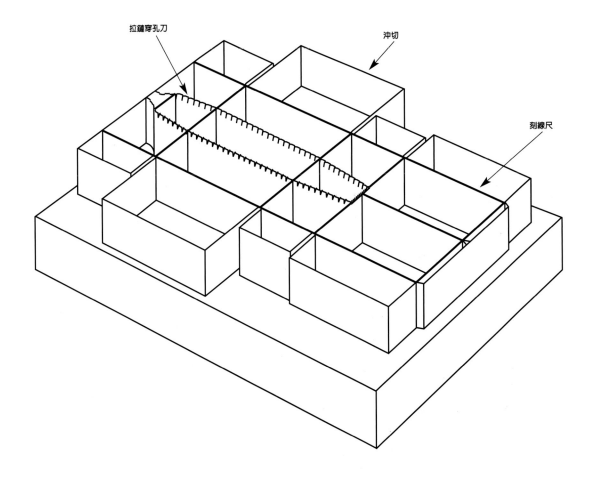

拉鏈穿孔刀

沖切

刻線尺

結構包裝設計

包裝是所有貿易形式的關鍵因素:它在產品保護,儲存及運輸的過程中極為重要,在許多情況下,包裝設計是顧客接觸任何產品時的第一個印象。顧客會即刻對包裝外形作出反應,並在進行購買抉擇時受到影響。不同的產品類型,譬如巧克力盒或牛奶包裝盒,通常能夠很容易透過其特定的形式加以辨別。另一方面,獨特產品 (譬如首飾或香水) 的生產商則可能會特意選擇一個不同尋常的,引人注目的形式。

同時,包裝又起到保護,儲存及運輸產品的作用,因此它必須既牢固,又在尺寸和外形上體現效益。

因此,好的包裝對於物流和產品營銷來說至關重要。本書可作為結構設計的參考書。這裡的所有設計都根據其實用性和可接受性的原則加以選擇,並可經過簡單的修改滿足特定的要求。每個設計構思都以簡明易懂的方式加以說明:左邊一頁是平面圖,有著沖模輪廓圖,右邊一頁則為成品。折疊線以長虛線標出,穿孔線以小點標出,模型內的沖切則以細直線標出。

有關基本結構,鎖定方法以及術語和圖解的技術資訊,可見第 54 至 71 頁。

CD-ROM

每個設計的沖切形狀均以可用於 Mac 和視窗電腦的 eps 向量格式儲存在隨附的 CD-ROM 上。可以輸入圖像的軟體程式允許你進入 CD-ROM ,擴縮及印刷各種設計。

不過,演示程式,如 Adobe Illustrator , Freehand 等,還可以透過數位方式對設計進行靈活的調整,因為這些程式能使數位文檔的尺寸完全適合你自己的特定要求。

雖然你可以任意使用本書和 CD 上的設計,開發新的包裝方案,但在事先徵得 The Pepin Press/Agile Rabbit Editions 公司的同意之前,這些圖像卻不能用於任何形式的商業用途,包括所有類型的印刷和數位式出版 (參見第 2 頁和 CD 標籤上的地址)。

本書附帶免費的 CD-ROM ,但 CD-ROM 不得單獨出售。如果 CD 不能與你的電腦系統相容,出版商不負任何責任。

波紋形紙板（纖維板）類型

無線

單面

單壁（雙面）

雙壁

三壁

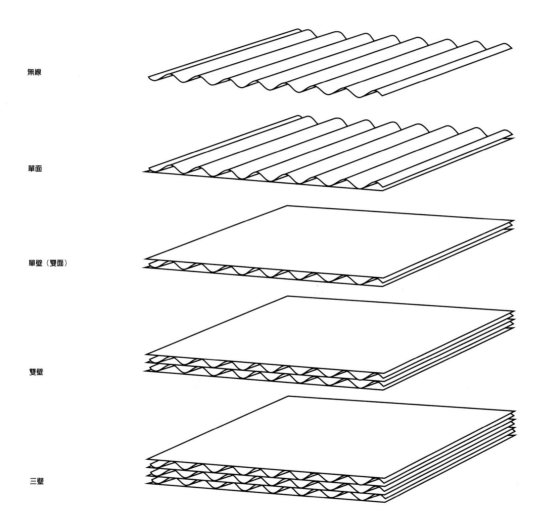

包裝材料

紙張和紙板有各種規格。就零售環境而言，塗料（單面或雙面）紙板或紙片是首選材料。材料的重量或厚度自然取決於包裝的尺寸和物體的重量。不過，重量在 230 和 410 克/平方米（gsm）之間的材料較為普遍。

就大規模包裝和運輸而言，必須使用牢固的材料。這方面最常用的是波紋形纖維板。雖然市面上有許多不同的規格，但最常用的類型是單面波紋紙板，它比較柔性，可以包在產品四周；就強度和堅硬度而言，單壁，雙壁及三壁波紋紙板的性質依次上昇。壁（或內襯）可採用簡單的回收利用的棕色紙漿，如果是較為昂貴的材料，可採用壓製或塗料紙，牛皮紙或薄金屬片。

粗紙板也經常用於包裝，它採用廢紙製造，大部分呈灰色。粗紙板的柔性取決於其厚度，但一般而言，在折疊的情況下，這種材料比一樣厚度的波紋形纖維板容易破裂。由於其顏色和硬度，吸收性強的表面，它不很適合印刷。

印 刷

重量在 410 克/平方米以下的塗料紙板可以與普通紙張一樣在最現代化的膠板印刷機上進行印刷。這種材料可以透過上釉或層壓得到進一步的保護和美化。

在波紋紙板和粗紙板上印刷就不那麼容易，但這方面對它們的要求也較低。通常，對於大規模包裝，像產品編碼和數量這種簡單的，最好是大字體的資訊就足夠了。這可以透過活版印刷或曲面印刷加以印刷。對於簡單，黑體的符號（「這一面朝上」，「易碎」，「重」等)，這些技術也足夠了。不過，如果在波紋紙黏起來之前先對外壁加以印刷，也可以對波紋紙板進行較為複雜的印刷。這種方法經

常用於裝在運輸紙板裏供應給客戶的沉重或易碎物品，如電腦和廚房家電產品。

沖切和刻線（起皺）

自然，包裝設計的形狀需要沖切。不過，經常需要在設計形狀的內部作進一步的切割或穿孔。

此外，為了減少折疊對紙板造成的應力，紙板也必須在折疊前進行劃線（或起皺）。劃線還有助於減少破裂的可能性，而就有些類型的紙板而言，為了形成整潔，分明的折疊，也有必要進行劃線。

切割，刻線及穿孔刀

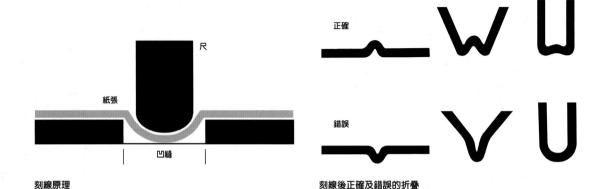

刻線原理　　　　　　　　　　　　　　　　**刻線後正確及錯誤的折疊**

除了全面切割和劃線以外，還有其它方式：如不完全割穿紙板的部分切割；完全但不連續割穿紙板的跳躍式刻線；以及切割和起皺交替進行的切皺工藝。

至於紙板的沖切刻線，必須製作一個包括由切刀和刻線尺組成的模具。

基本結構

許多年來，包裝行業一直採用標準的風格作為特定的包裝形式。其中一些在第 62 至 67 頁有所解釋。最近以來，包裝設計變得愈來愈根據特定的需要專門製作，這些標準的風格完全不能覆蓋各種設計可能。

無論如何，第 56 至 61 頁上的基本結構可以作為大多數結構設計的出發點。第 68 至 71 頁上說明的鎖定方法也是如此。

製 作

在設計一個包裝的過程中，必須就基於設計的包裝品製作的技術方面徵求印刷商，裝訂商或者材料供應商的意見。除了切割，刻線和折疊以外，還應注意印刷滲出方面的要求（參見第 54 頁）以及膠接。在製作之前，我們強力建議你先用最終材料，根據包裝品的確切尺寸做一個模型。

Basic Structures, Locking Methods, and Terminology

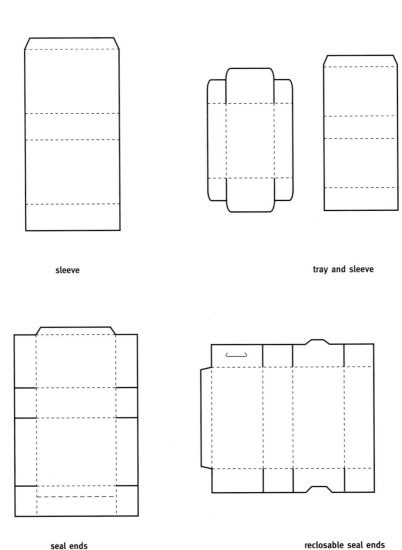

sleeve

tray and sleeve

seal ends

reclosable seal ends

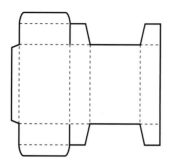

straight tuck

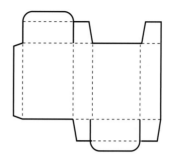

reverse tuck

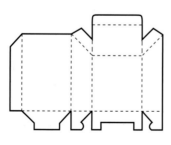

tapered top

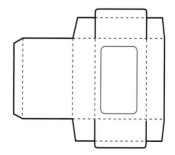

window carton

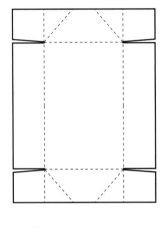

tray

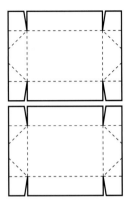

tray and lid

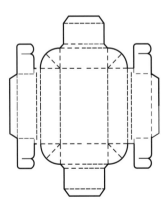

hollow wall tray

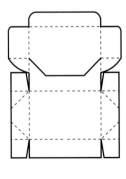

display package

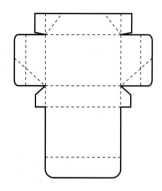

tray with hinged lid

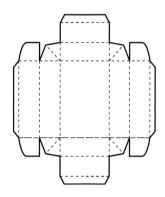

tray with hinged lid

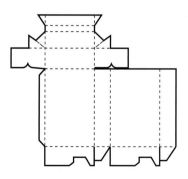

flip top

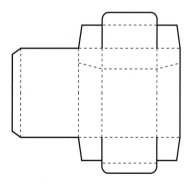

perforated flip top

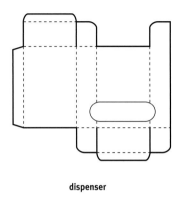

dispenser

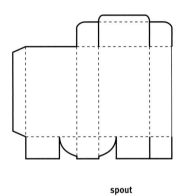

spout

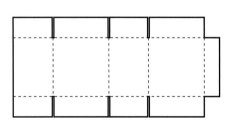

universal

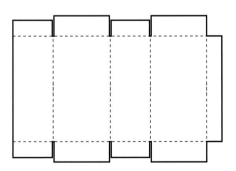

full overlap

Basic Structures

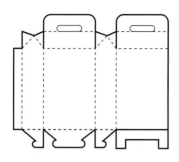

carrier

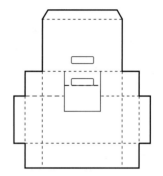

carrier

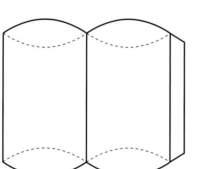

pillow pack

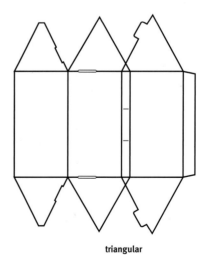

triangular

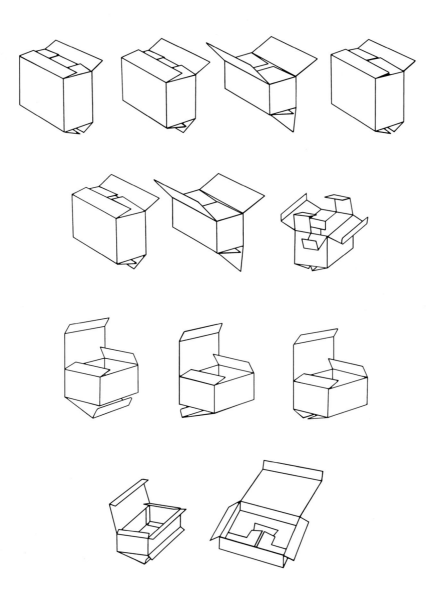

Standard Styles (Code B)

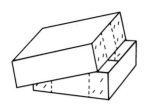

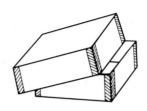

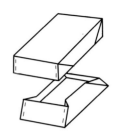

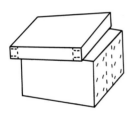

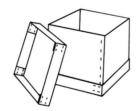

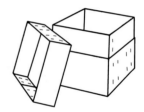

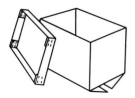

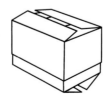

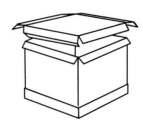

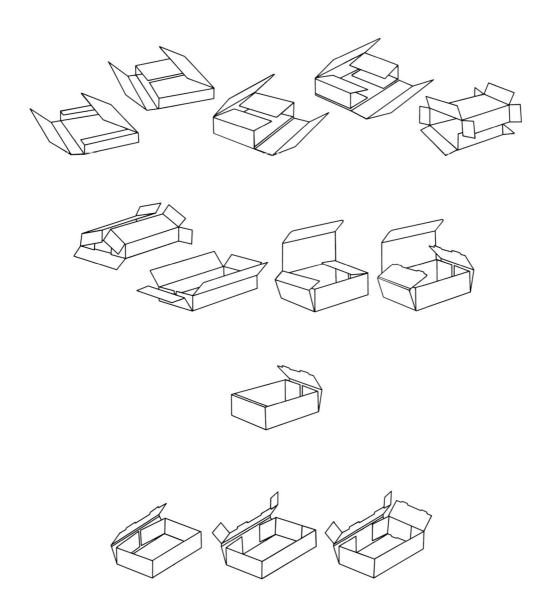

Standard Styles (Code D)

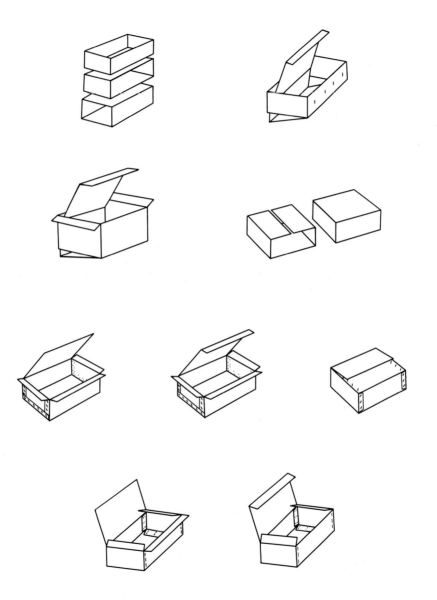

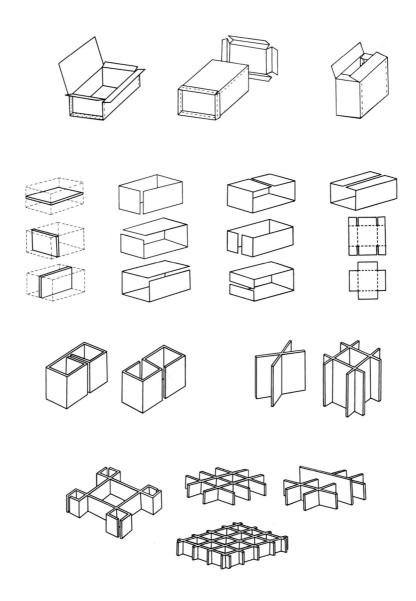

Standard Styles (Codes F and I)

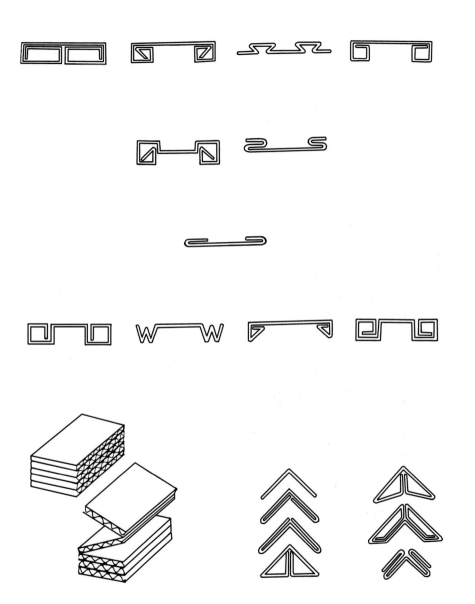

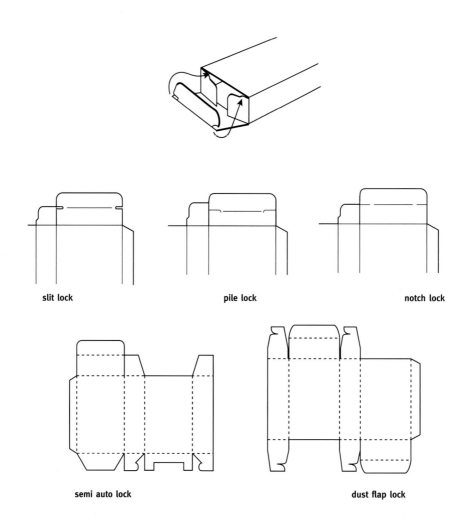

slit lock

pile lock

notch lock

semi auto lock

dust flap lock

tucklocks

gusseted dust flap

top panel lock

semi auto lock

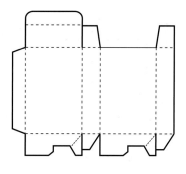

auto lock

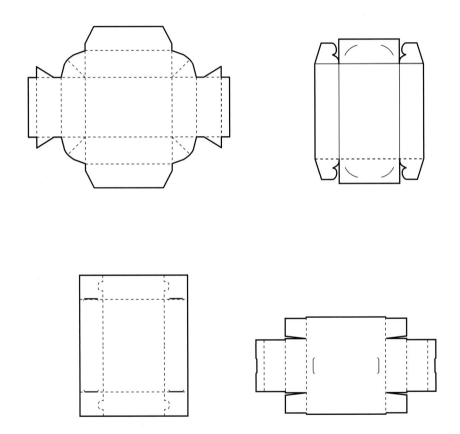

side and end panel locks

Locking Methods

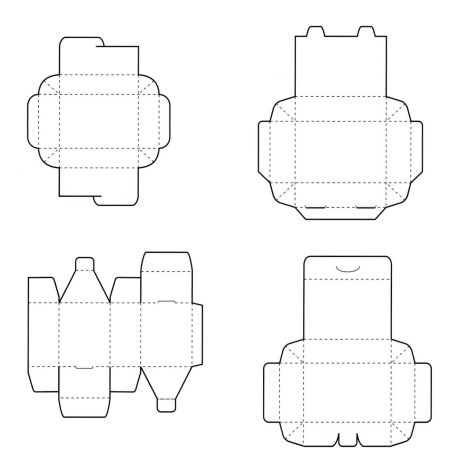

top panel locks

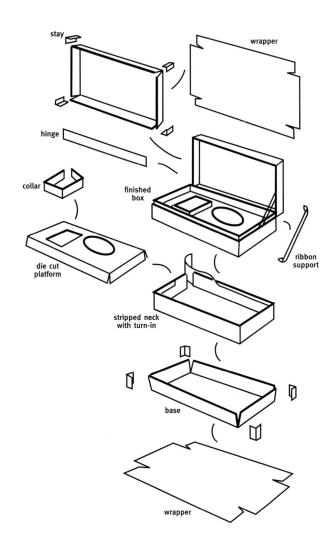

stay

wrapper

hinge

collar

finished box

die cut platform

ribbon support

stripped neck with turn-in

base

wrapper

Designs
デザイン
設計

Regular Boxes

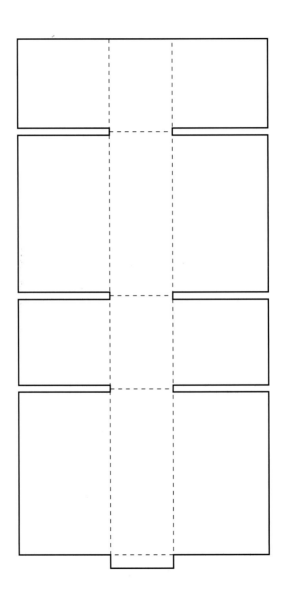

Universal Box

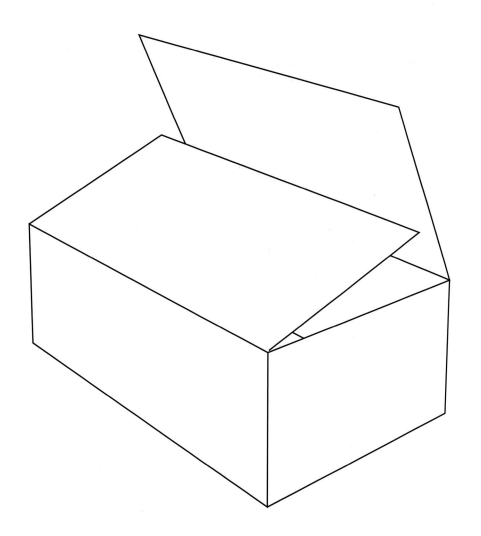

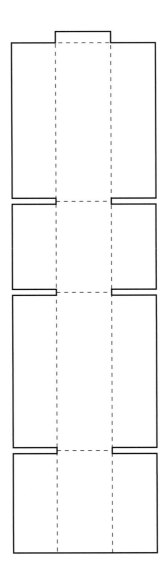

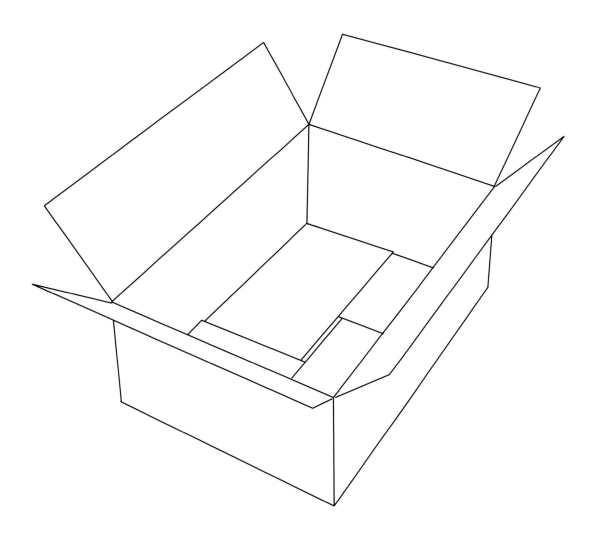

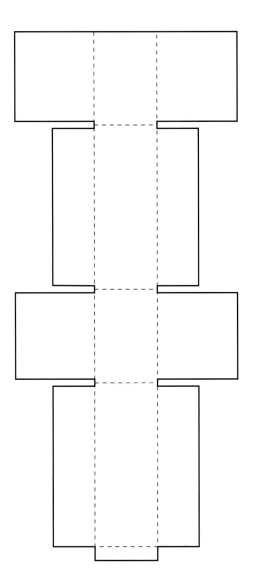

Full-overlap Carton

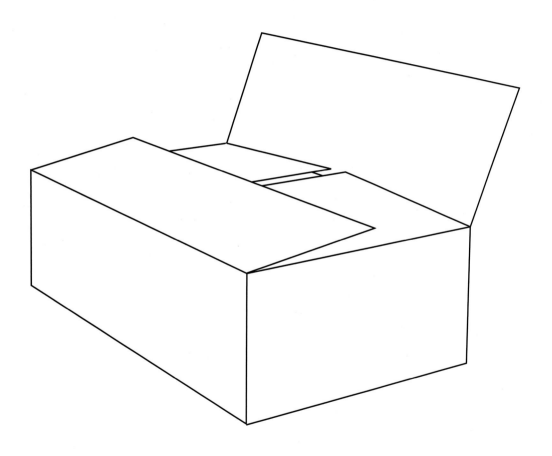

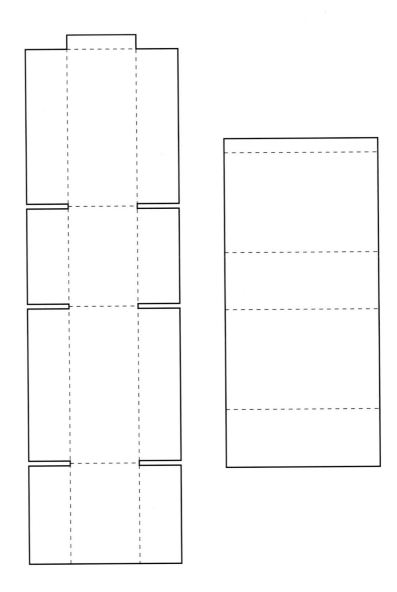

Tray and Sleeve

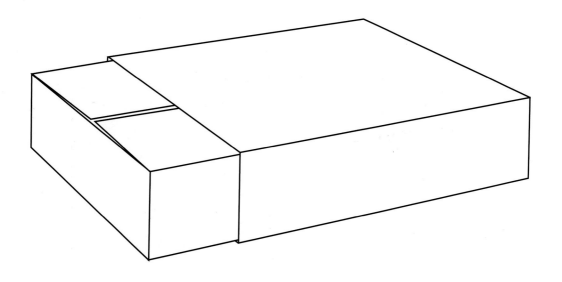

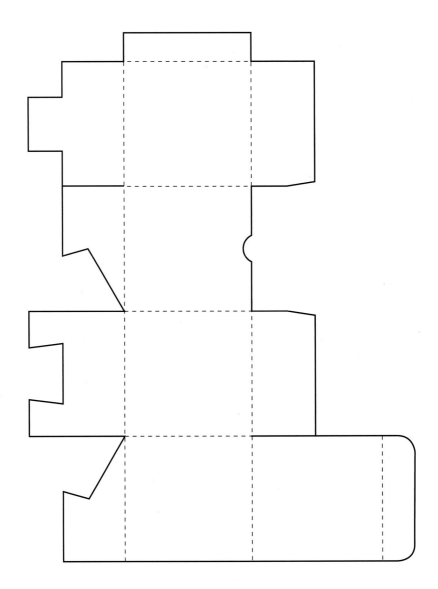

Auto Lock Bottom Tuck Lock Top

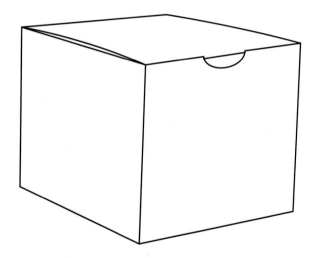

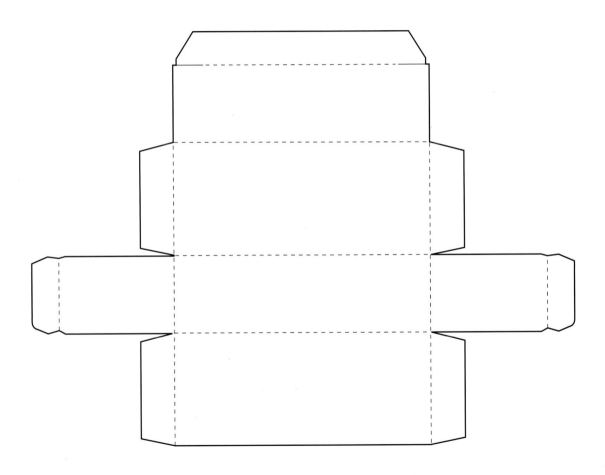

Tuck Lock and Dust Flaps

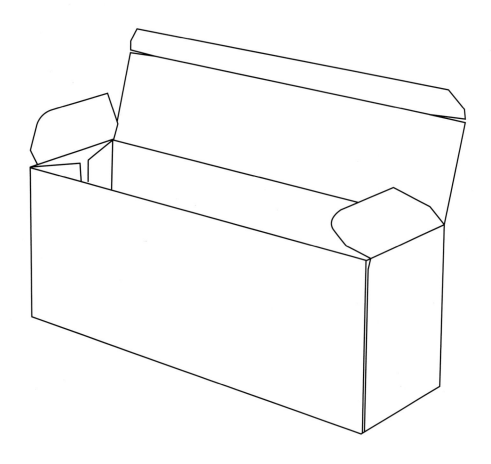

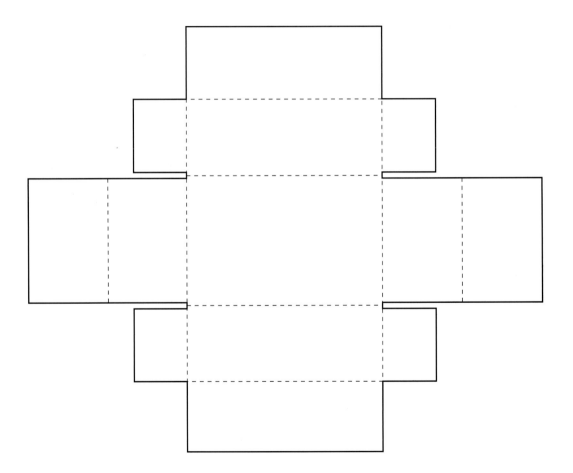

Seal Ends Box

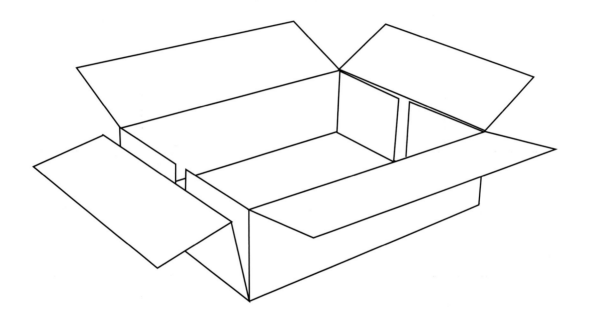

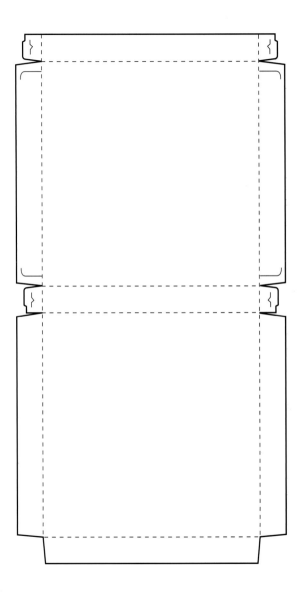

Pizza Box

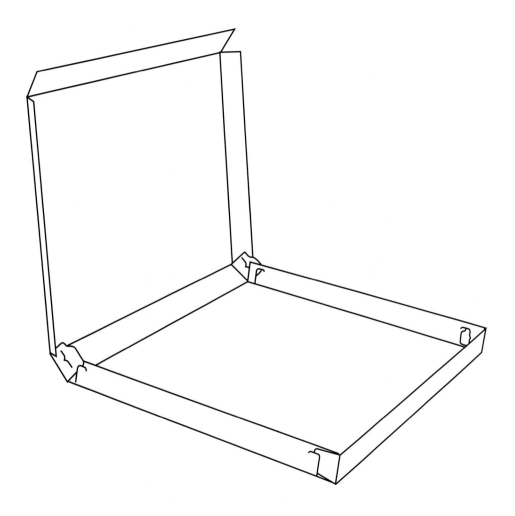

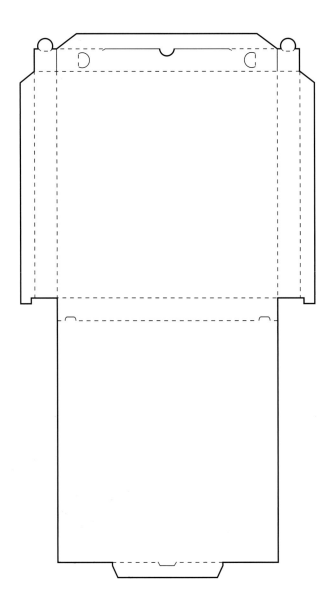

Pizza Box

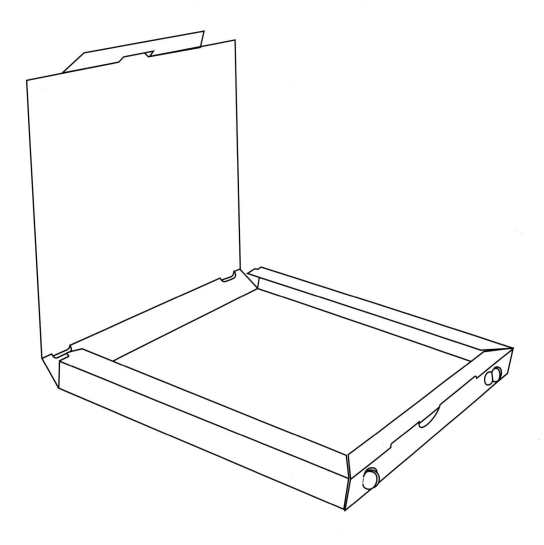

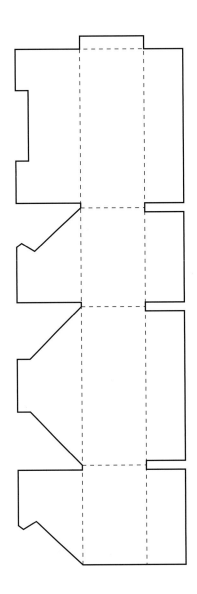

Auto Lock Carton

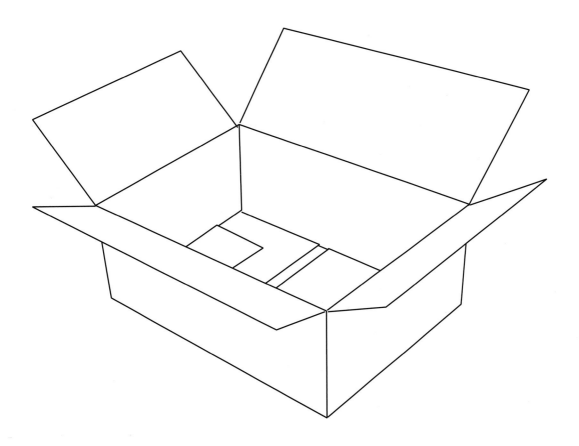

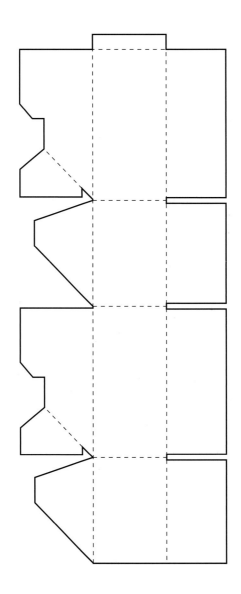

Auto Lock Carton

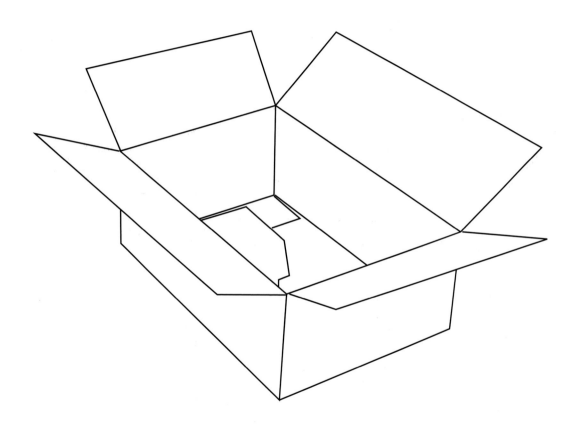

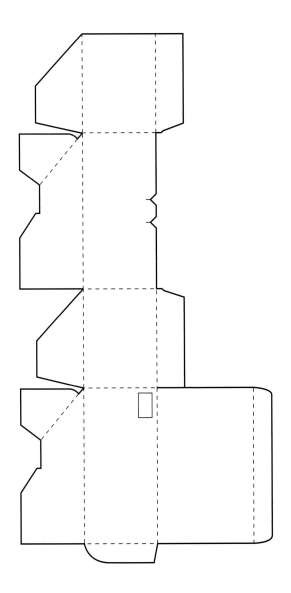

Auto Lock Carton with Window

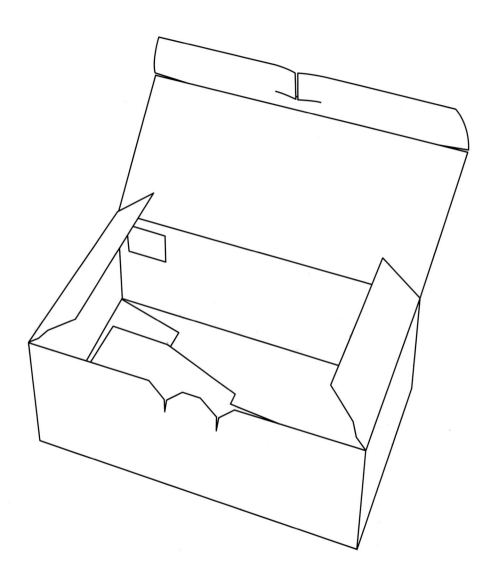

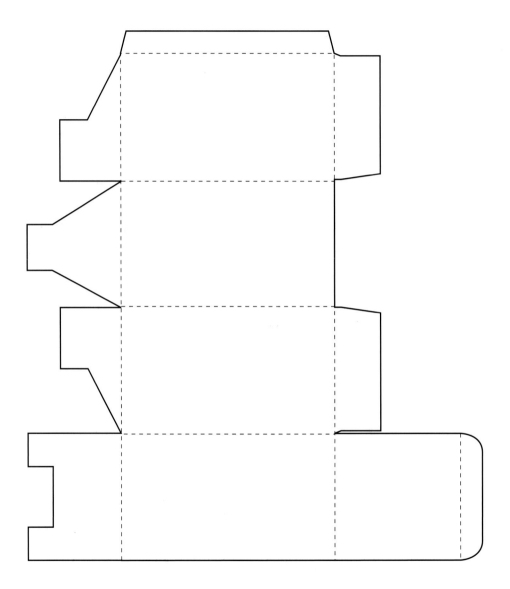

Snap Lock Bottom Tuck Lock Top

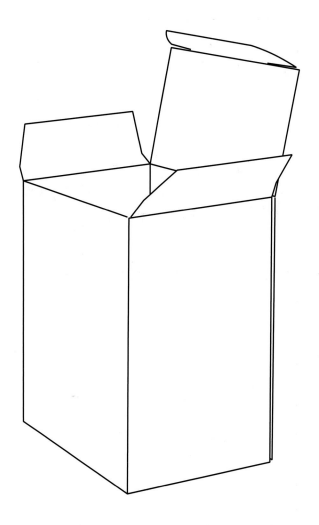

Snap Lock Bottom Tuck Lock Top

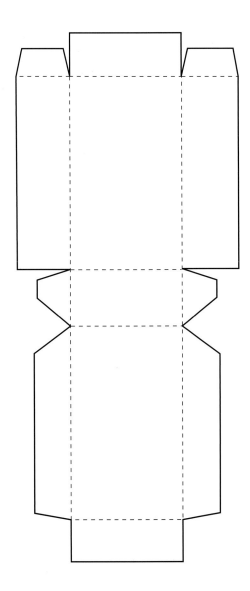

Seal Ends

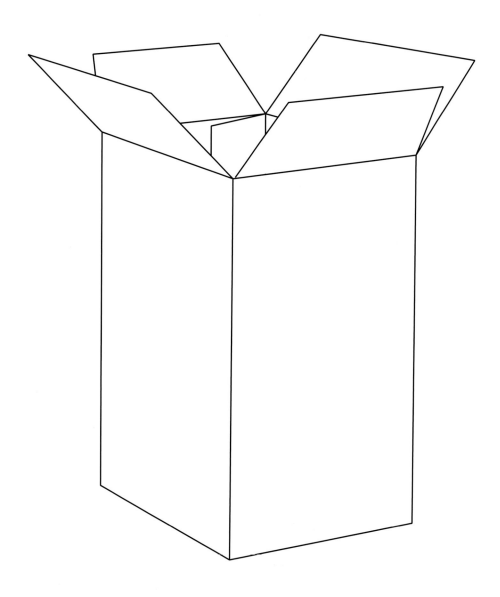

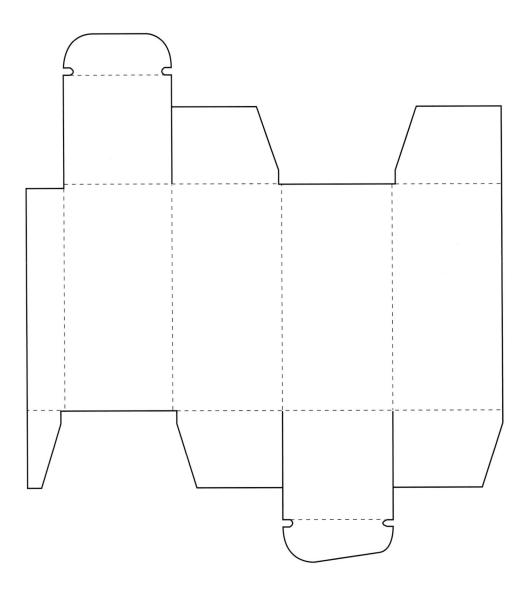

Reverse Tuck Box

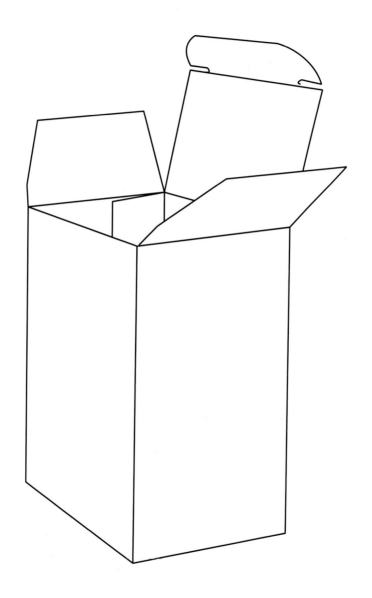

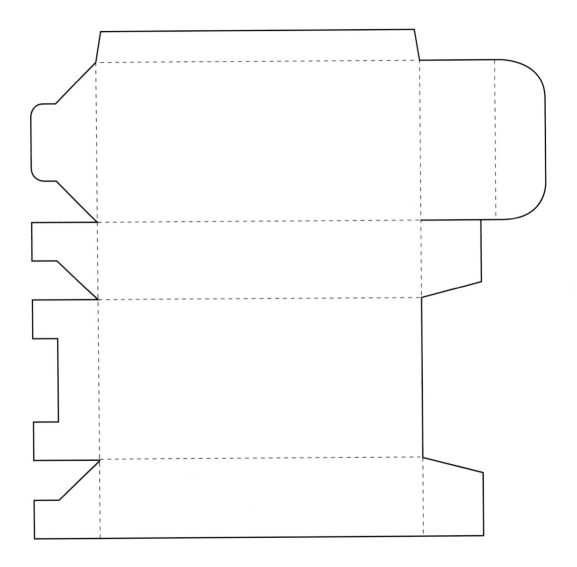

Snap Lock Bottom

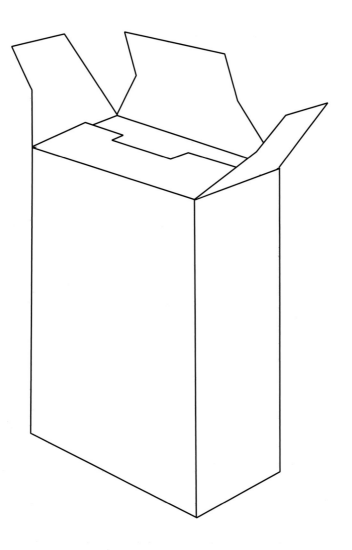

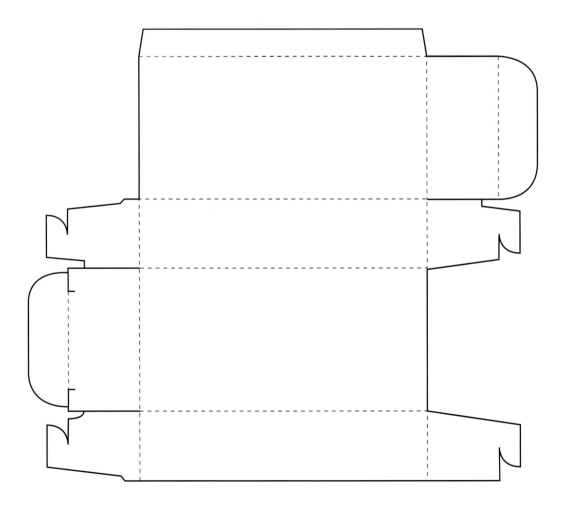

106　　Reverse Tuck with Dust Flaps

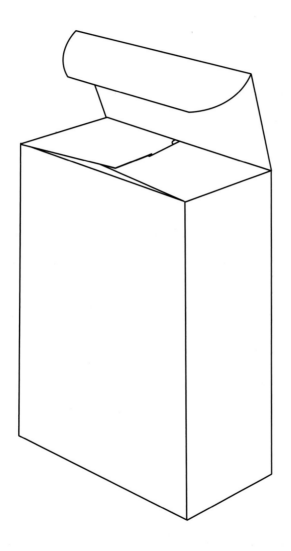

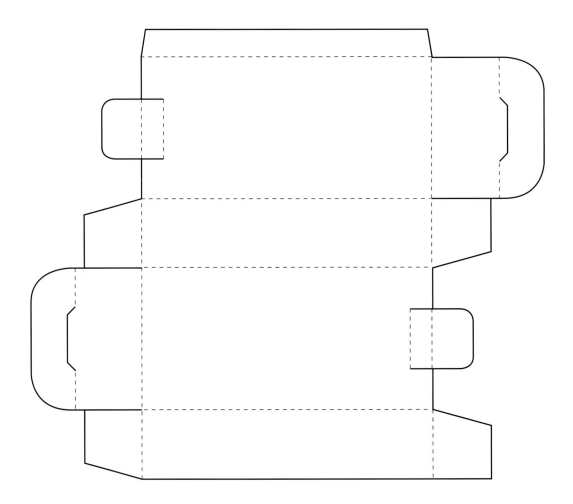

Locking Tabs

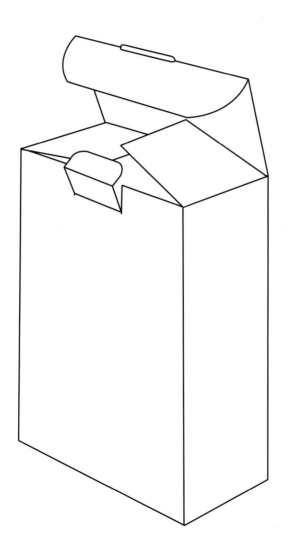

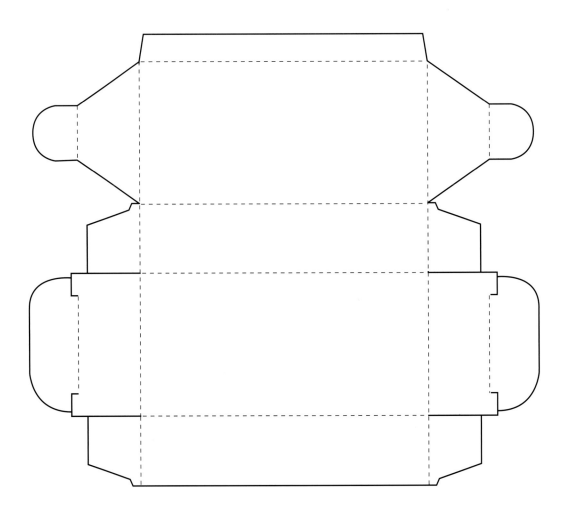

Locking Tabs

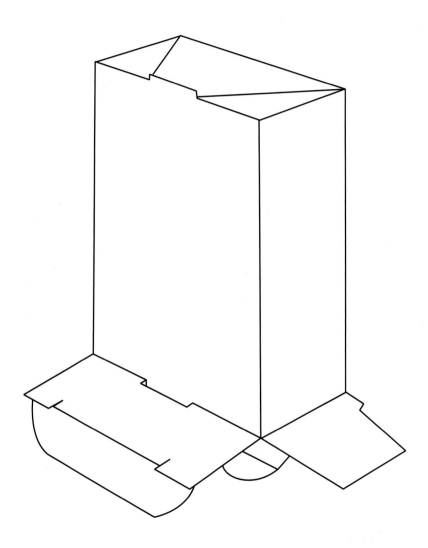

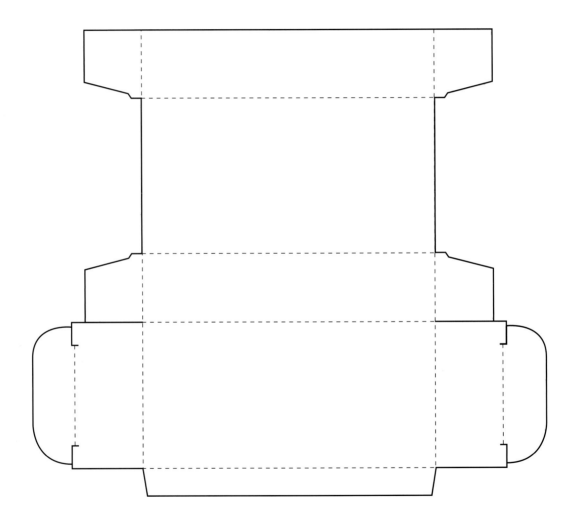

Reclosable Locking Tab

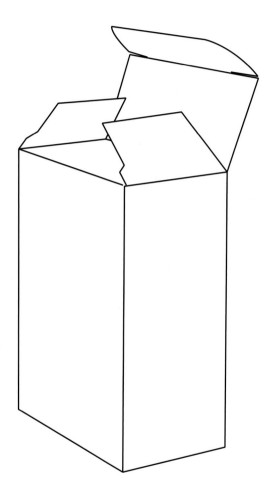

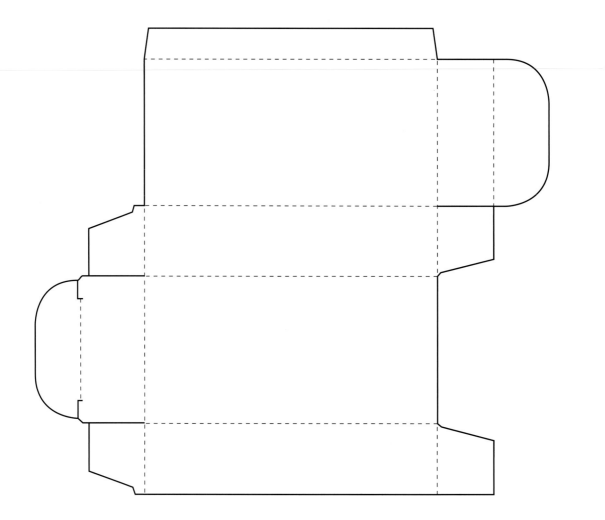

Reclosable Locking Tab

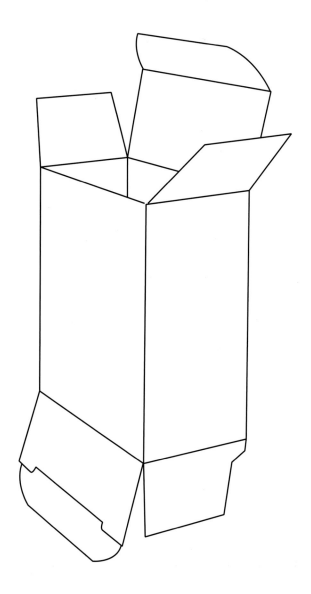

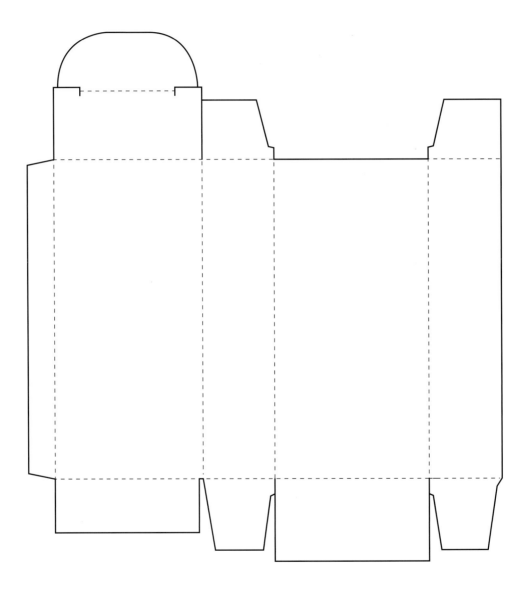

Reclosable Locking Tab

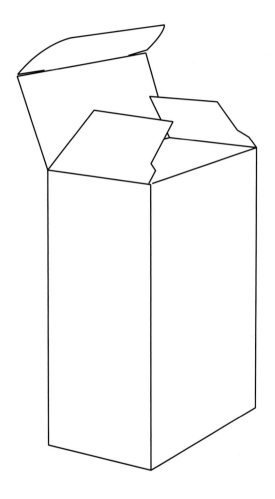

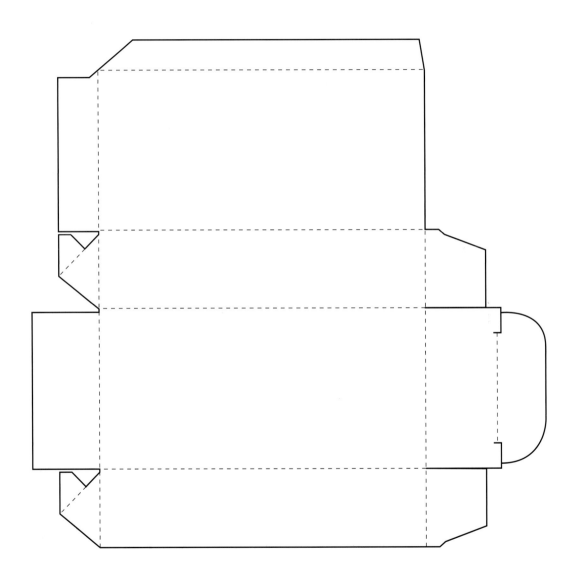

Collapsible Auto Lock Bottom

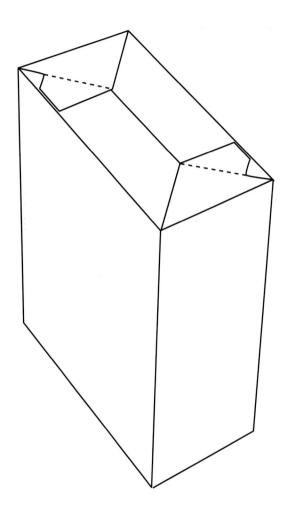

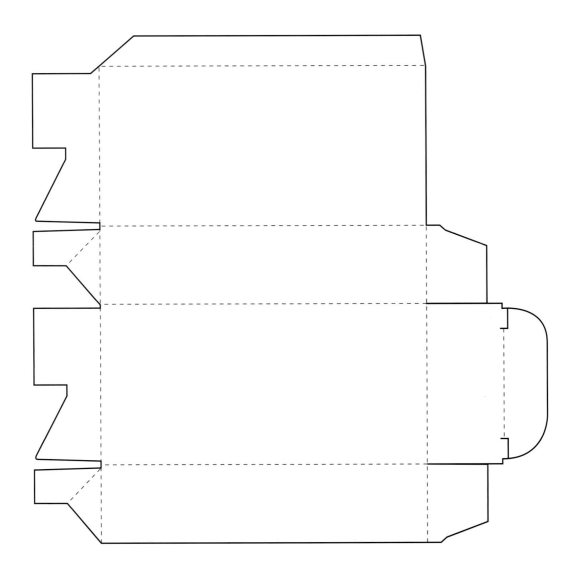

Collapsible Auto Lock Bottom

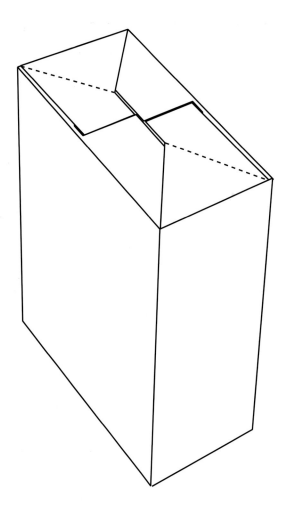

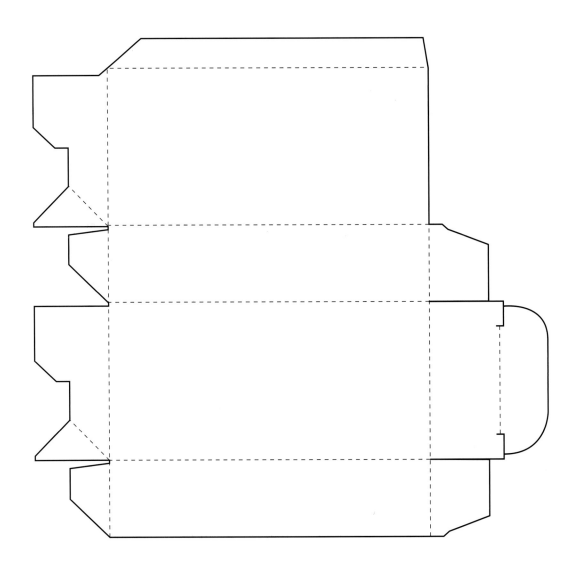

Collapsible Auto Lock Bottom

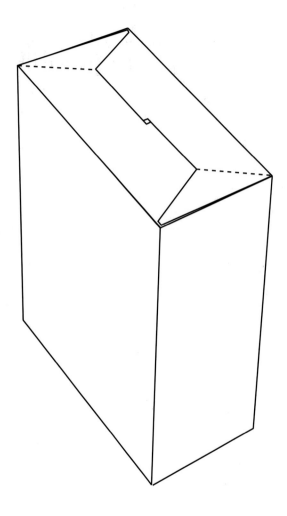

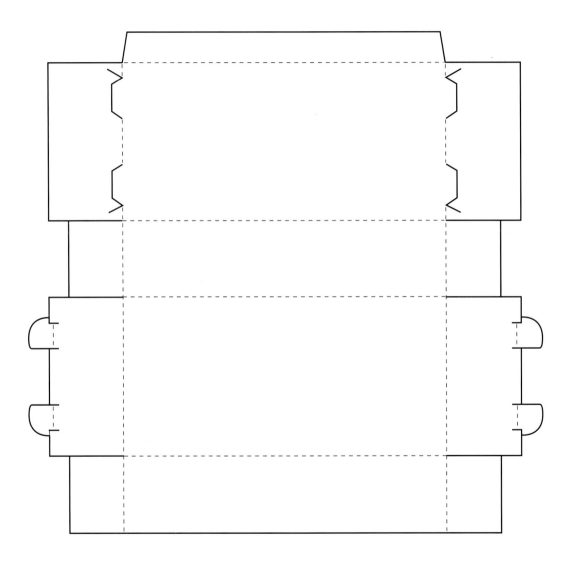

Double Locking Tabs

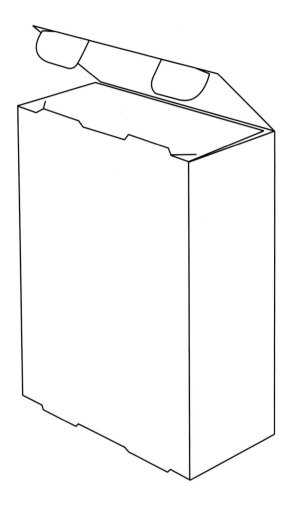

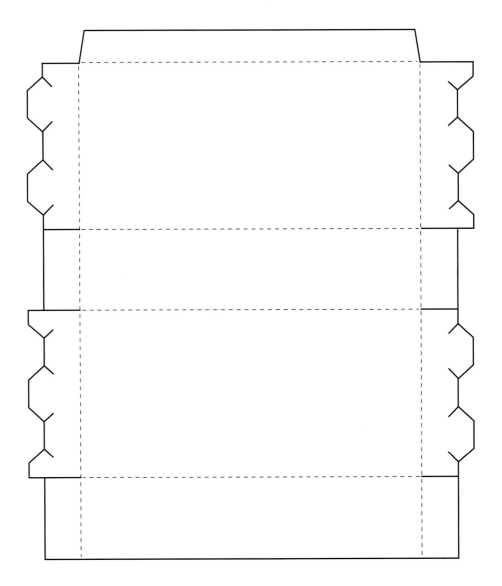

Double Locking Tabs

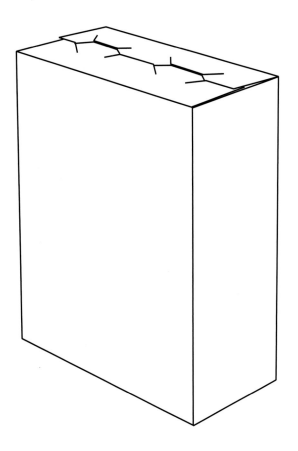

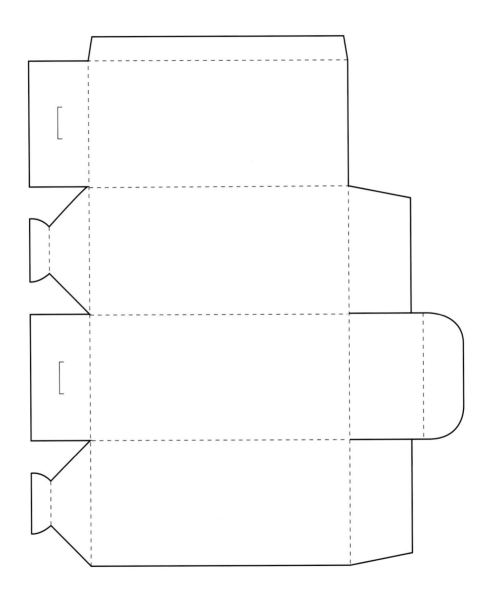

Single-slot Locking Tabs

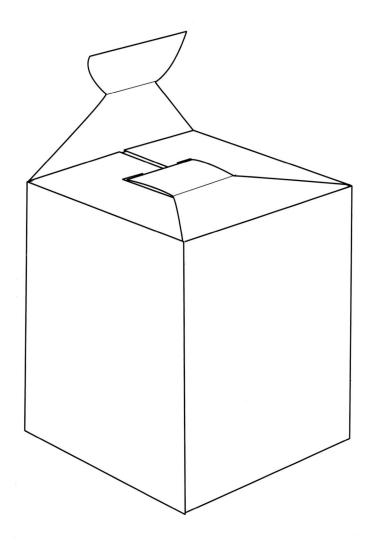

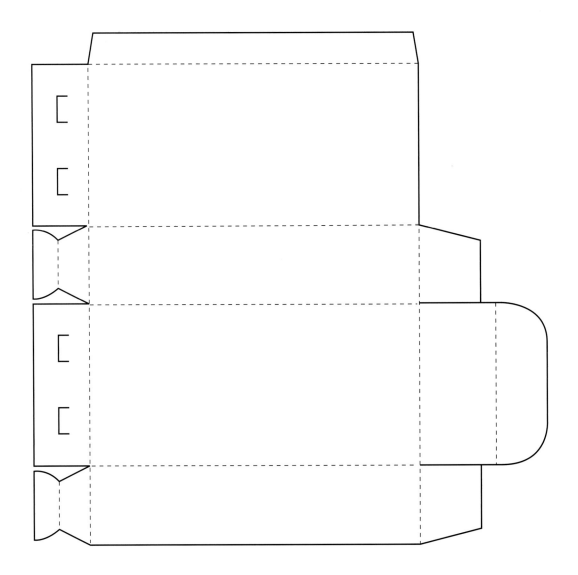

Double-slot Locking Tabs

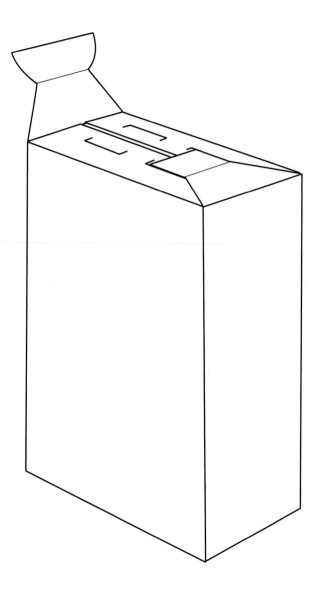

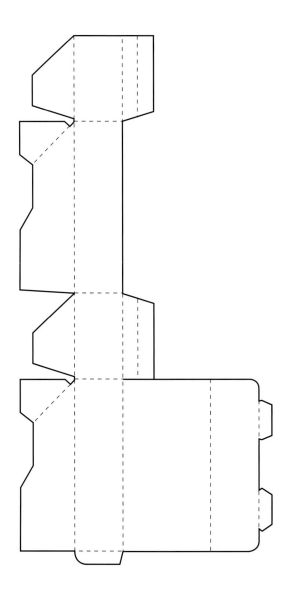

Double Locking Tabs

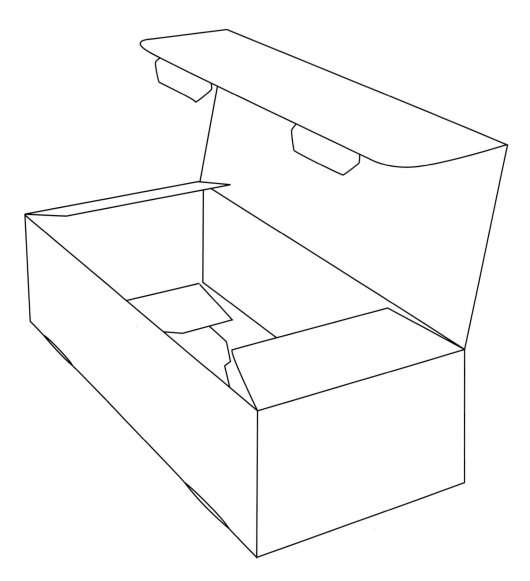

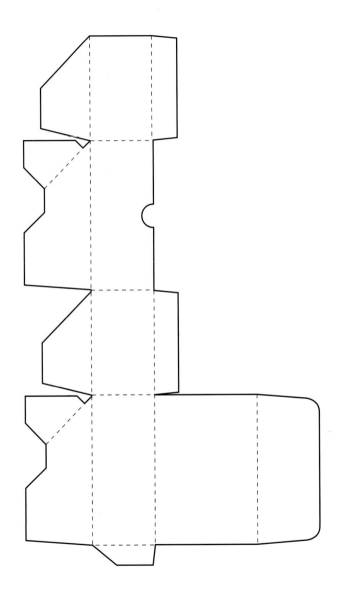

Tuck Lock Top with Thumb Hole

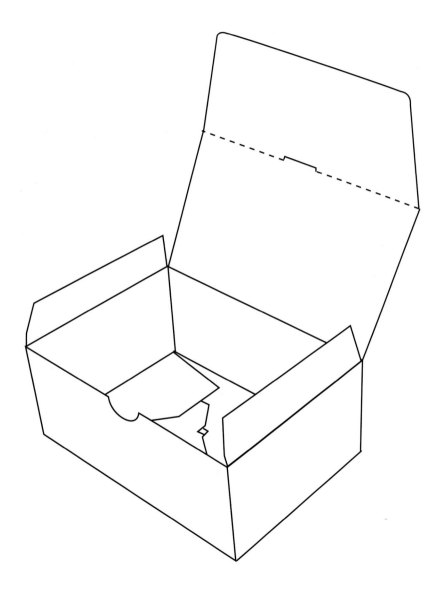

Tuck Lock Top with Thumb Hole 135

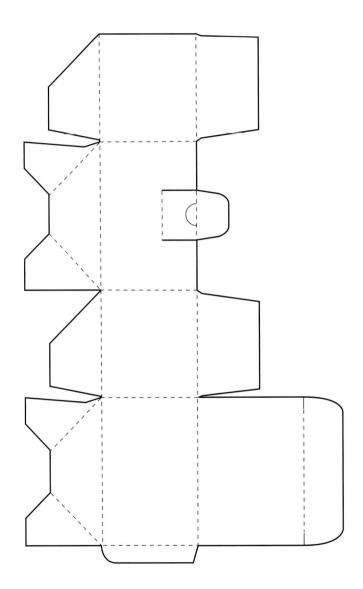

Locking Tab with Thumb Tab

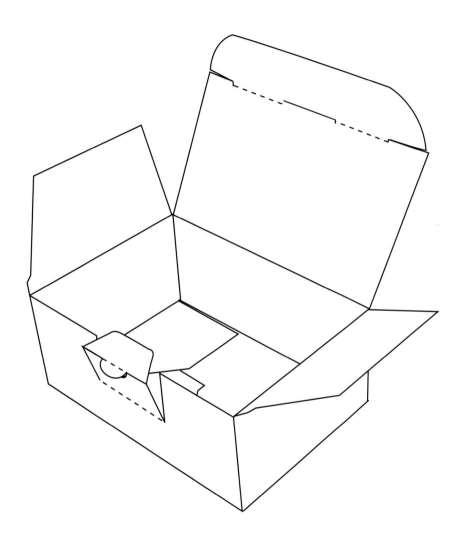

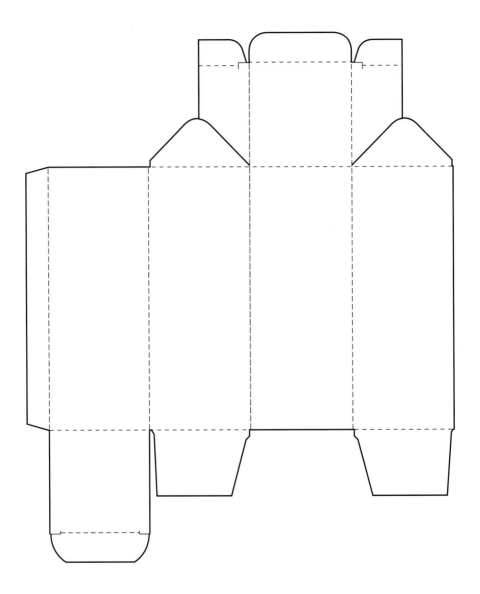

Reinforced Top

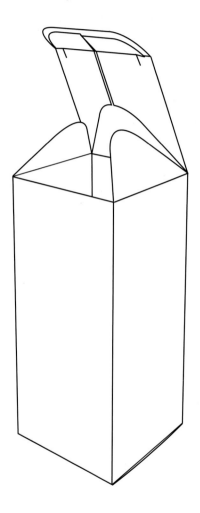

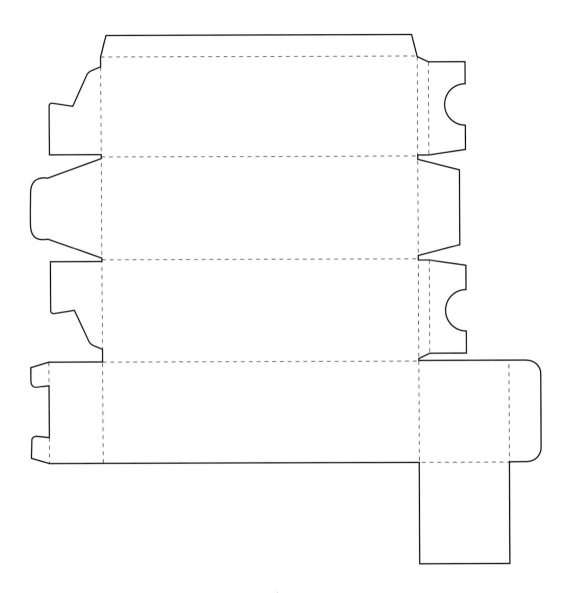

Built-in Bottle Support

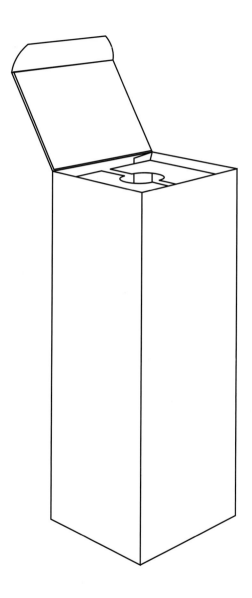

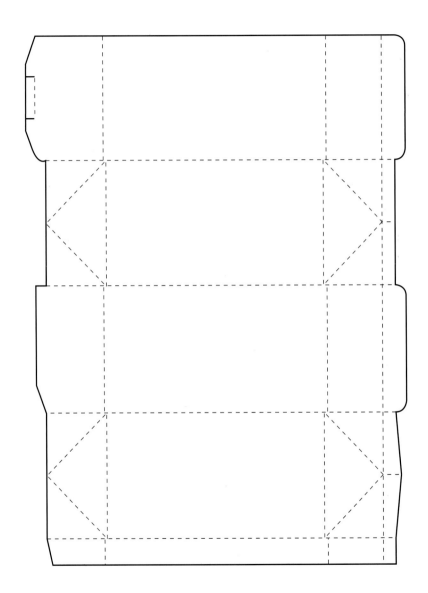

142 Milk Carton

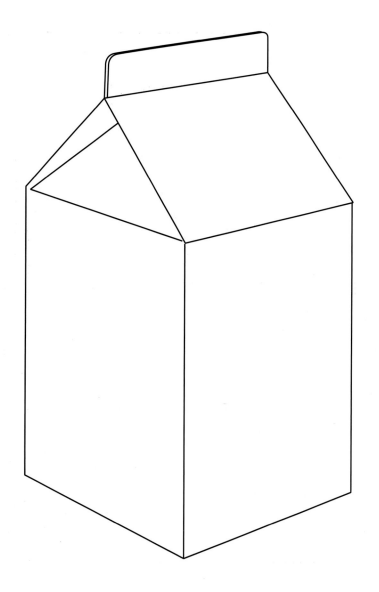

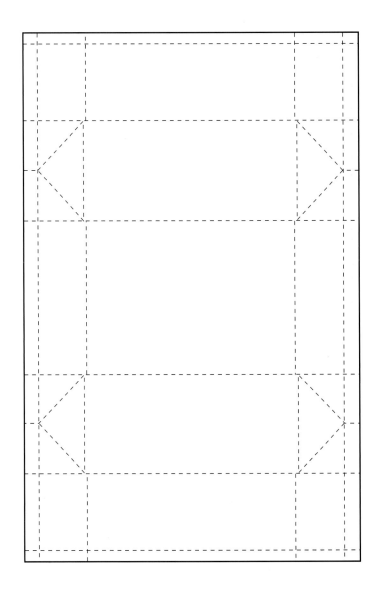

Juice Carton

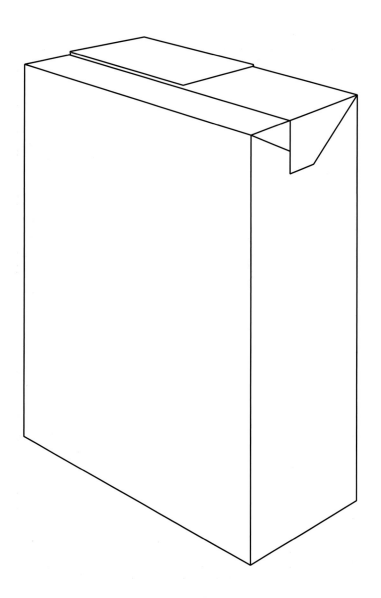

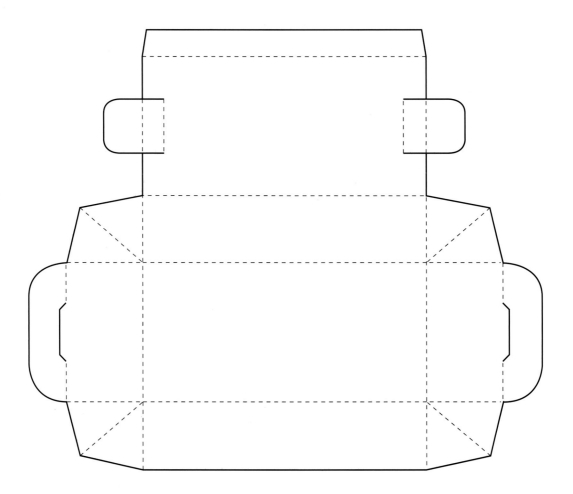

146 Fold-in Dust Panels

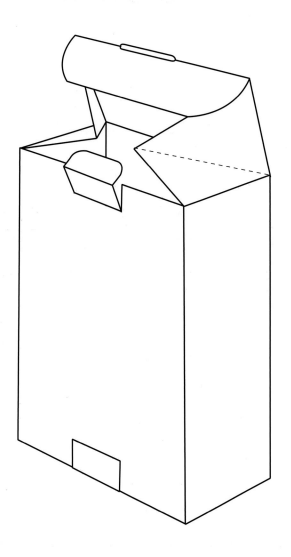

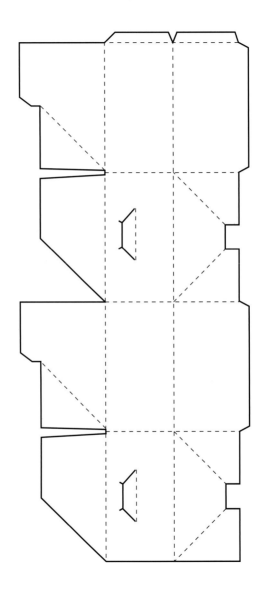

Tuck-in Side Slot

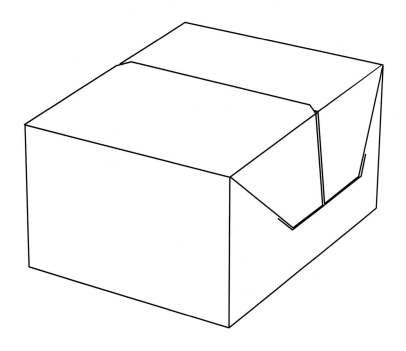

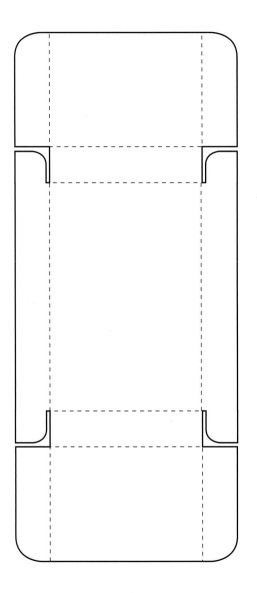

Two-panel Top Box

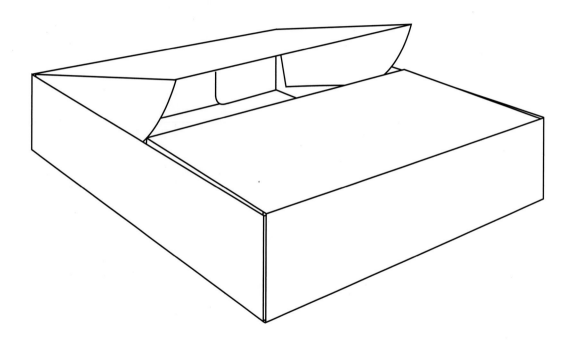

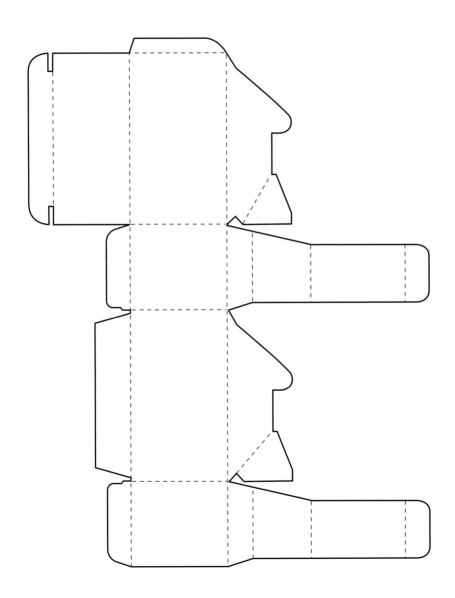

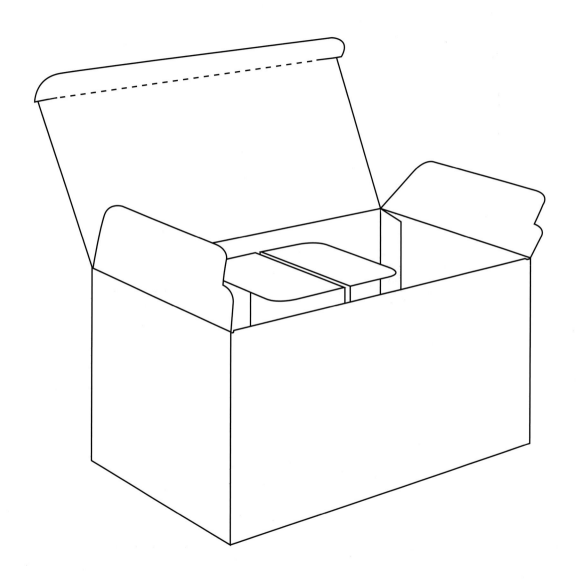

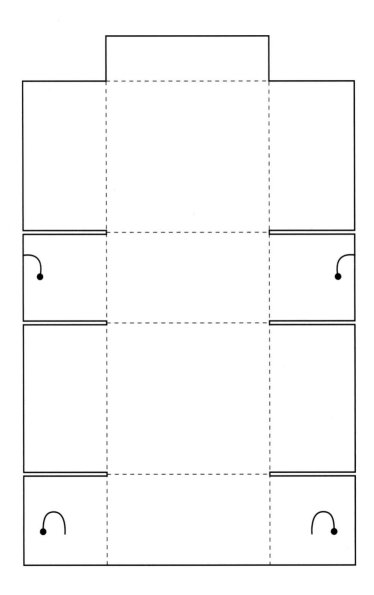

154 Side Locks

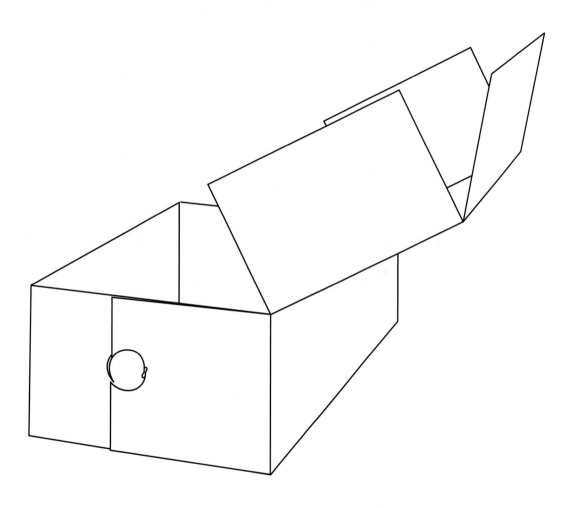

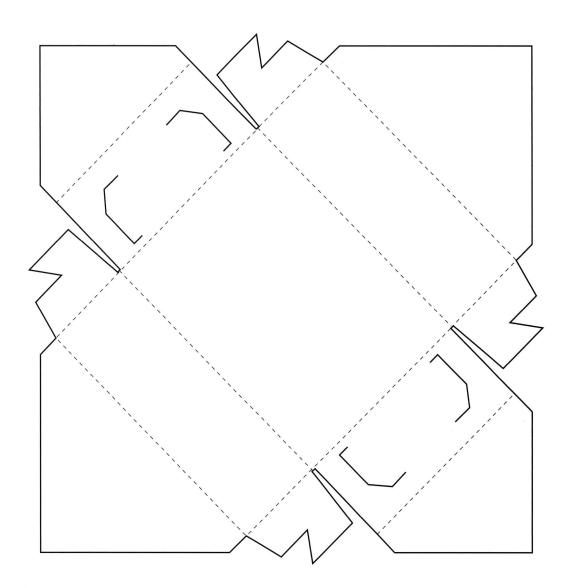

Double Side Locks

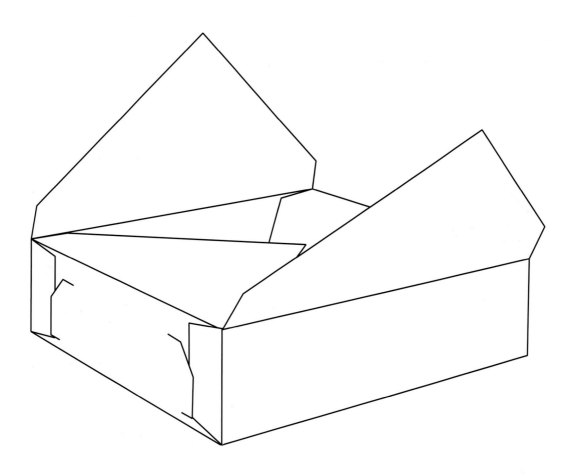

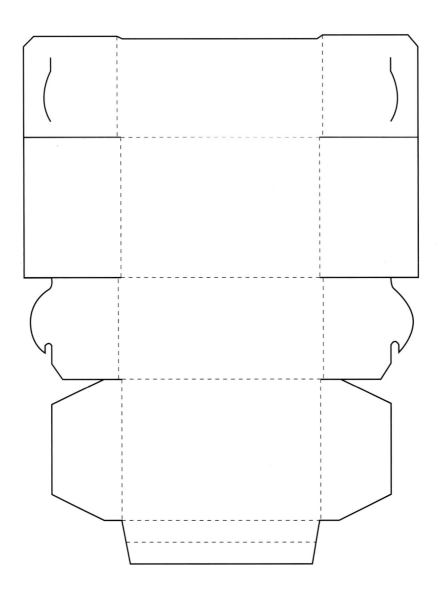

Sealed Cover and Side Locks

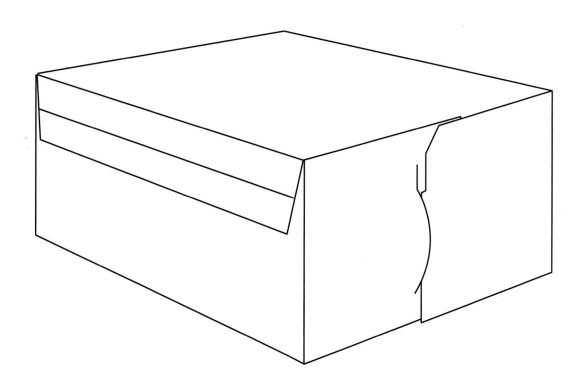

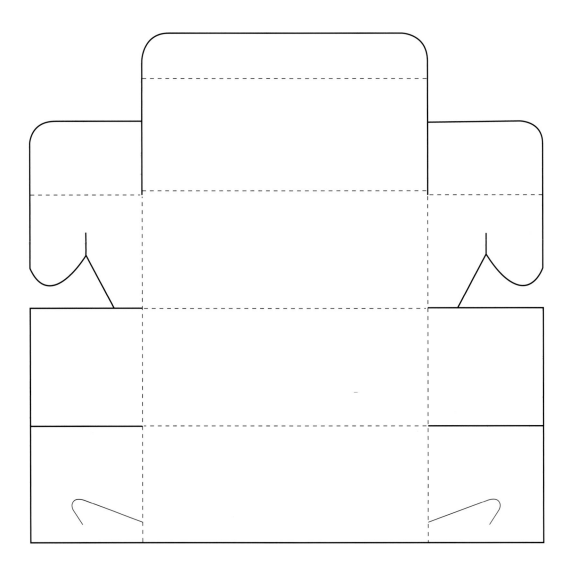

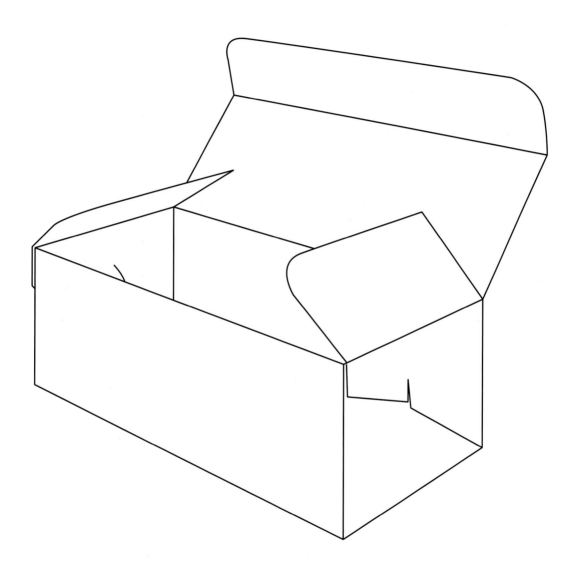

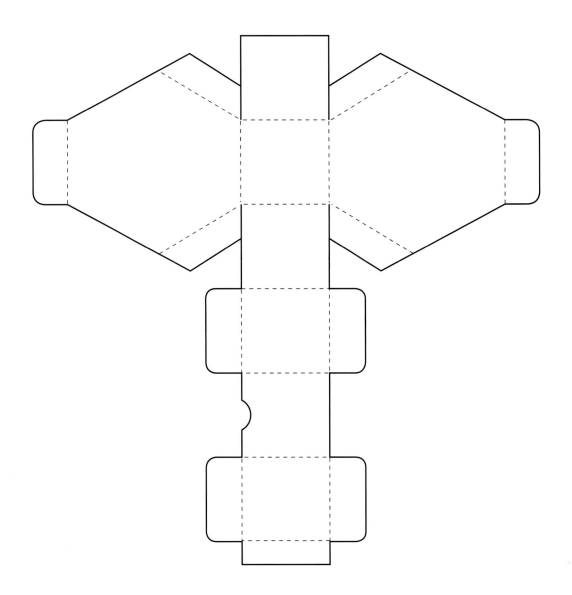

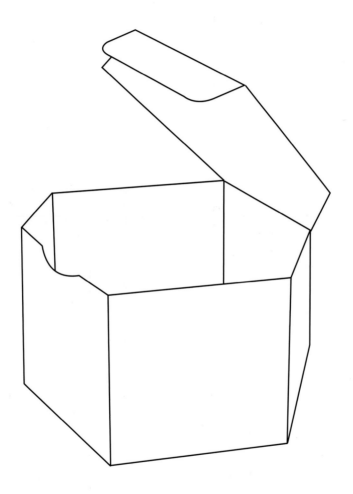

Tray and Lid Boxes

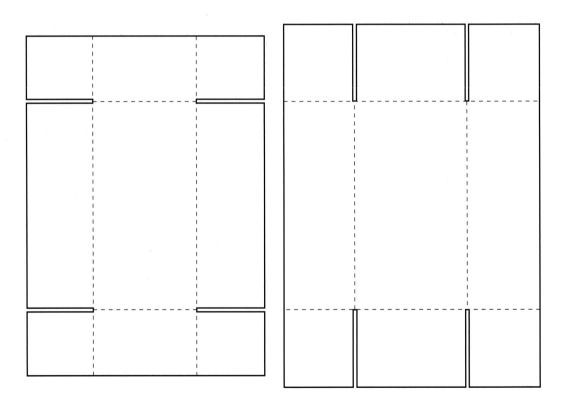

Full-telescopic Tray and Lid

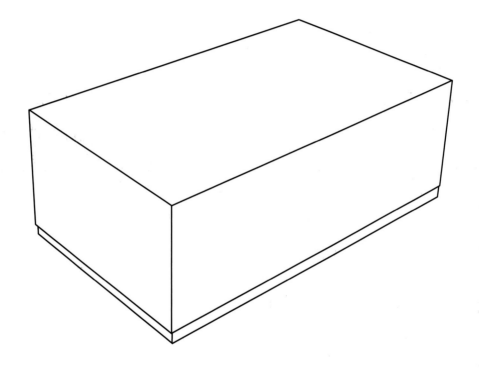

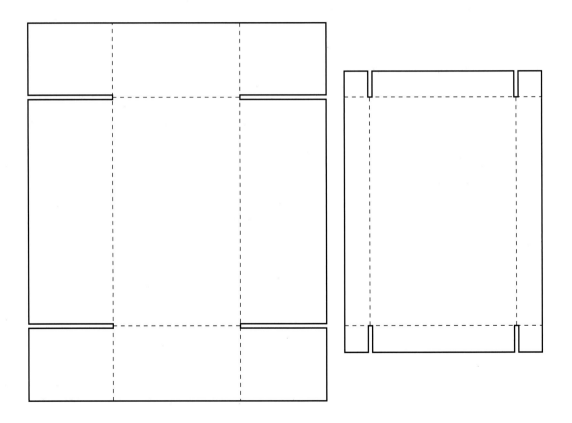

Tray and Lid

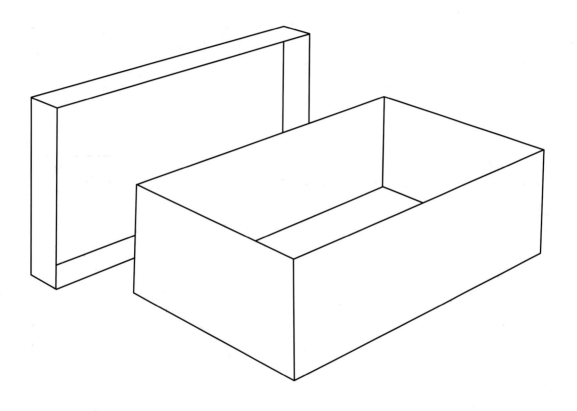

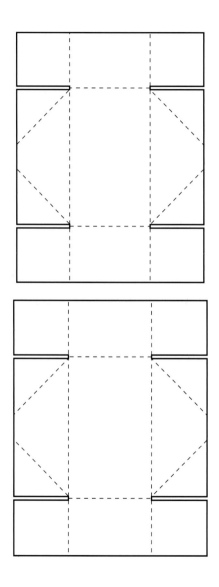

Collapsible Tray and Lid

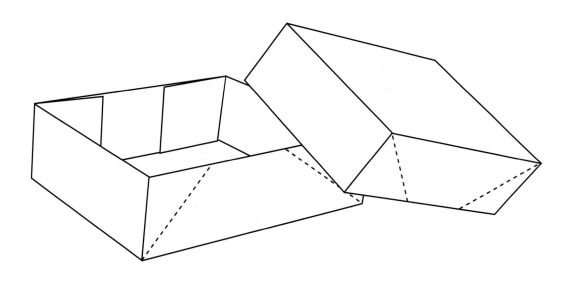

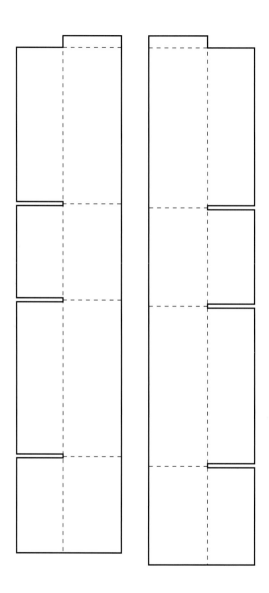

Full-telescopic Tray and Lid

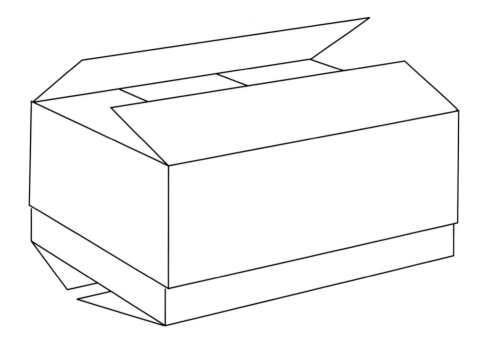

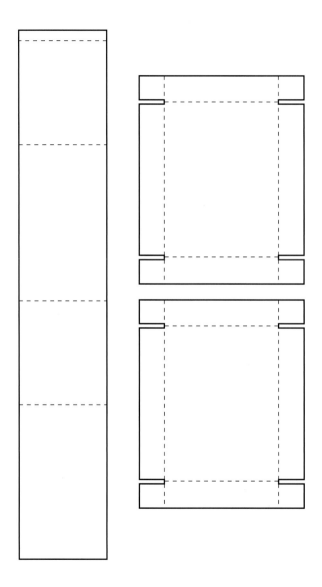

174 Top and Bottom Lid

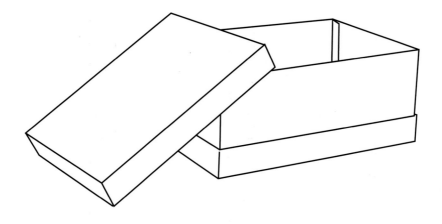

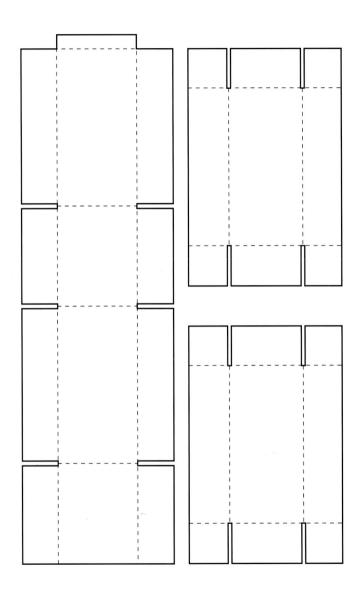

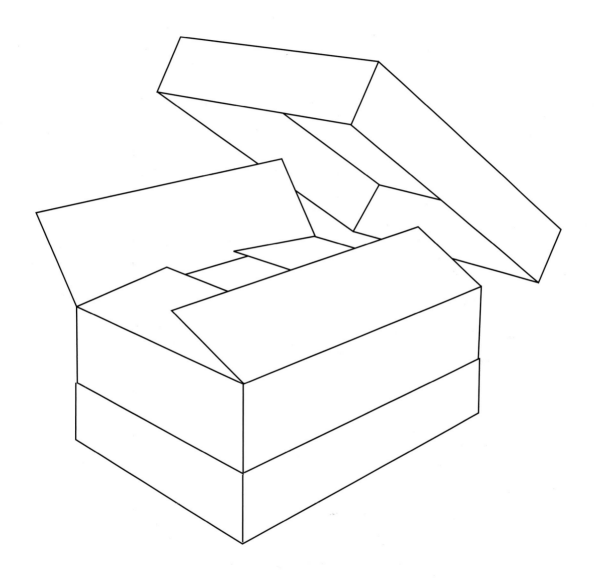

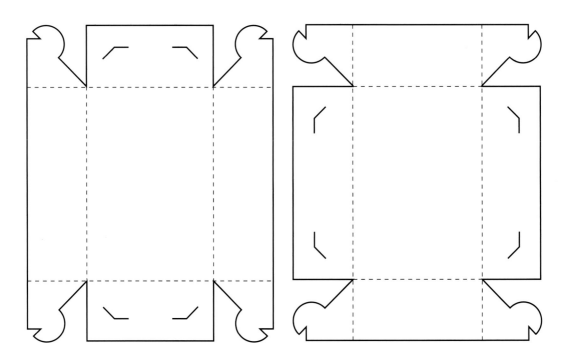

Tray and Cover with Lock Corners

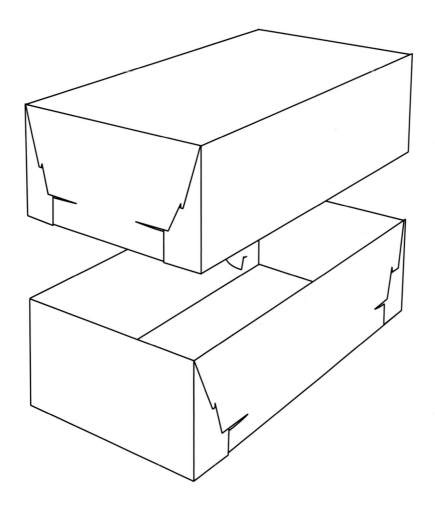

Tray and Cover with Lock Corners 179

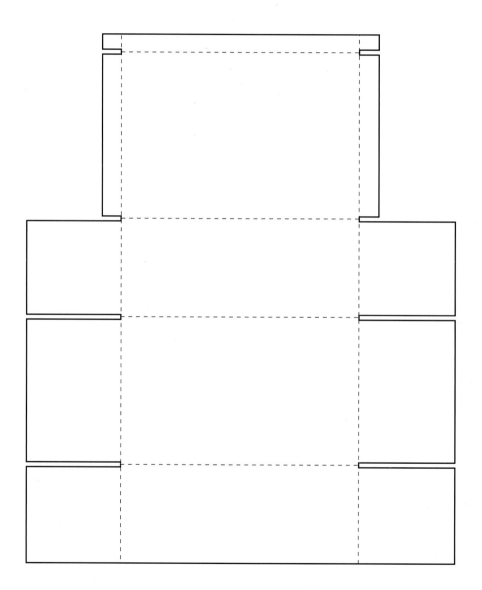

One-piece Tray and Lid

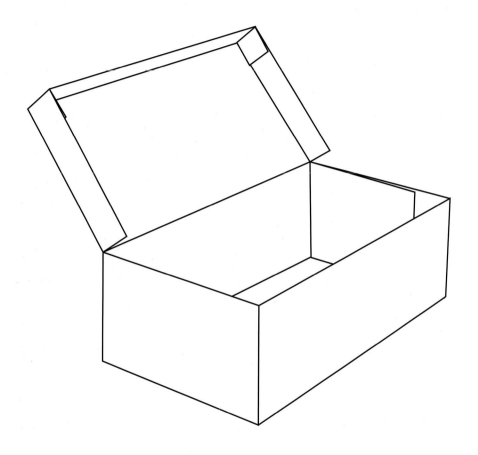

One-piece Tray and Lid 181

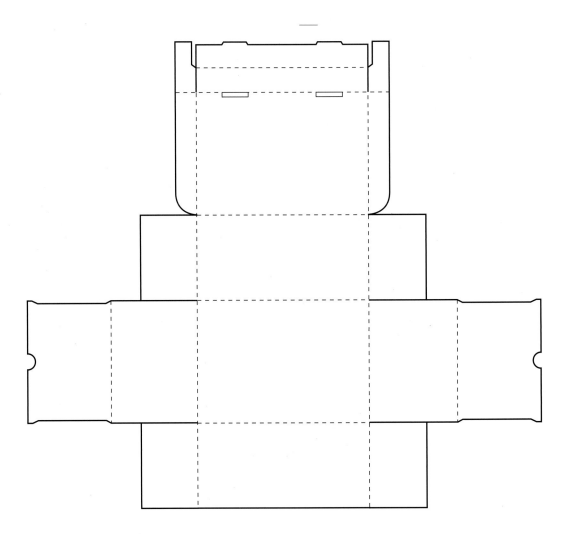

One-piece Tray and Lid with Double Side Walls

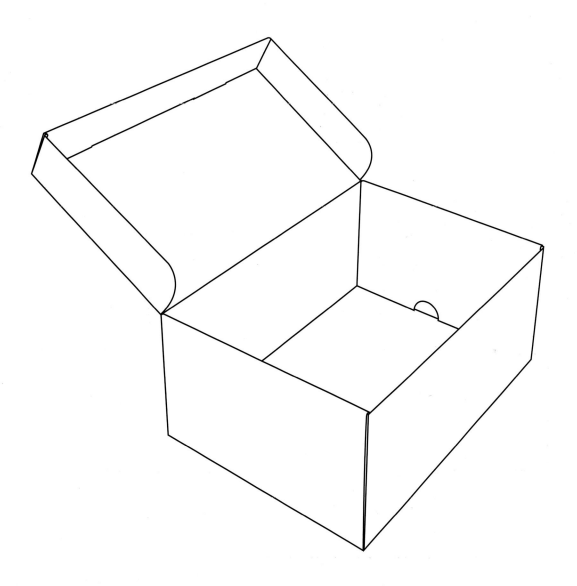

One-piece Tray and Lid with Double Side Walls 183

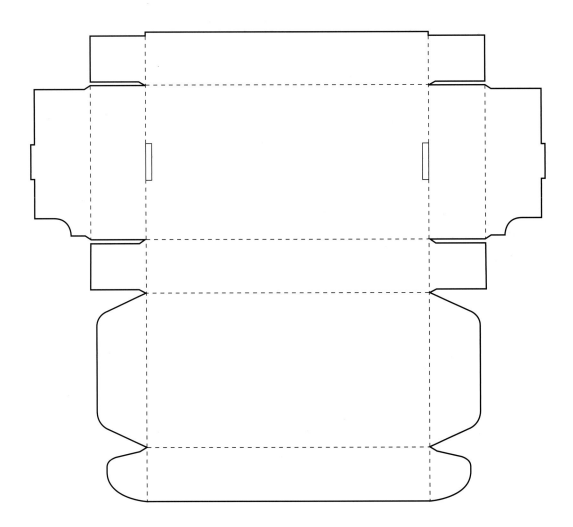

One-piece Tray and Lid with Dust Flaps

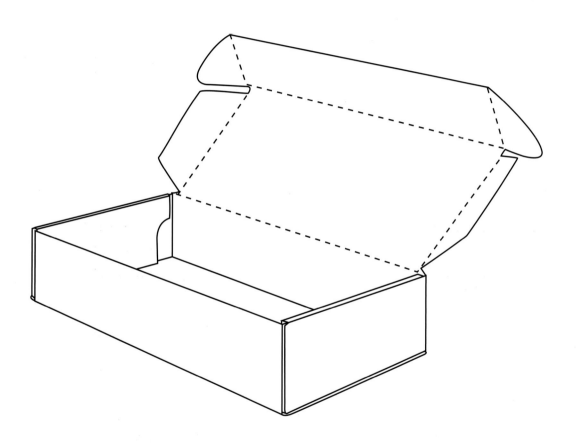

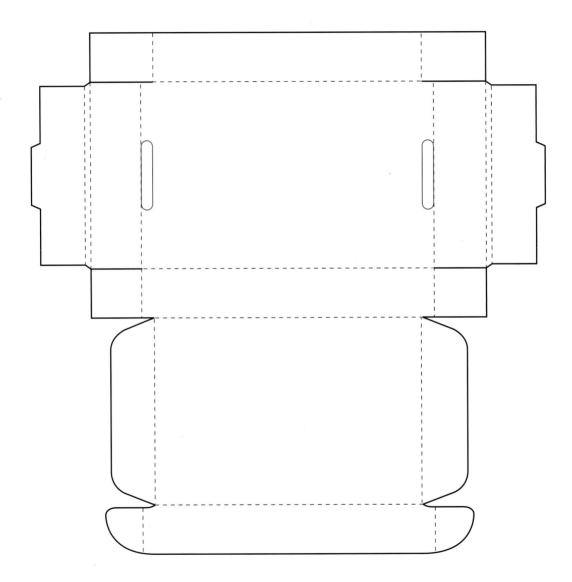

One-piece Tray and Lid with Dust Flaps

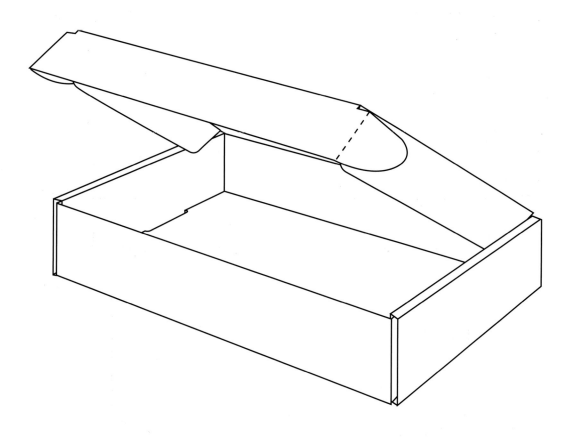

One-piece Tray and Lid with Dust Flaps 187

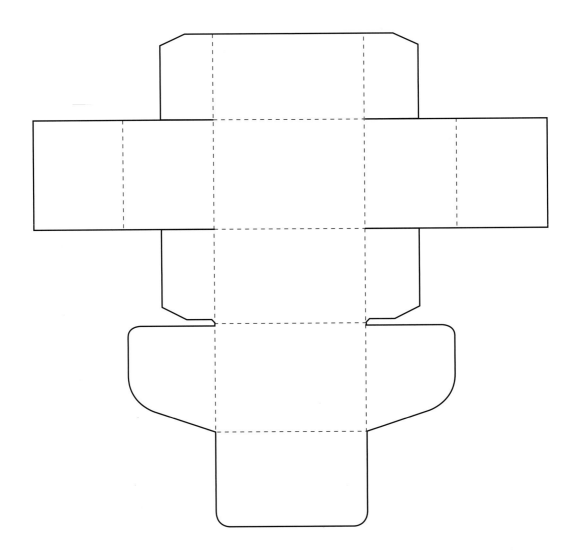

One-piece Tray and Lid with Dust Flaps

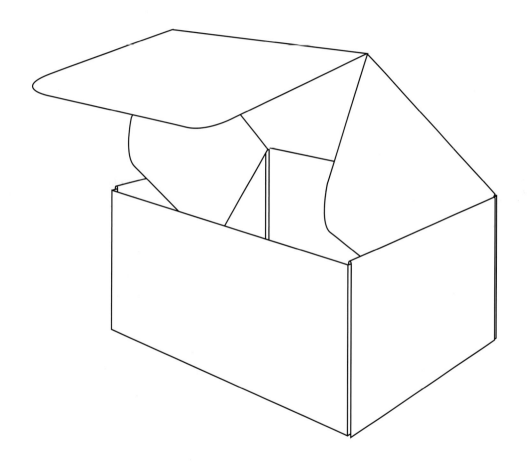

One-piece Tray and Lid with Dust Flaps 189

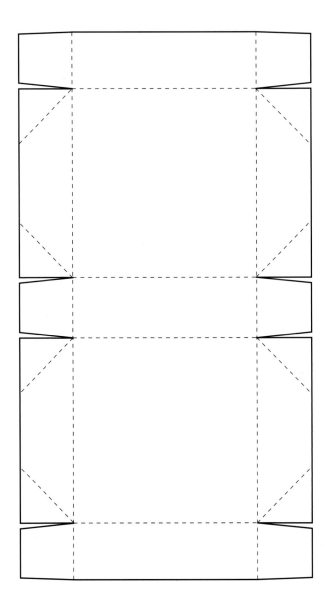

190 Collapsible Cake Box

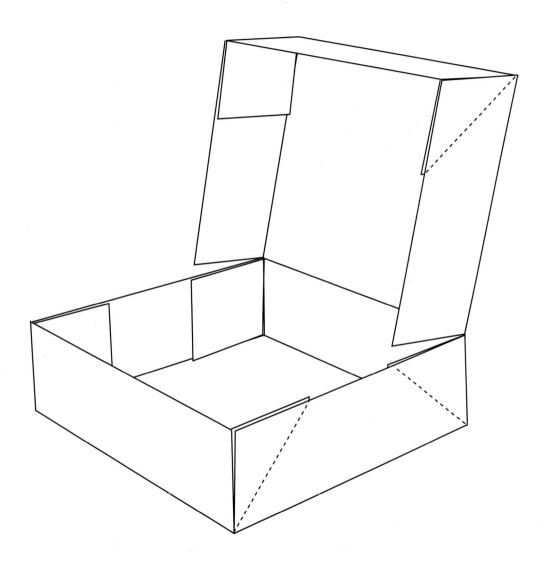

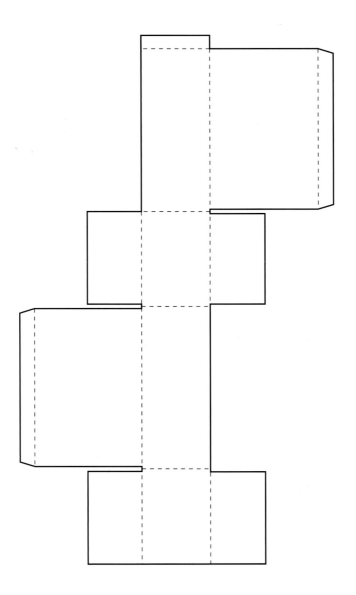

Reverse Tuck

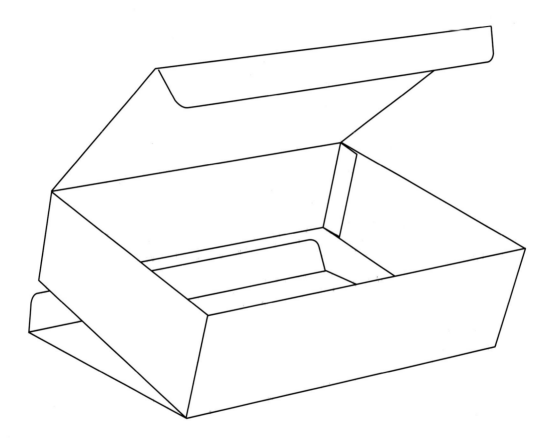

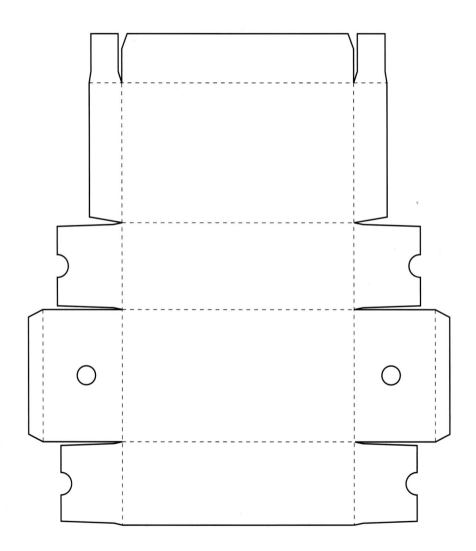

194 One-piece Tray and Lid with Viewing Hole

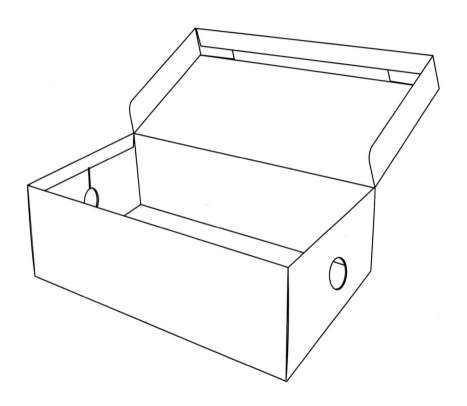

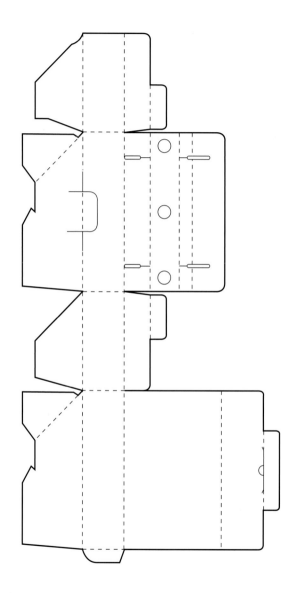

Double Locking Tab and Internal Divider

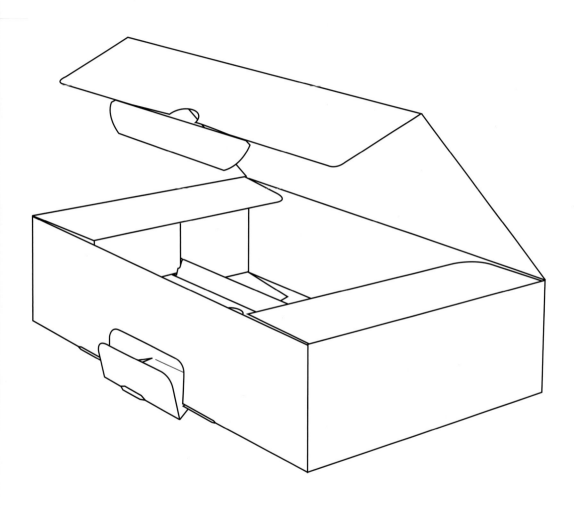

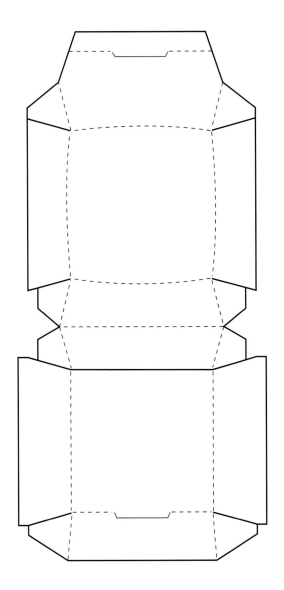

Tray and Lid with Inclining Side Panels

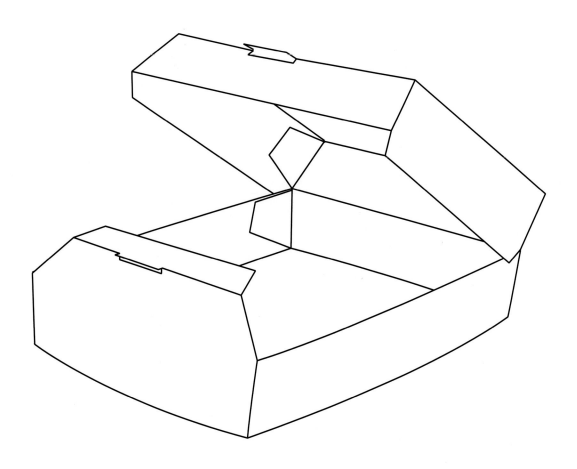

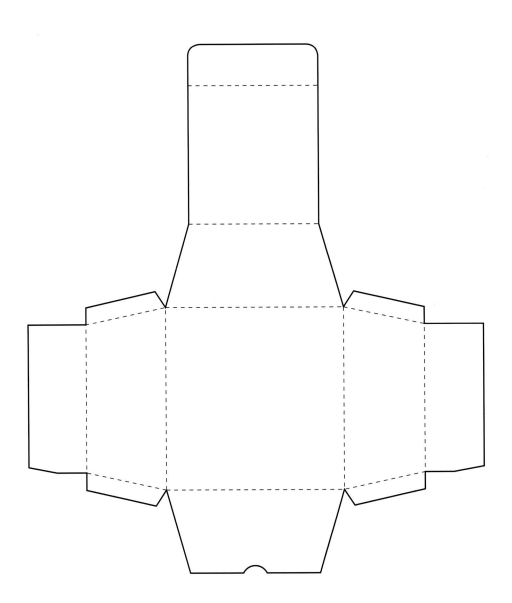

Tray and Lid with Inclining Side Panels

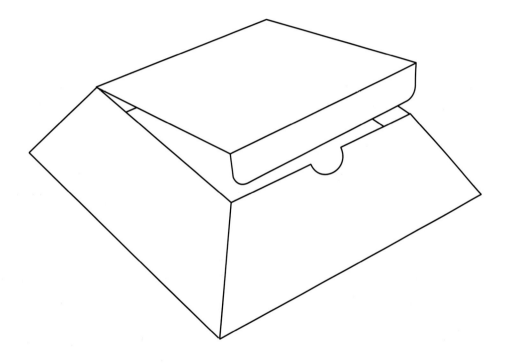

Heavy Duty Boxes

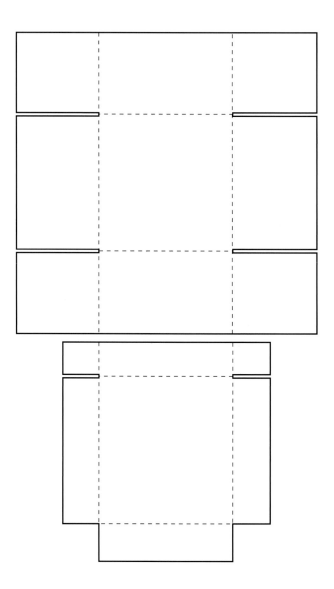

Tray with Stapled Lid

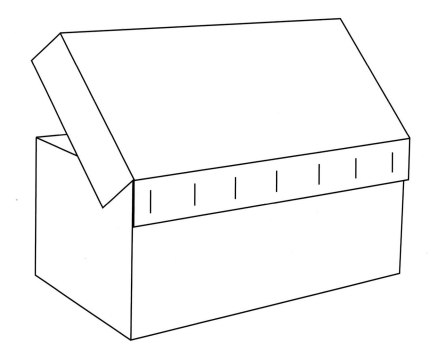

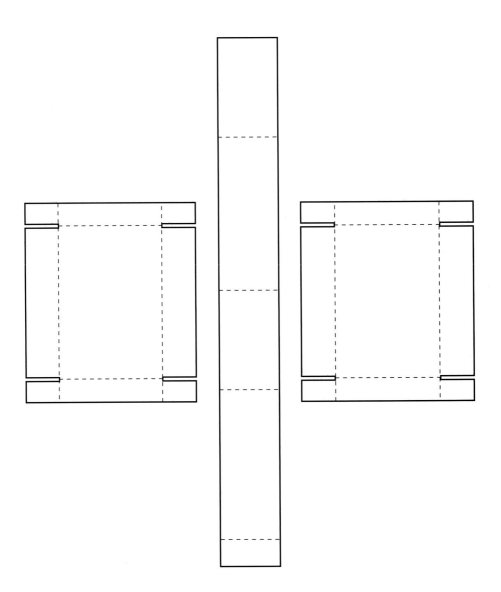

Stapled Bottom

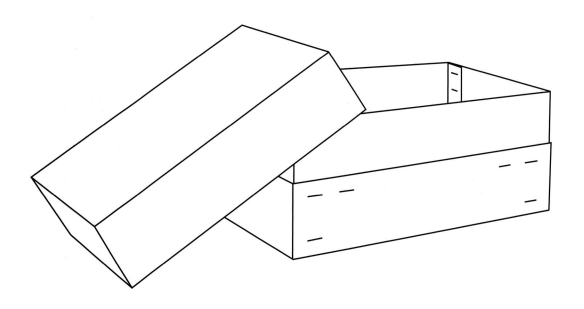

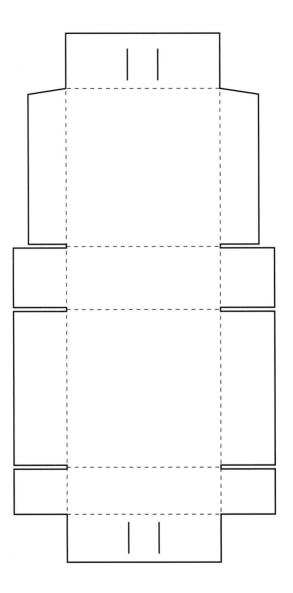

Stapled Side Panels

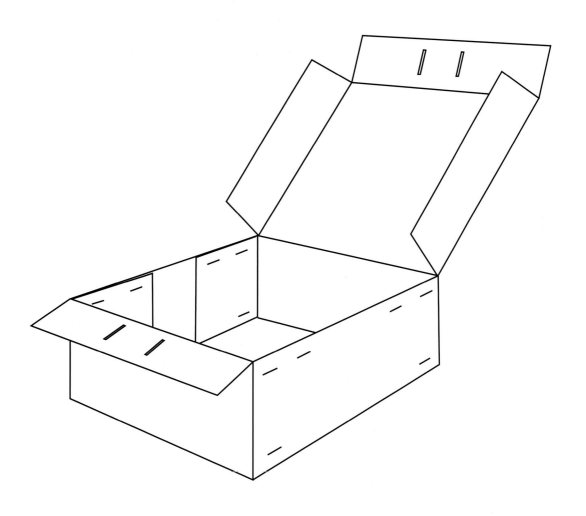

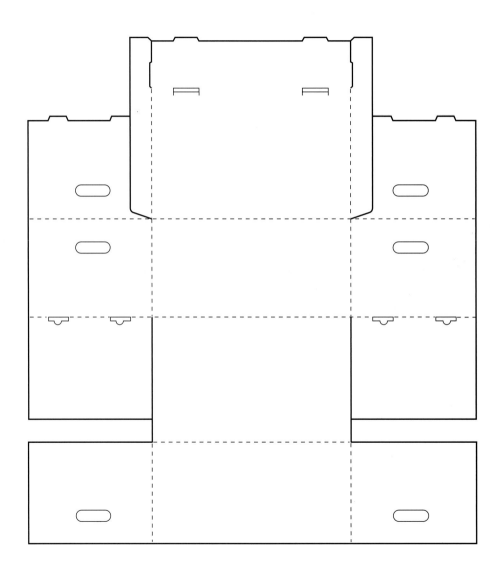

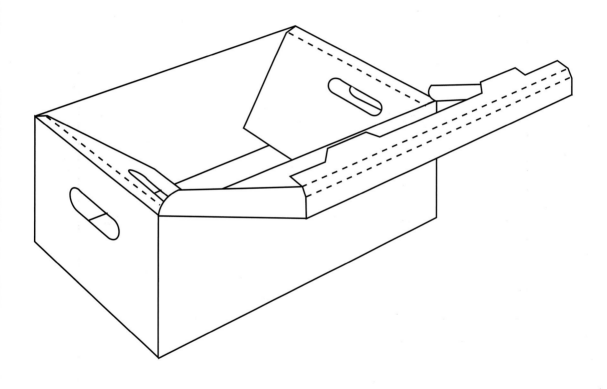

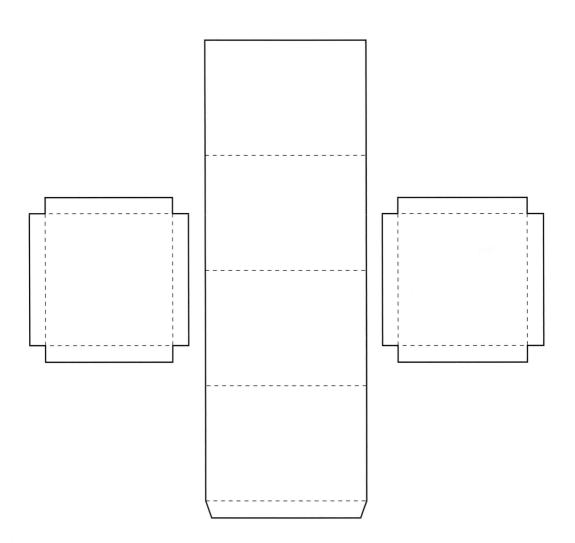

Reinforced Top and Bottom

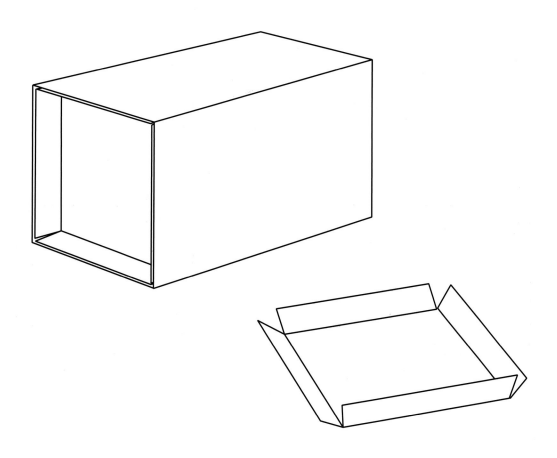

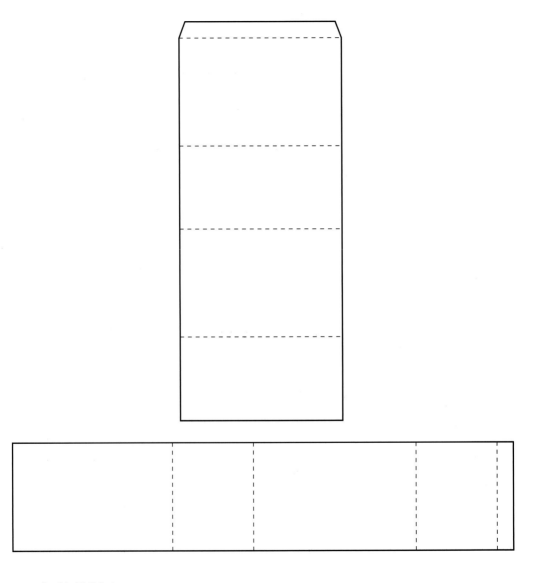

214 Double Wall Carton

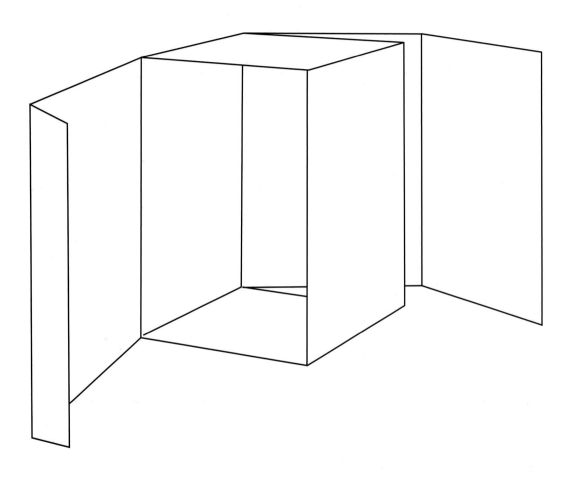

Double/Triple Wall Carton

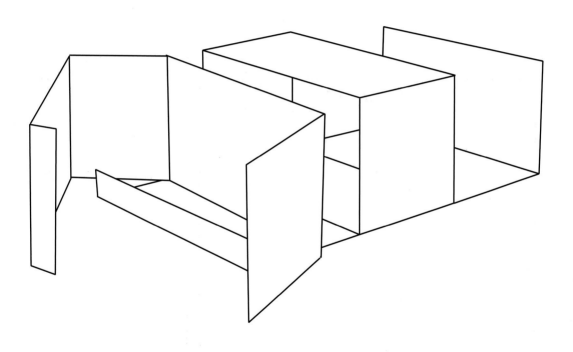

Double/Triple Wall Carton 217

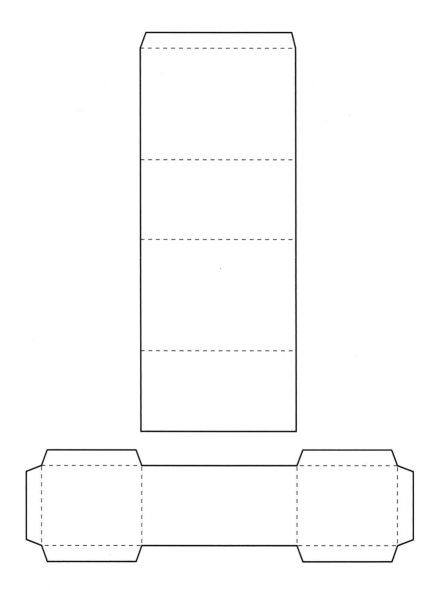

Double Wall Carton with Dust Flaps

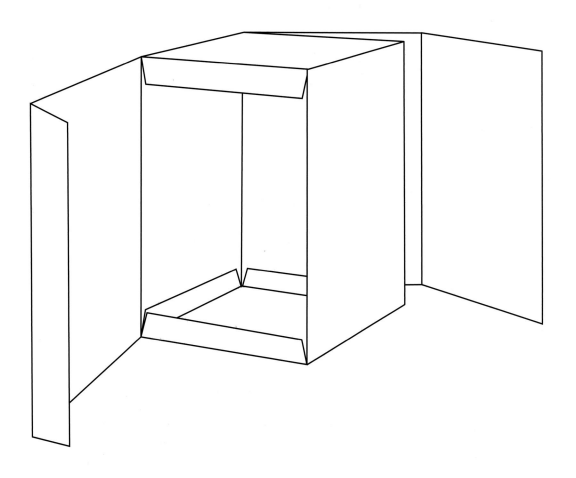

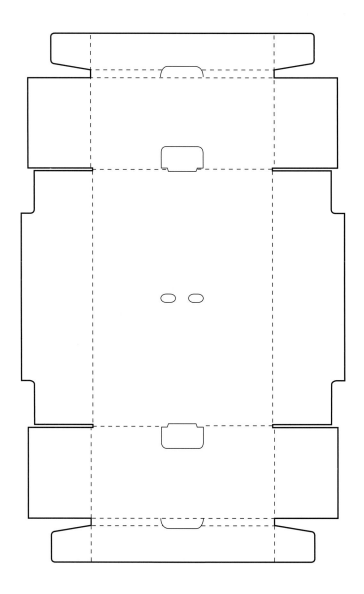

220 Stackable Fruit Box

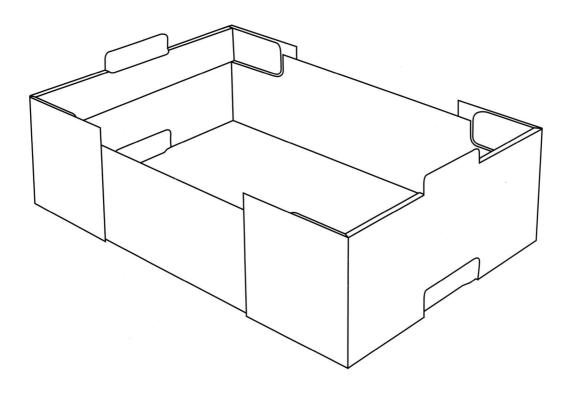

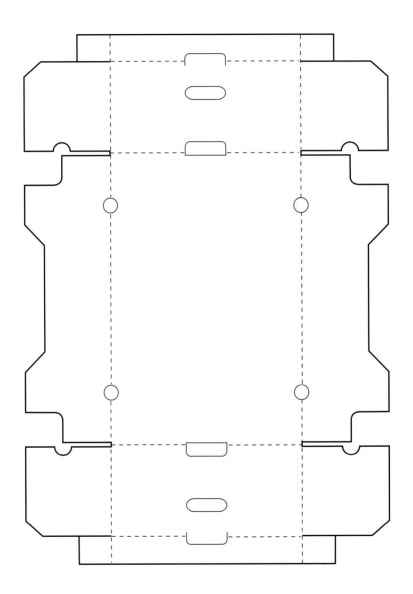

Stackable Fruit Box

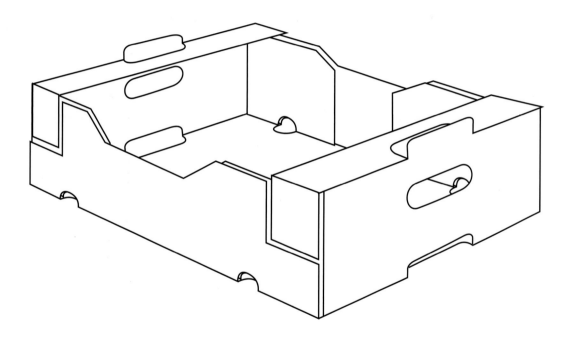

Trays and Cones

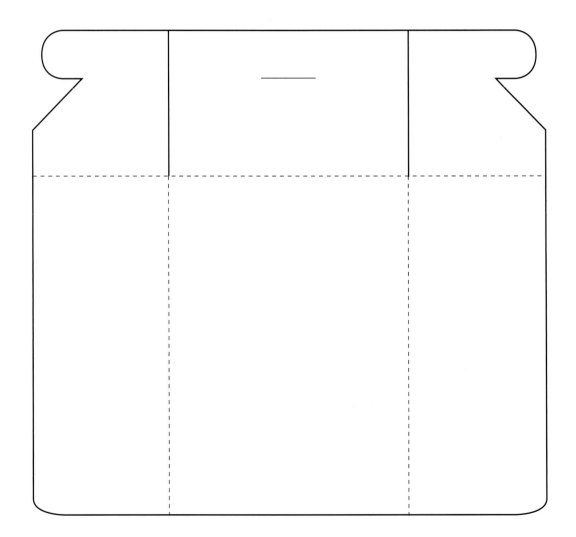

Open-ended Tray

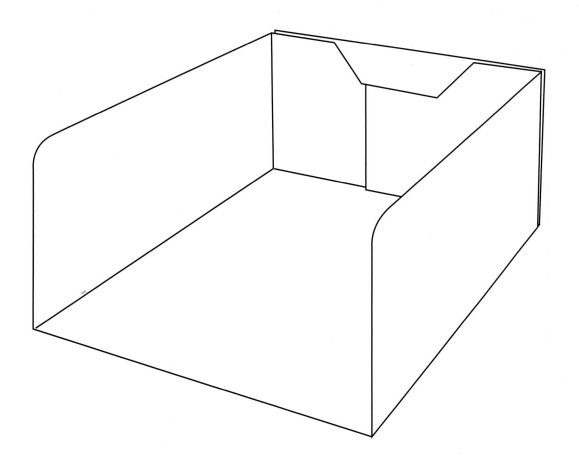

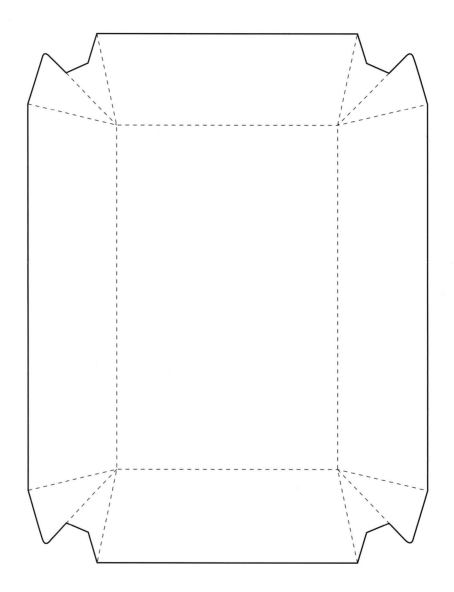

228 Tapered Tray

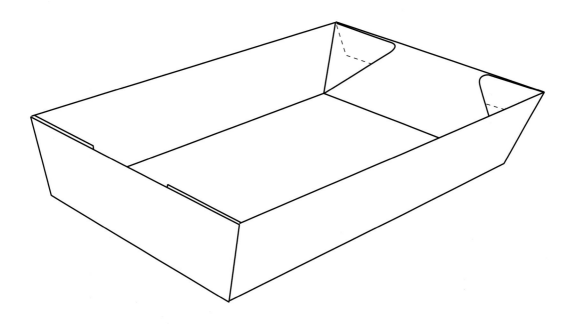

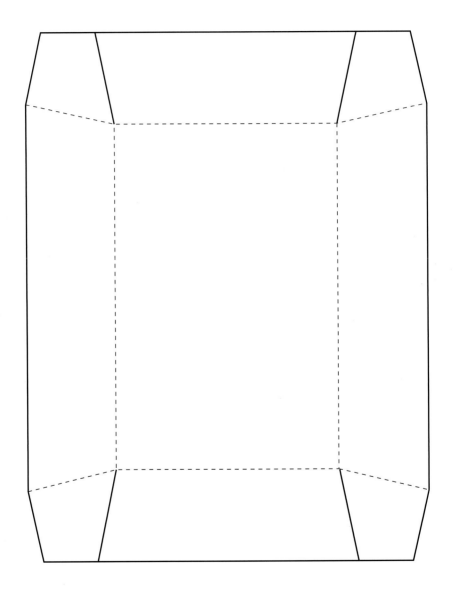

Tapered Tray

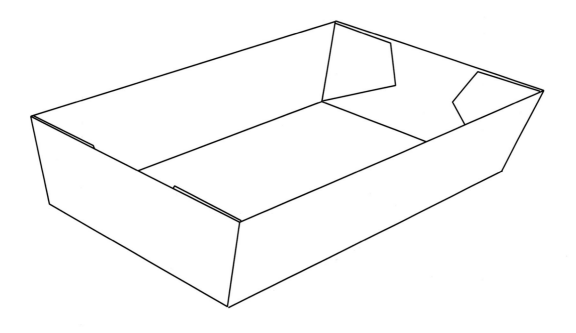

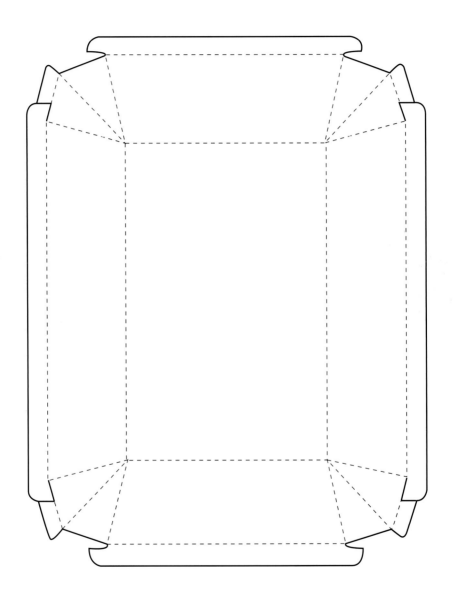

Tapered Tray with Ledge

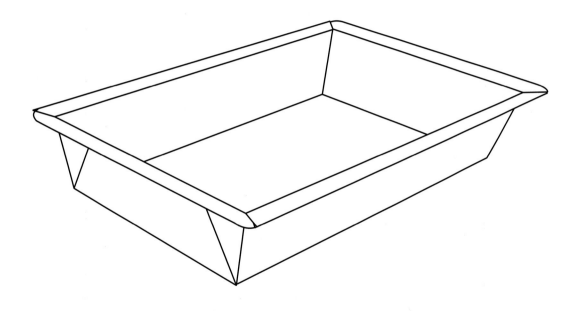

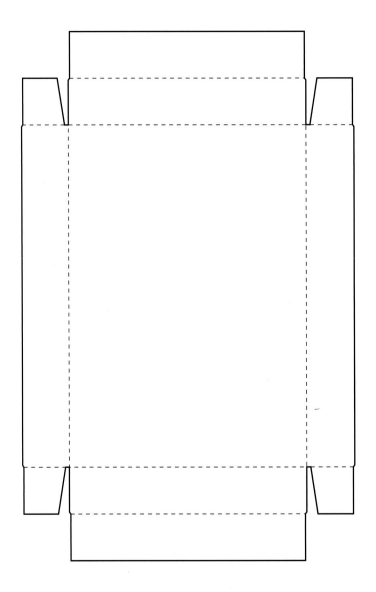

234 Tray

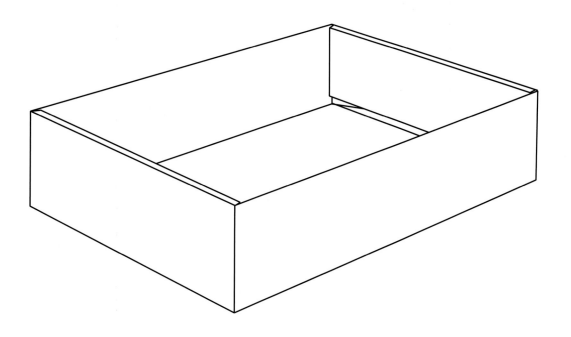

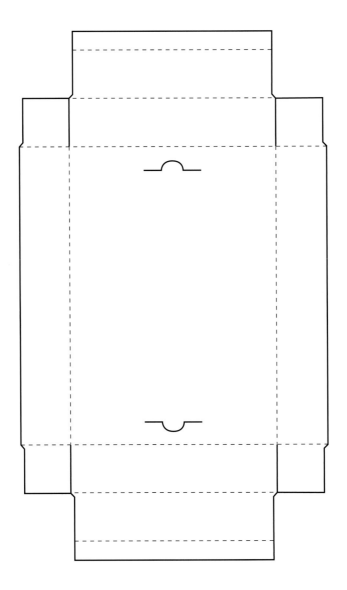

Tray with Tucked-in Side Panels

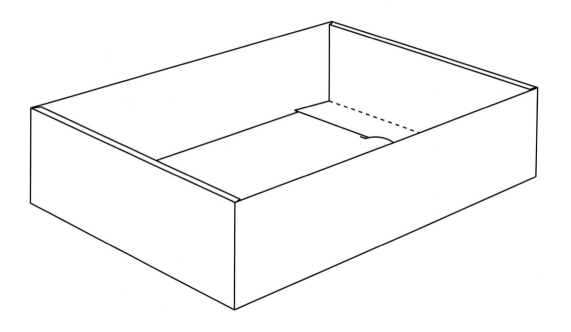

Tray with Tucked-in Side Panels 237

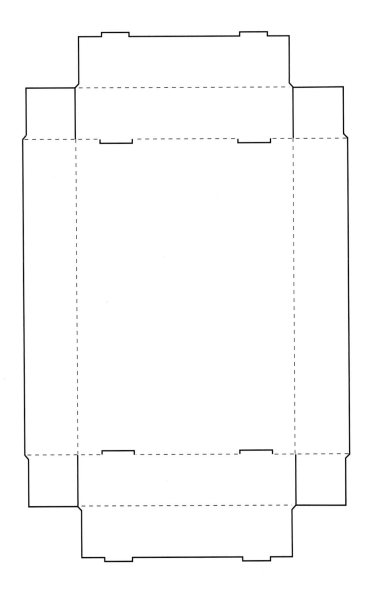

Tray with Tucked-in Side Panels

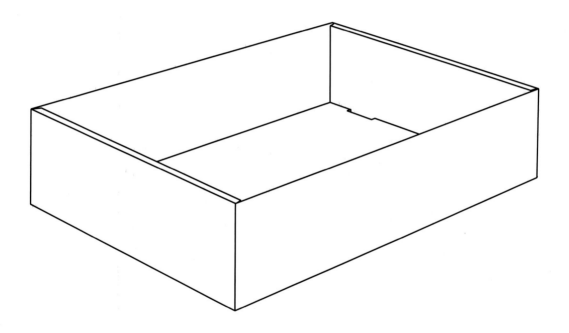

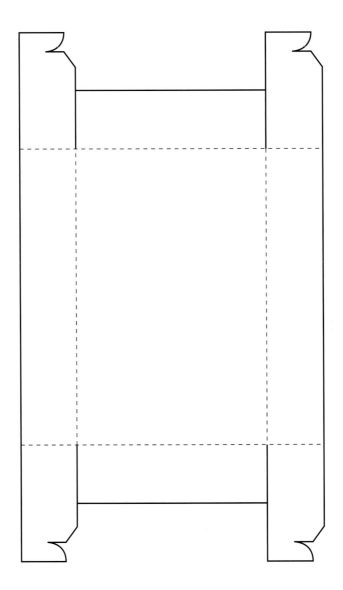

Tray with Side Panel Locks

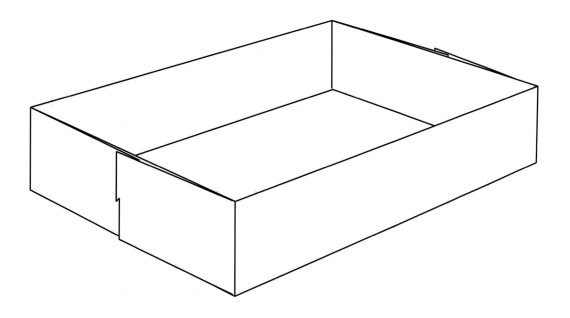

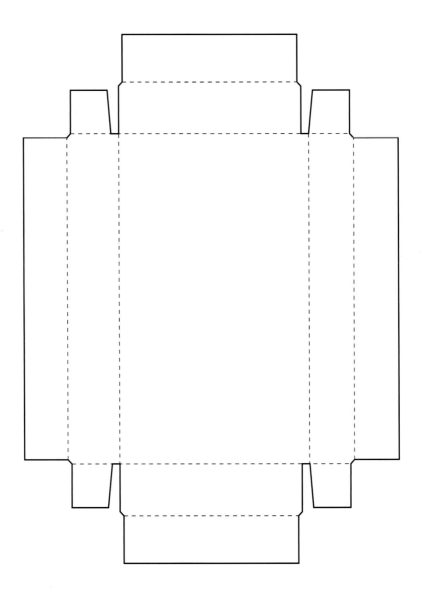

242 Double Wall Tray

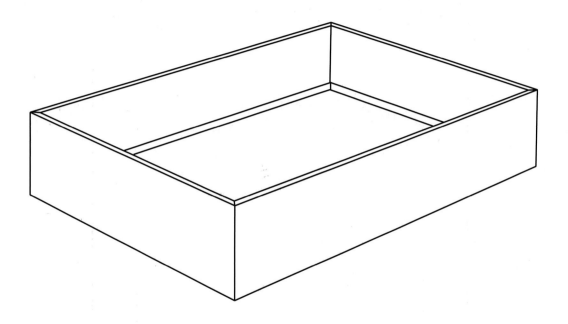

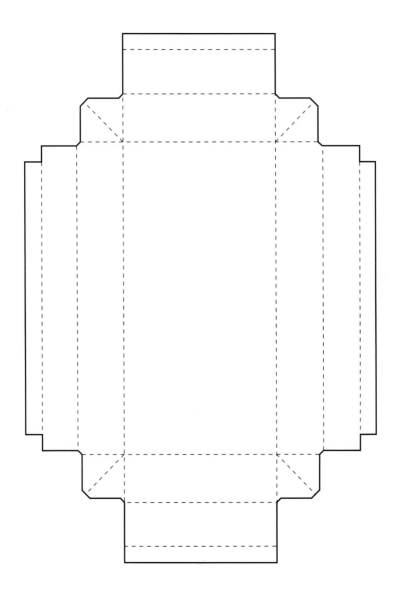

244 Double Wall Tray

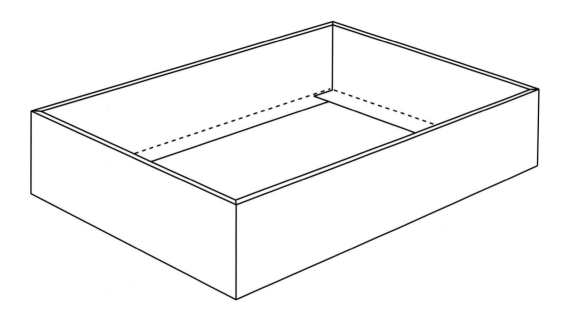

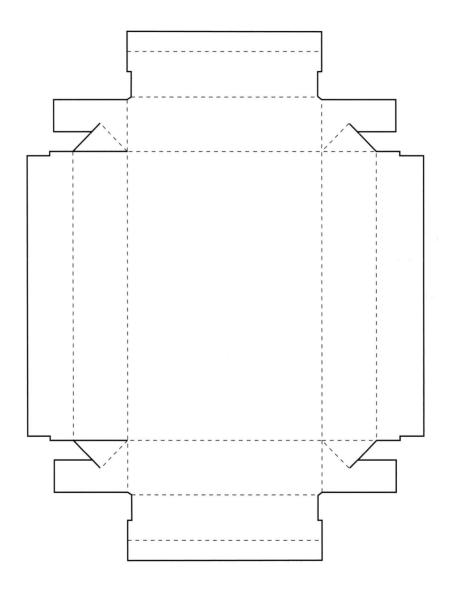

Double Wall Tray

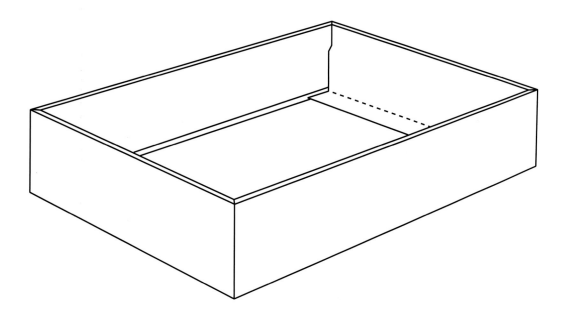

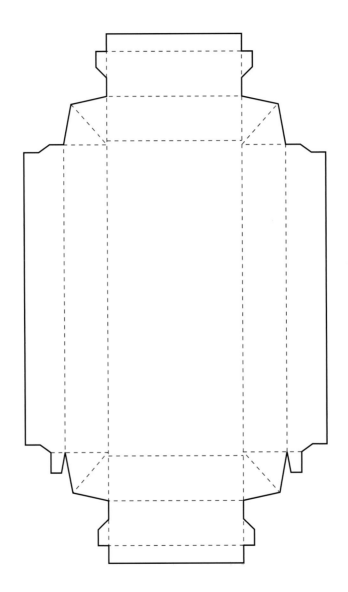

Double Wall Tray

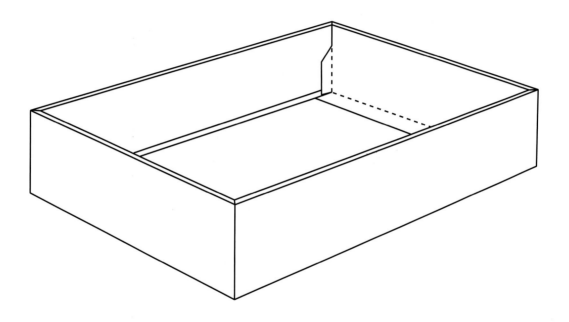

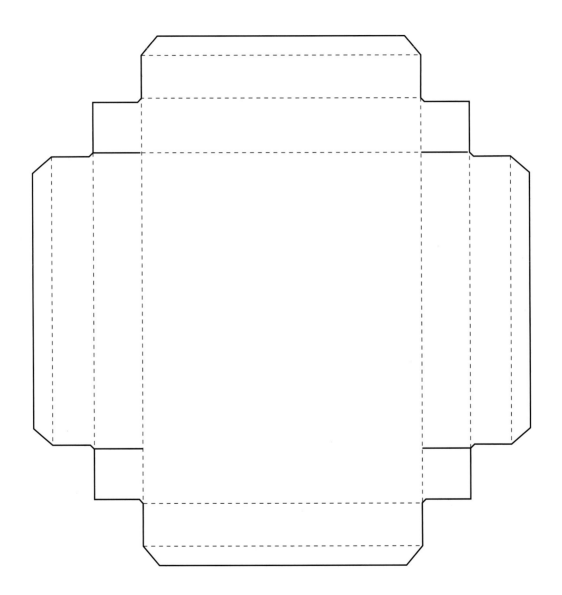

Double Wall Tray

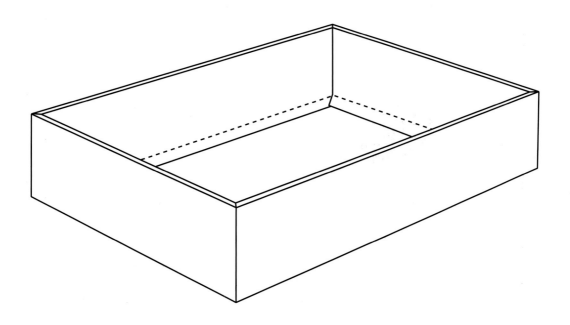

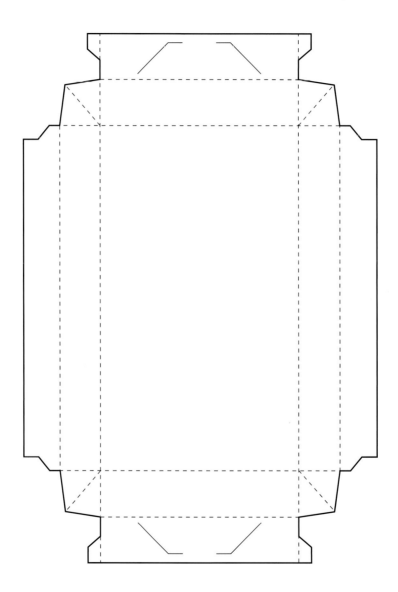

Double Wall Tray with Side Panel Locks

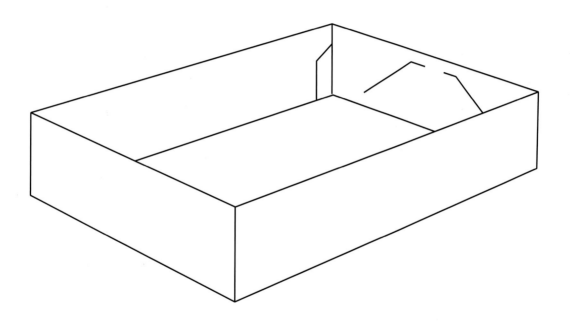

Double Wall Tray with Side Panel Locks 253

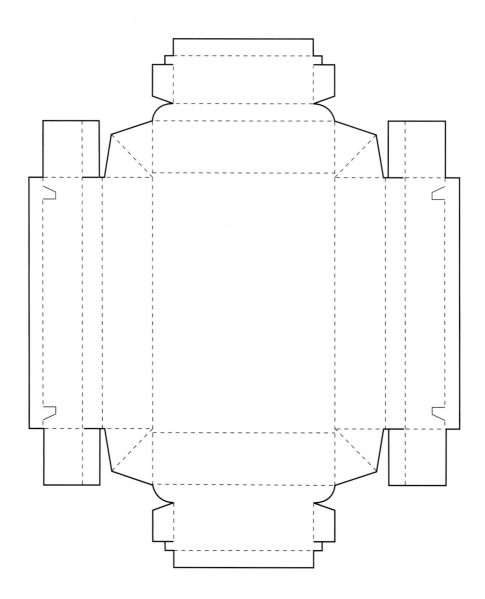

Hollow Wall Tray

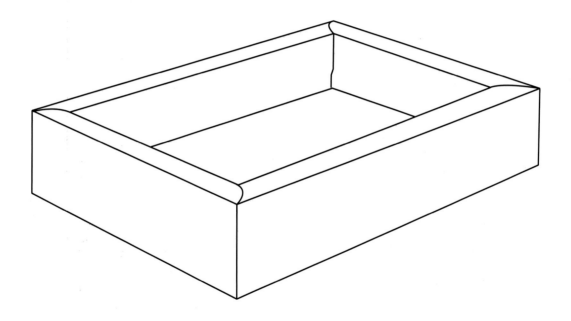

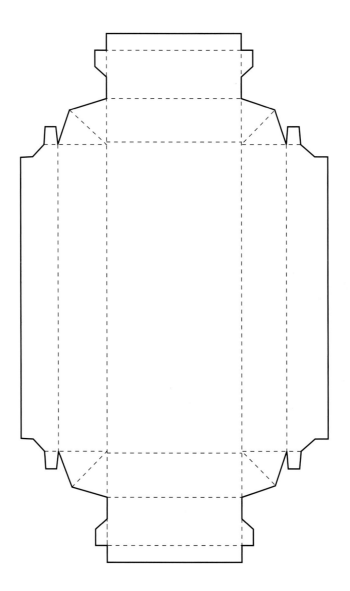

Collapsible Double Wall Tray

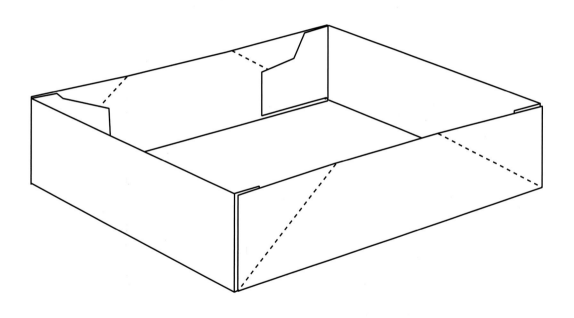

Collapsible Double Wall Tray 257

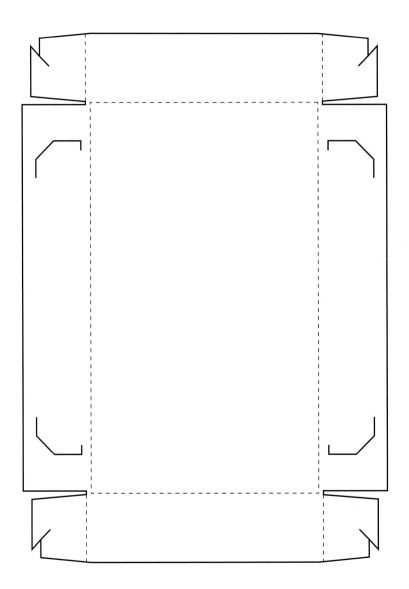

Tray with Side Panel Locks

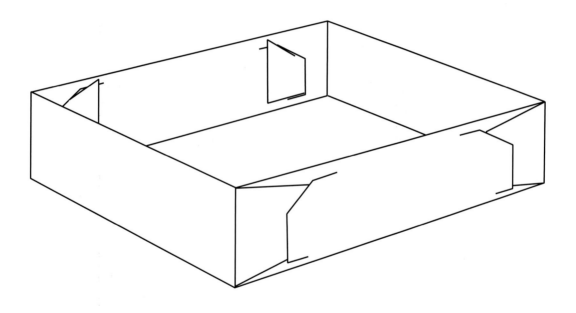

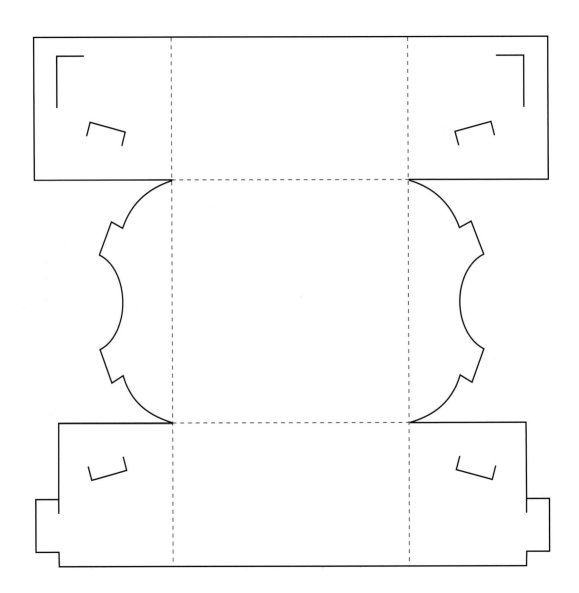

Tray with Double Side Panel Locks

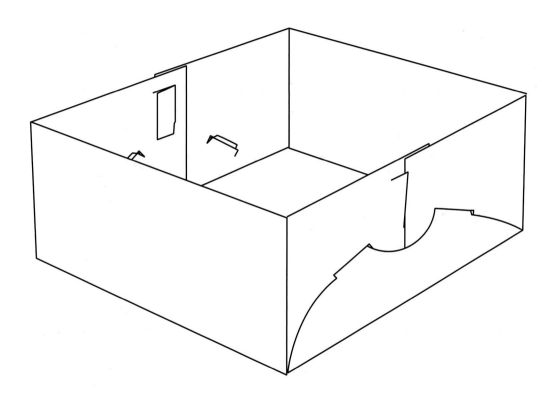

Tray with Double Side Panel Locks 261

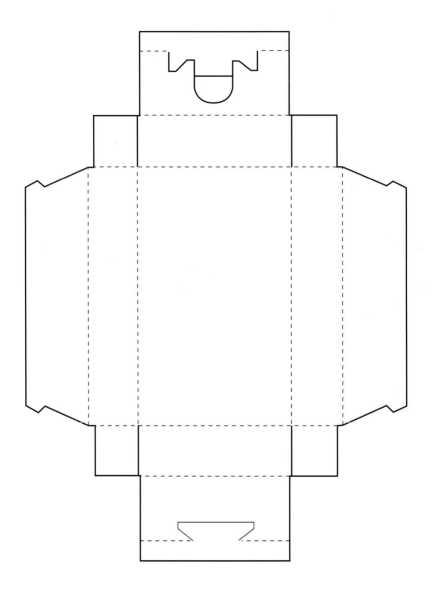

Tray with Bottle Support

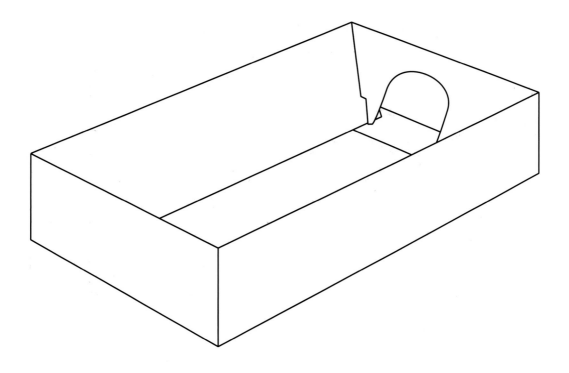

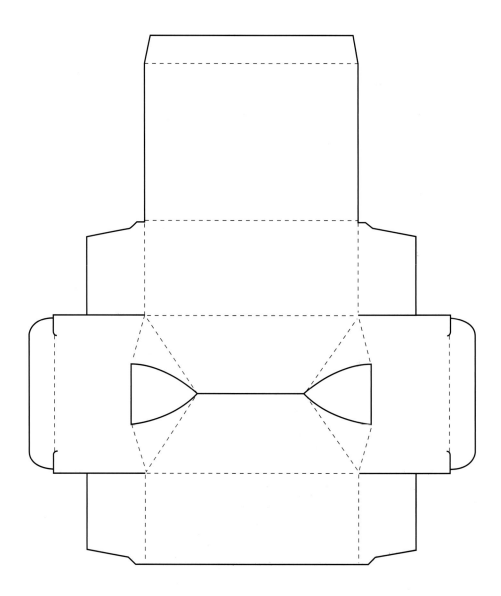

Half-open Tray

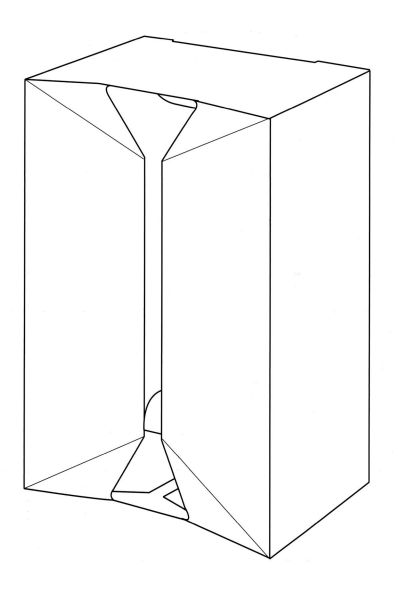

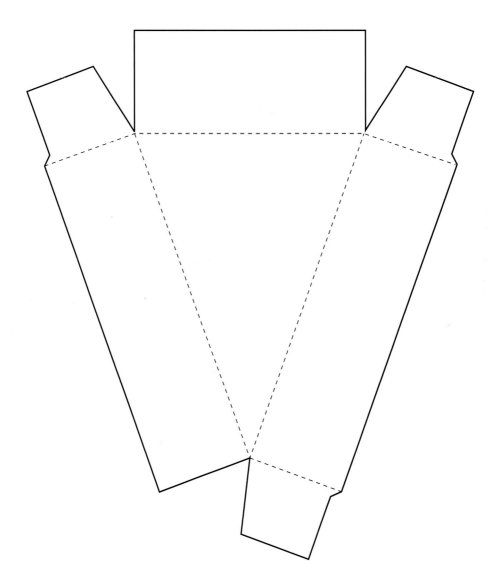

Triangular Tray

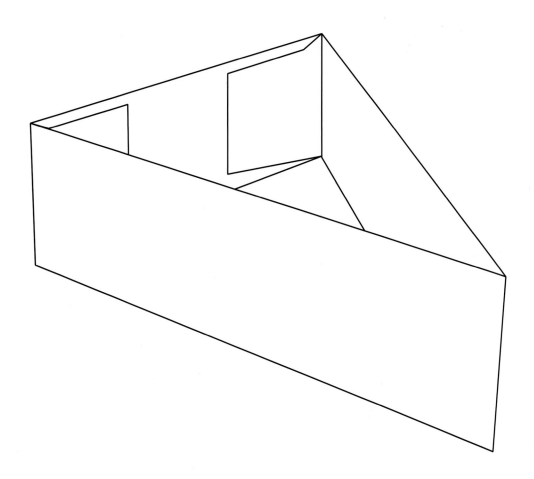

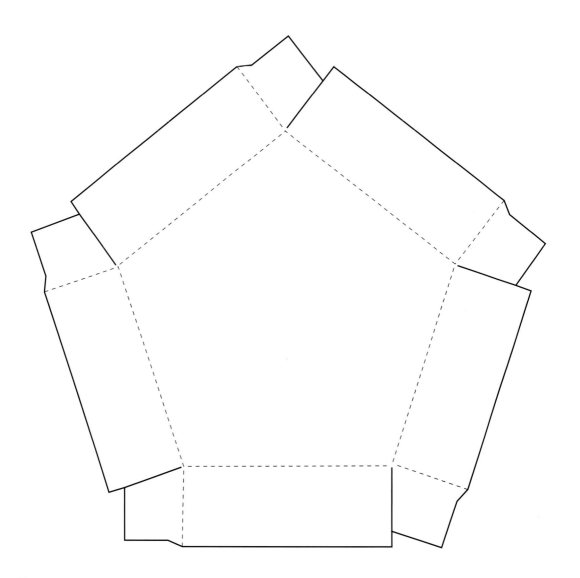

Pentagonal Tray

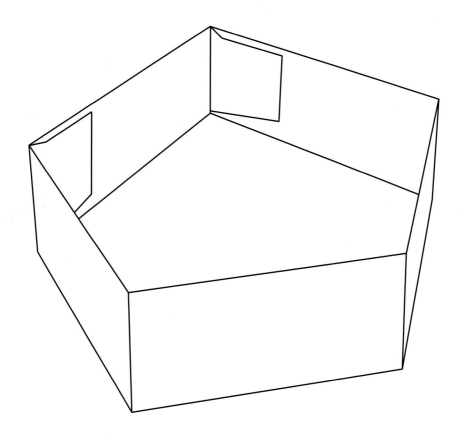

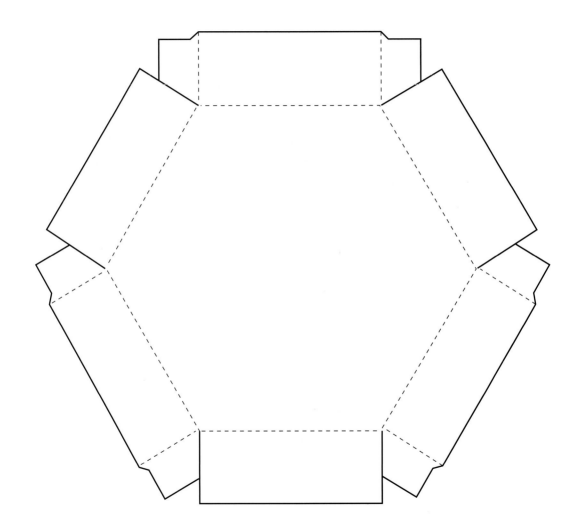

270 Hexagonal Tray

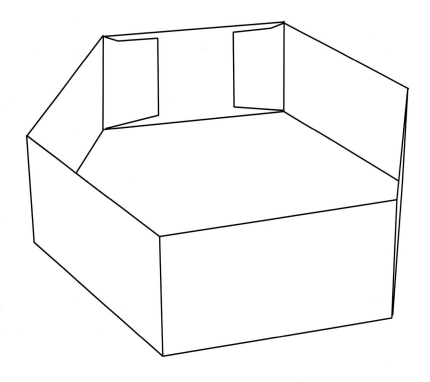

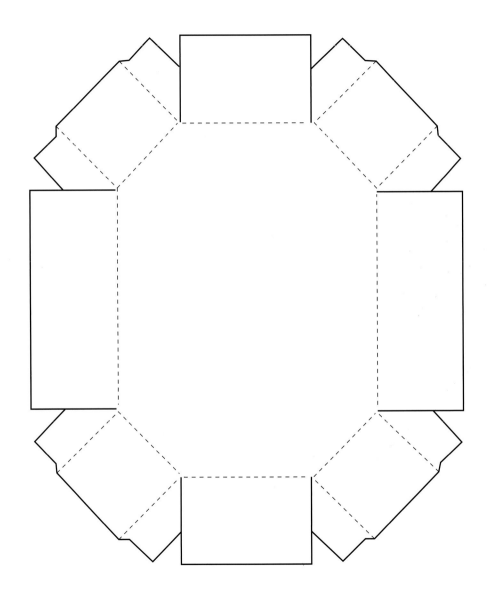

Soft Corner Tray

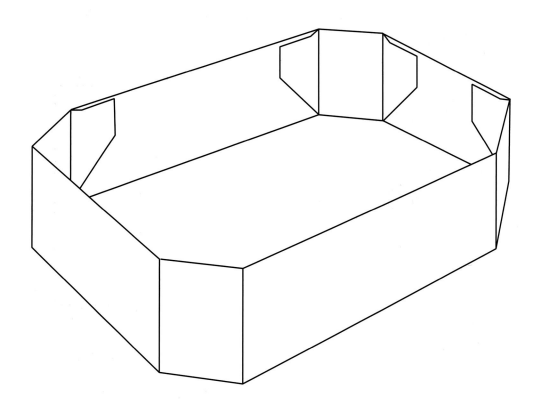

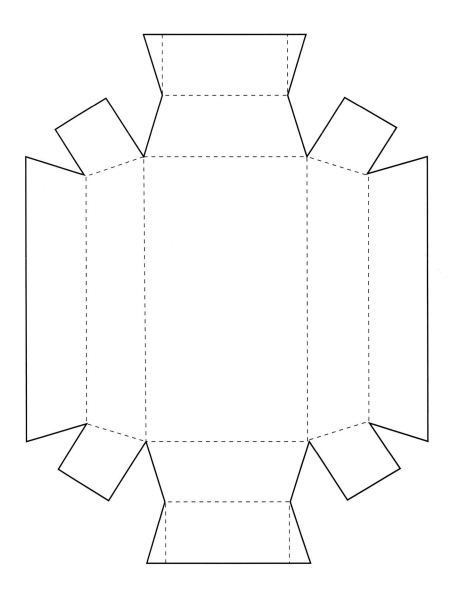

Tapered Tray

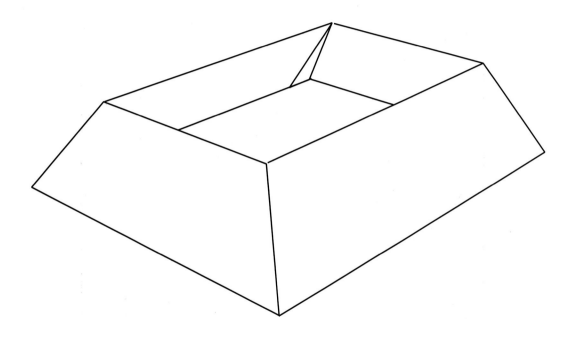

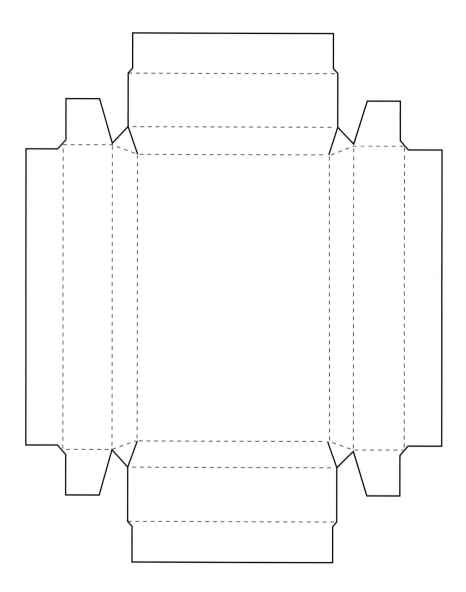

Angled Side Panels

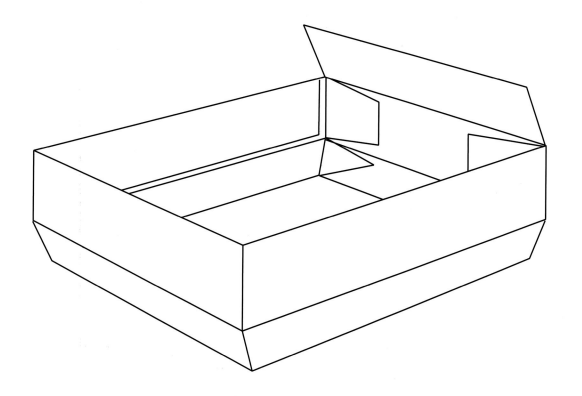

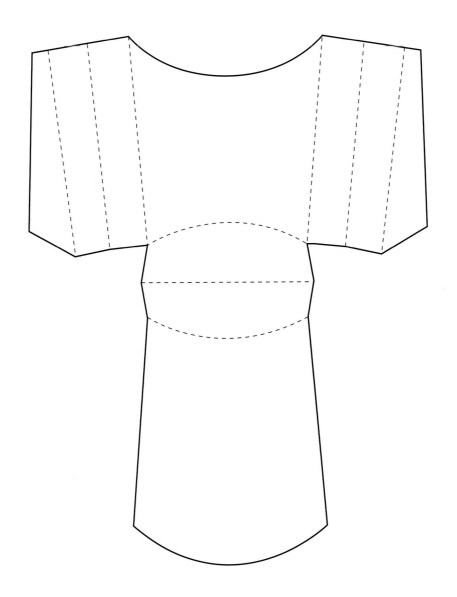

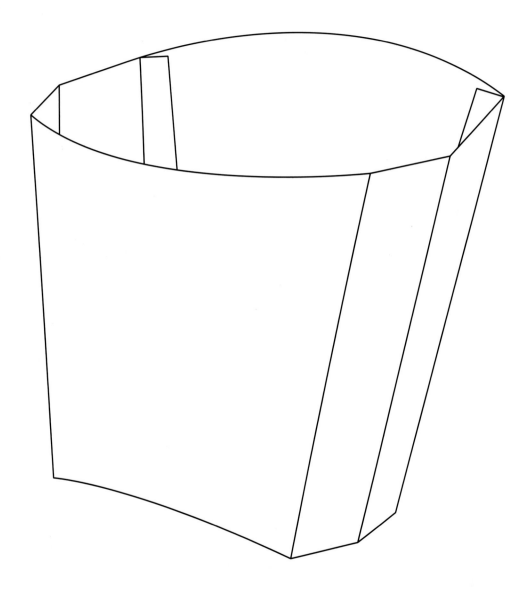

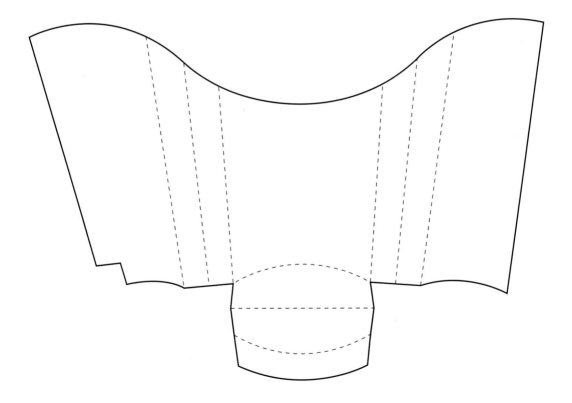

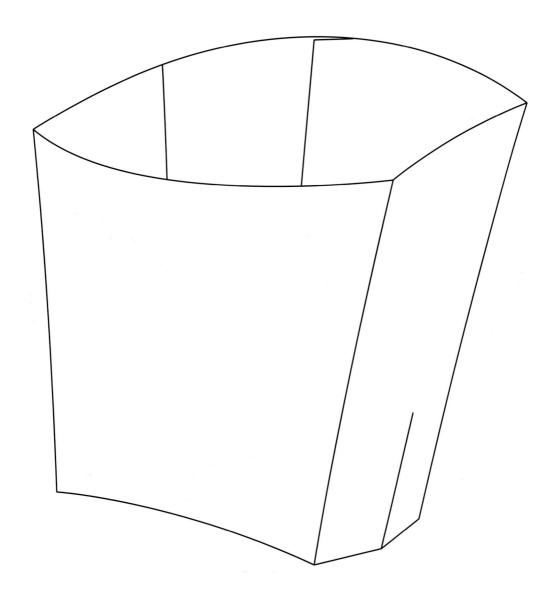

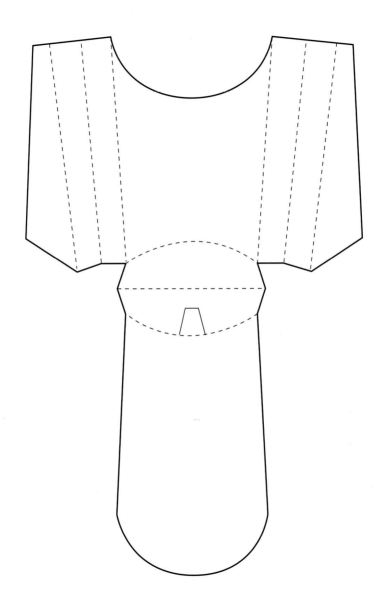

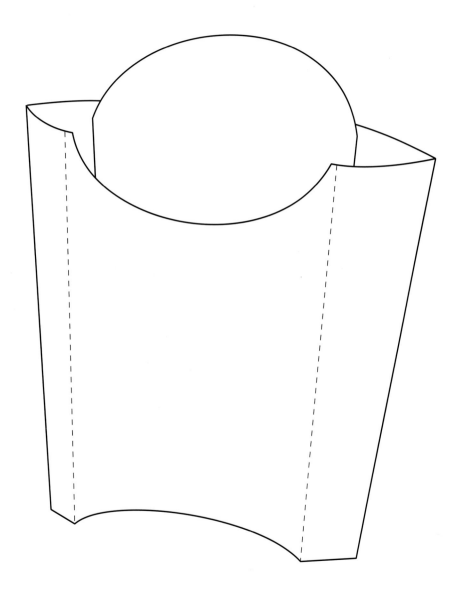

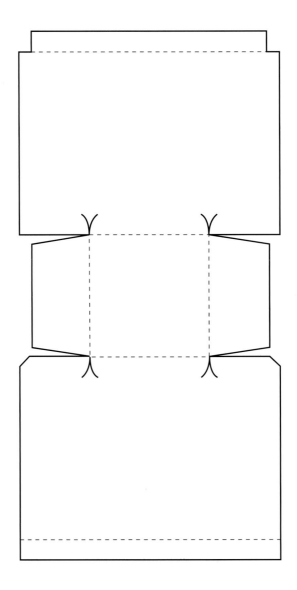

Cone with Square Bottom

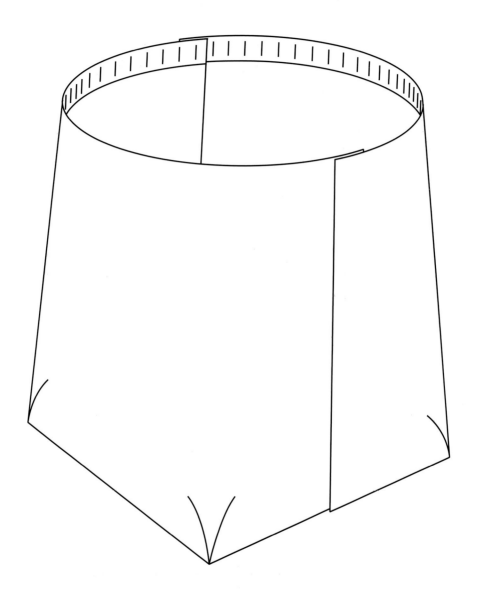

Tear-open Packaging

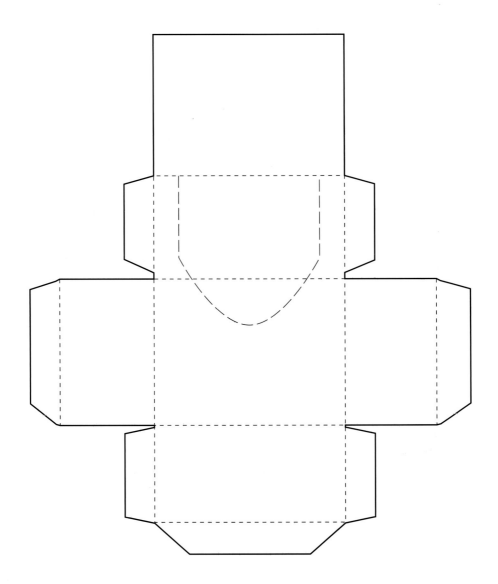

Tear-open Top

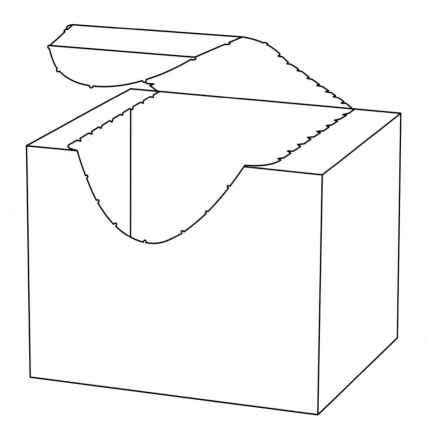

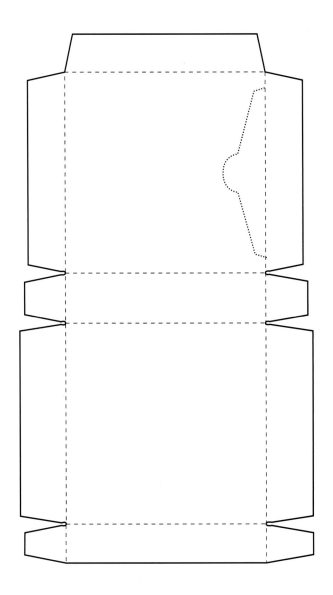

Tear-open Top

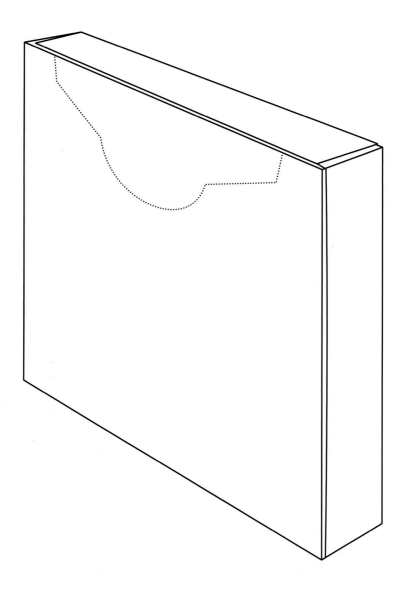

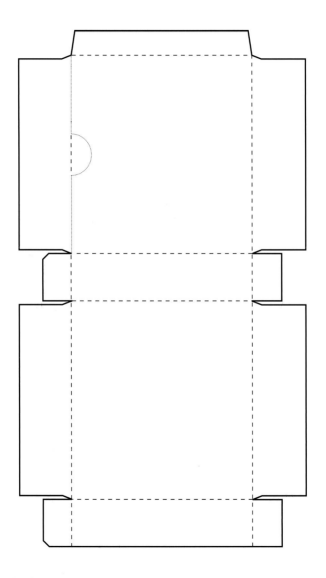

Perforated Thumb Tab

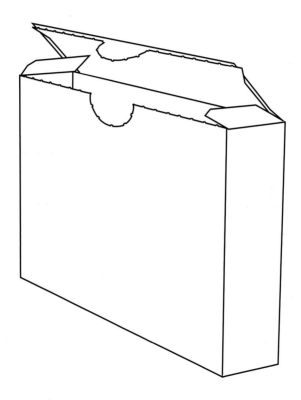

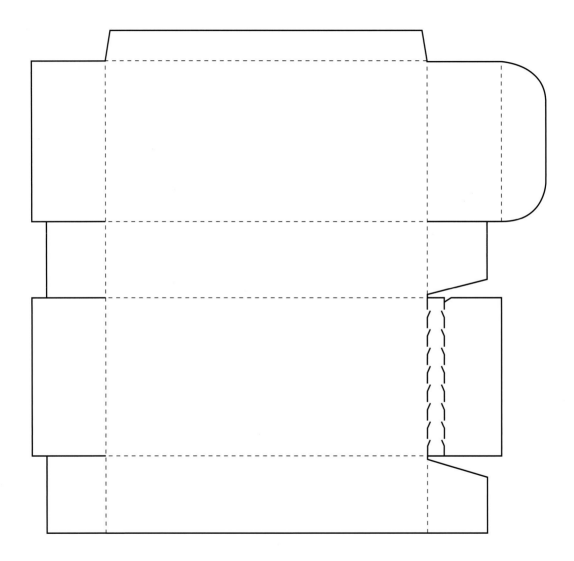

Top Zipper

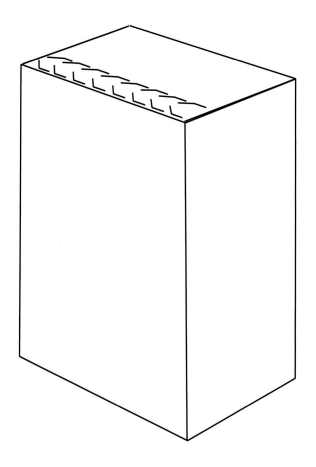

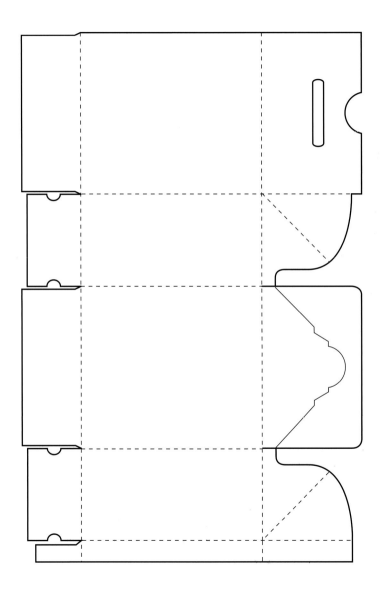

Reclosable Top

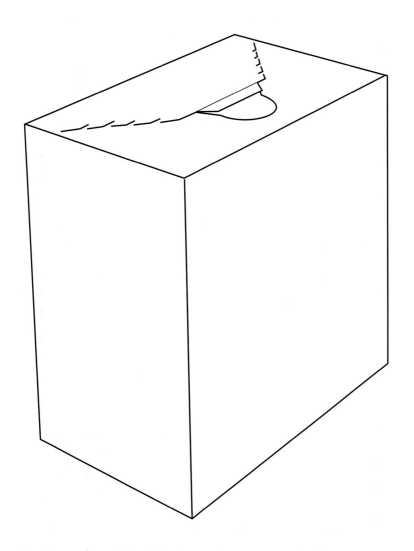

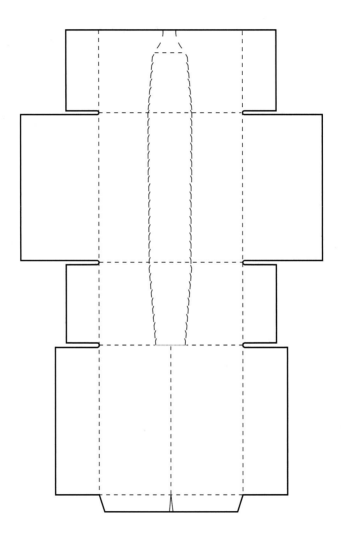

Tear-open Top and Side

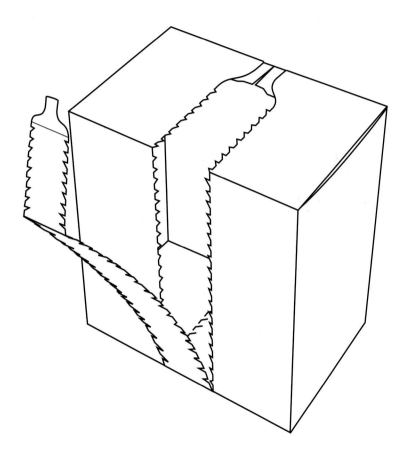

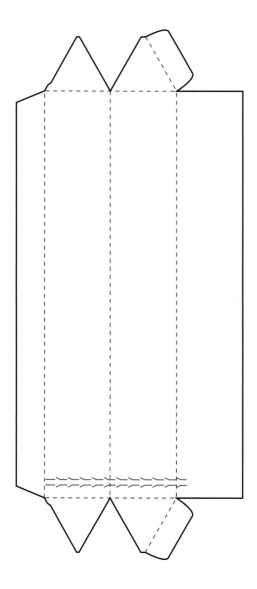

Triangular Tube with Zipper

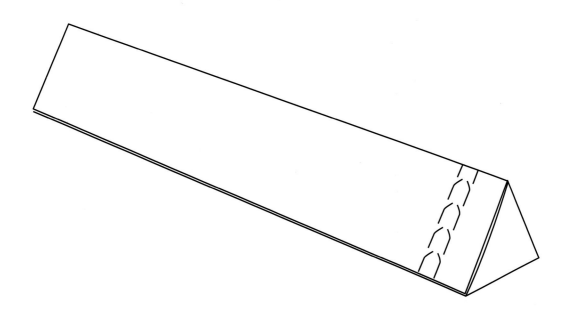

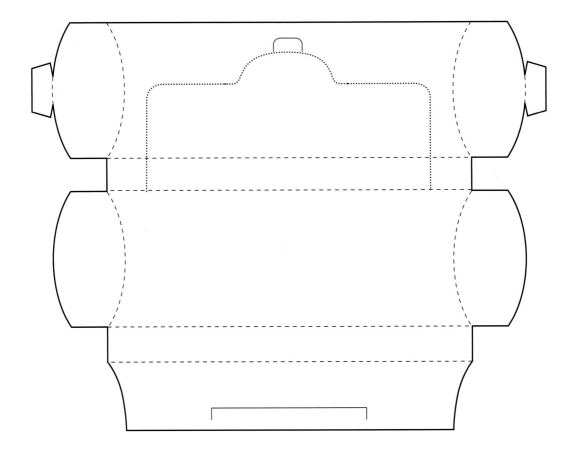

Tear-open Package

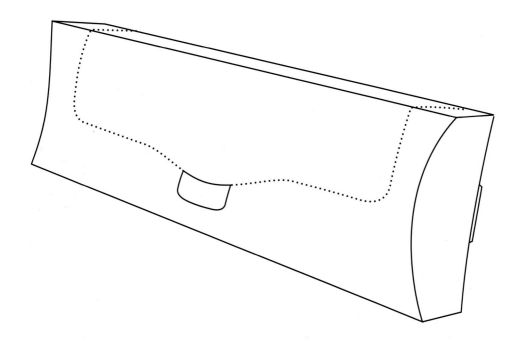

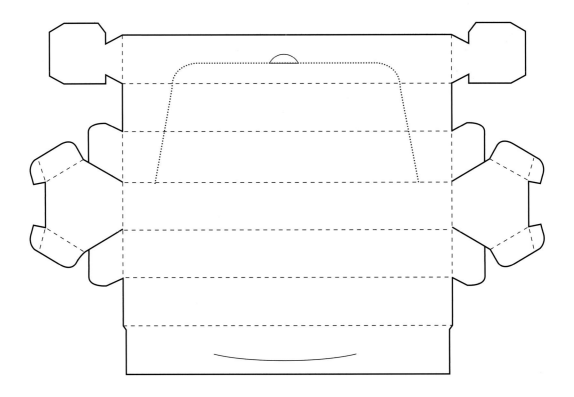

Tear-open Package

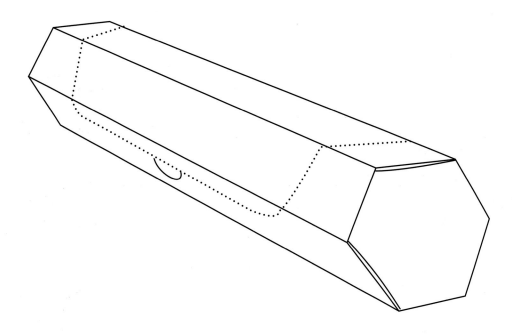

Display Packaging

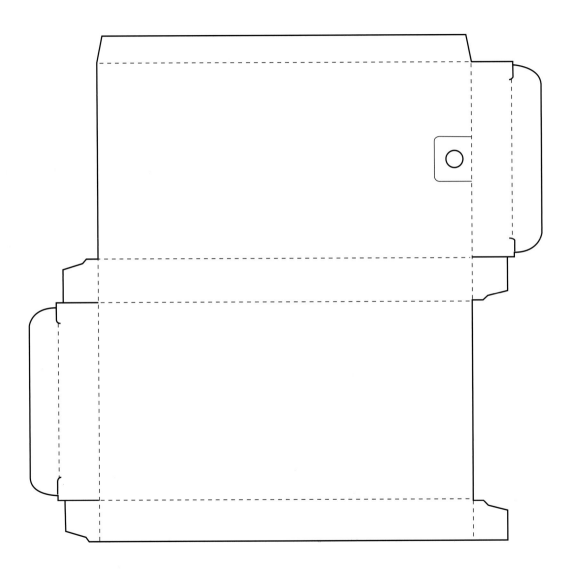

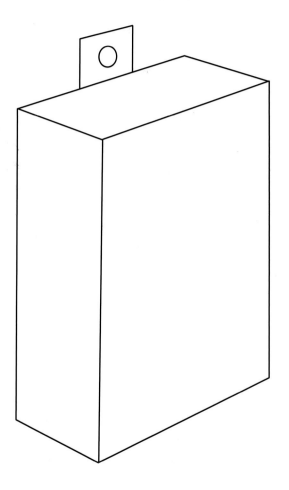

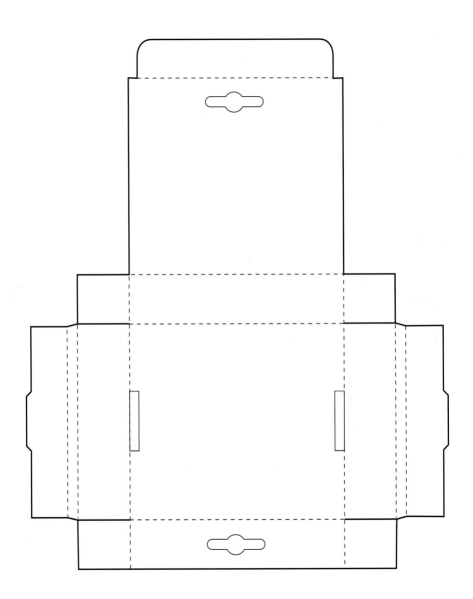

Hanging Hole

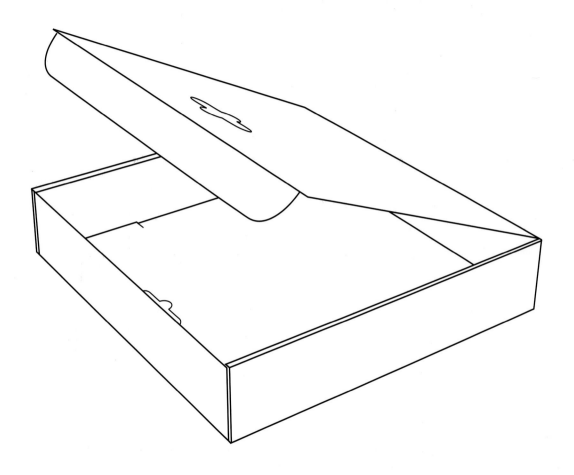

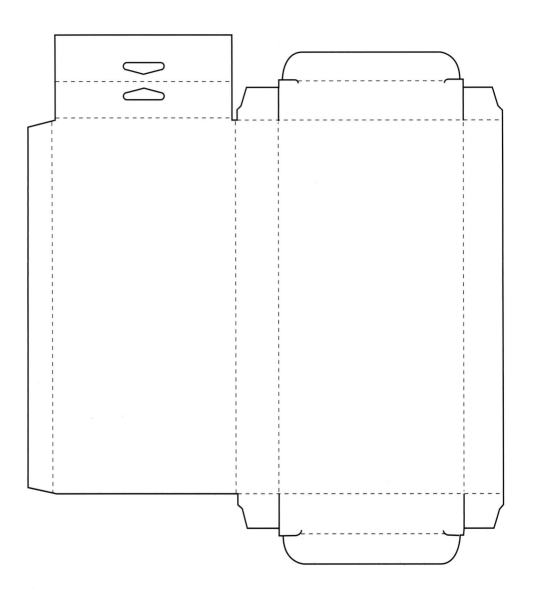

312 Back Panel with Hanging Hole

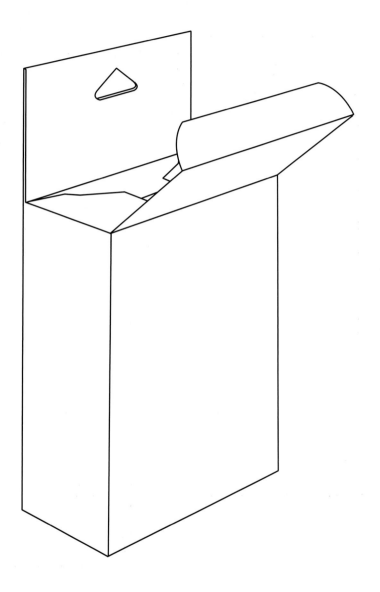

Back Panel with Hanging Hole 313

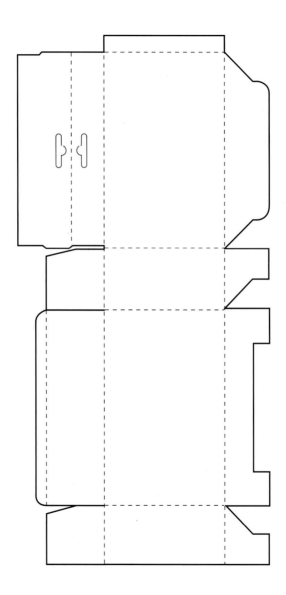

Back Panel with Hanging Hole

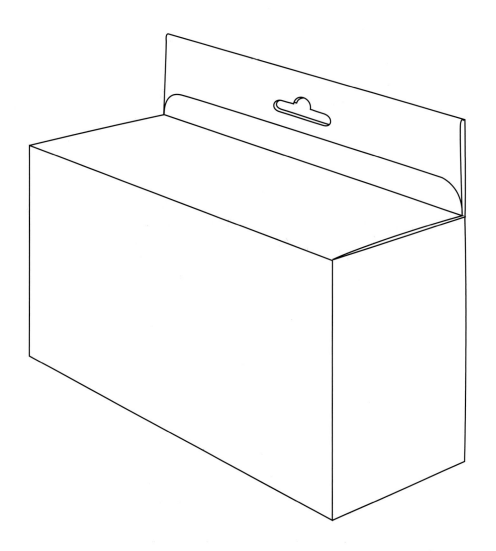

Back Panel with Hanging Hole 315

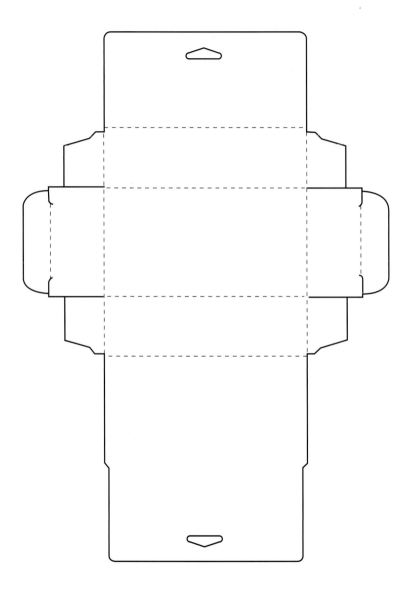

Back Panel with Hanging Hole

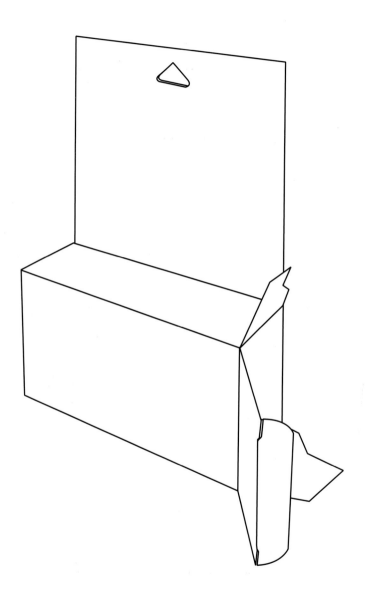

Back Panel with Hanging Hole 317

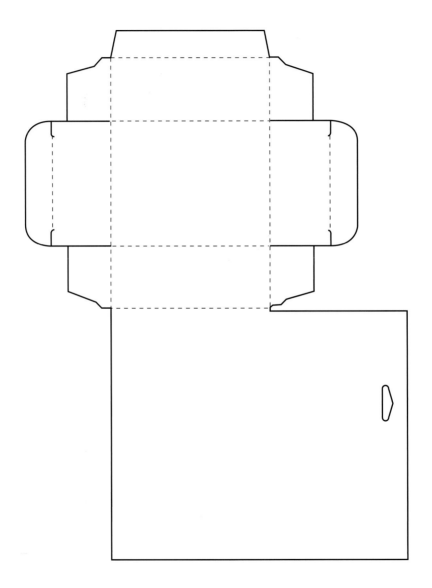

Extended Back Panel with Hanging Hole

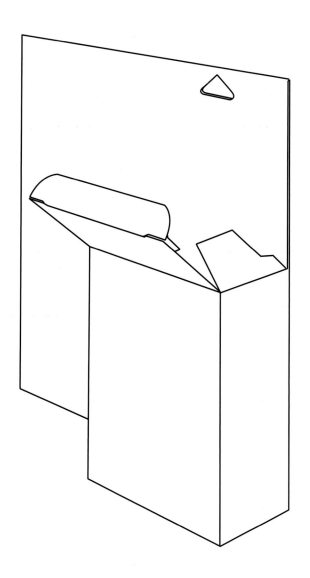

Extended Back Panel with Hanging Hole 319

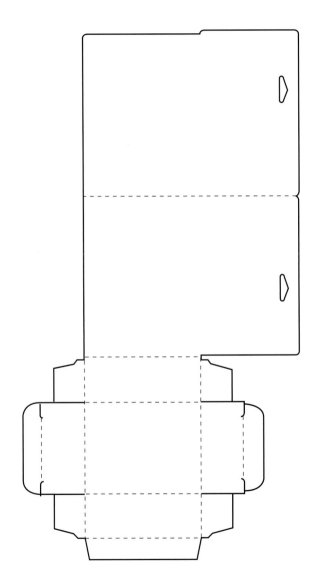

Extended Double Back Panel with Hanging Hole

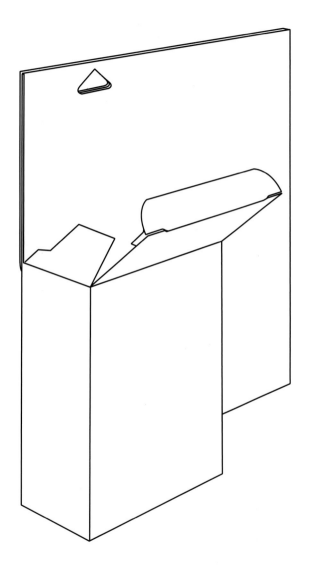

Extended Double Back Panel with Hanging Hole 321

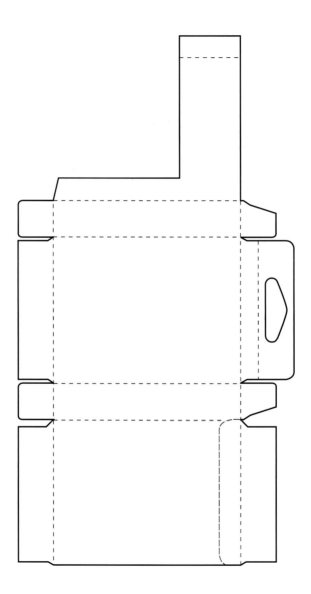

Suspendible Box

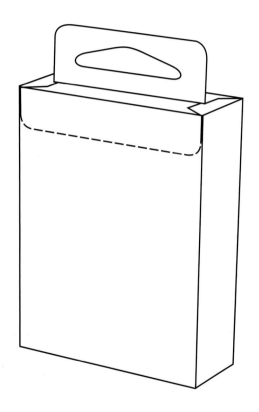

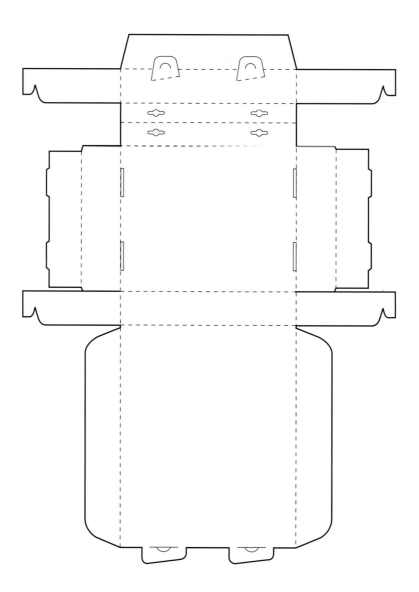

Back Panel with Hanging Holes

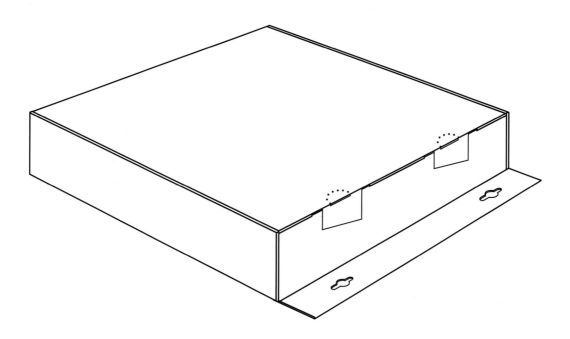

Back Panel with Hanging Holes

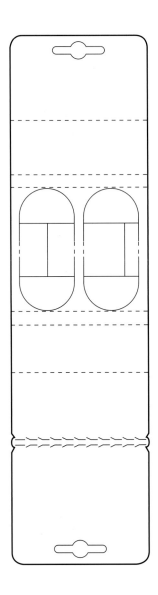

Open Display with Double Back

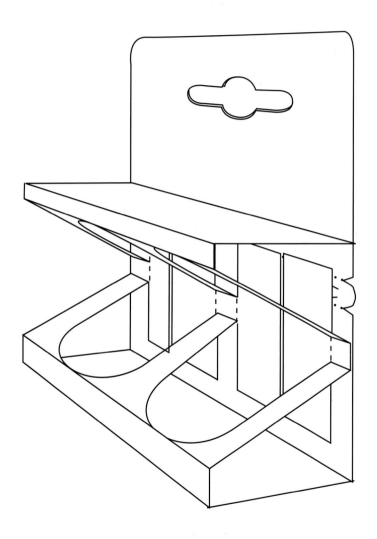

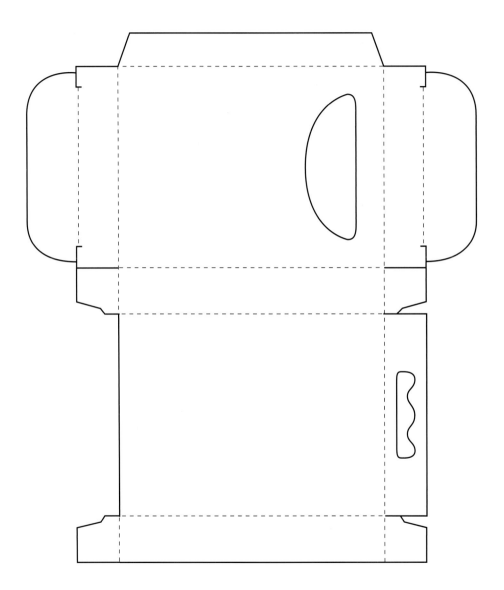

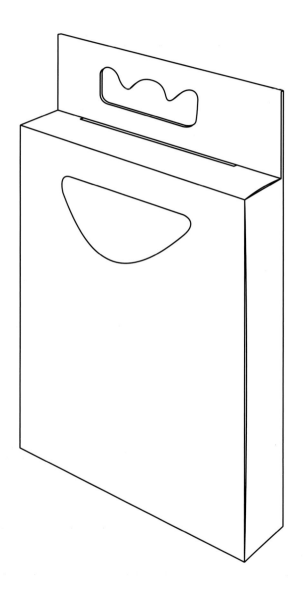

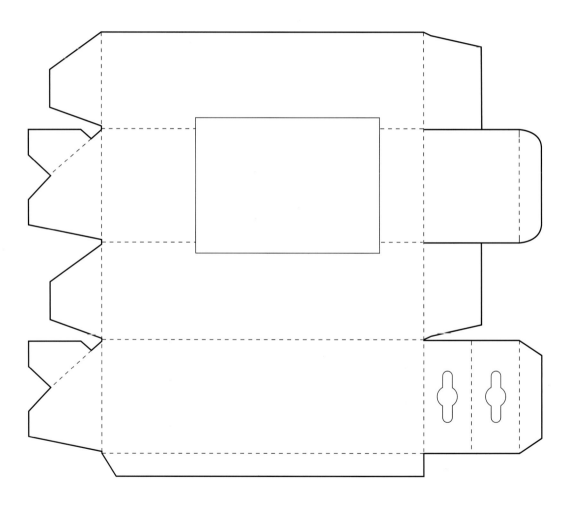

Hanging Panel and Window

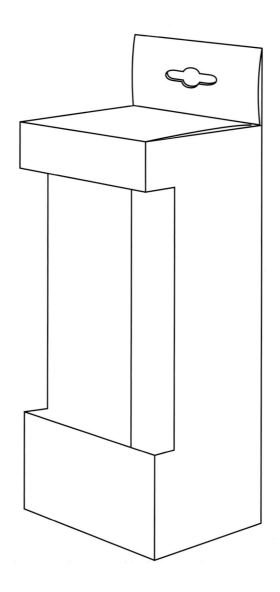

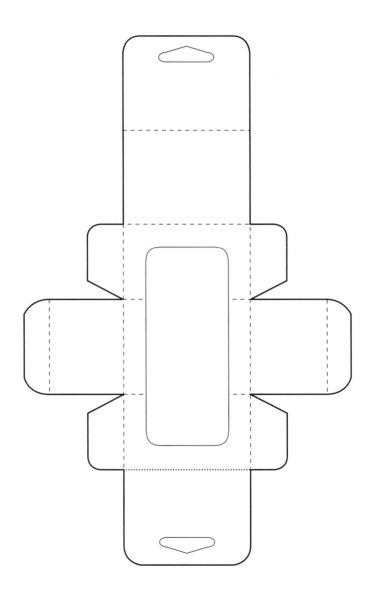

Hanging Panel and Window

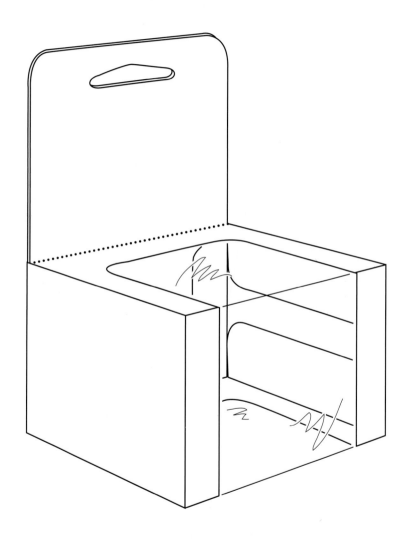

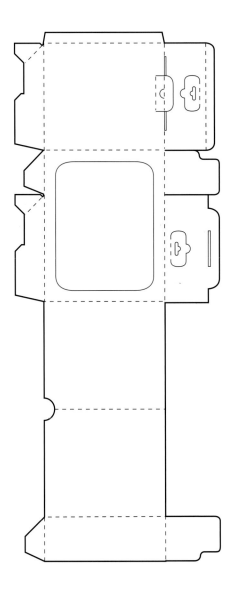

Hanging Panel and Closable Window

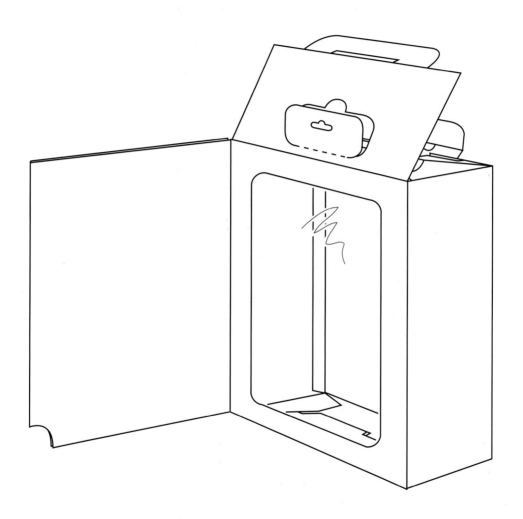

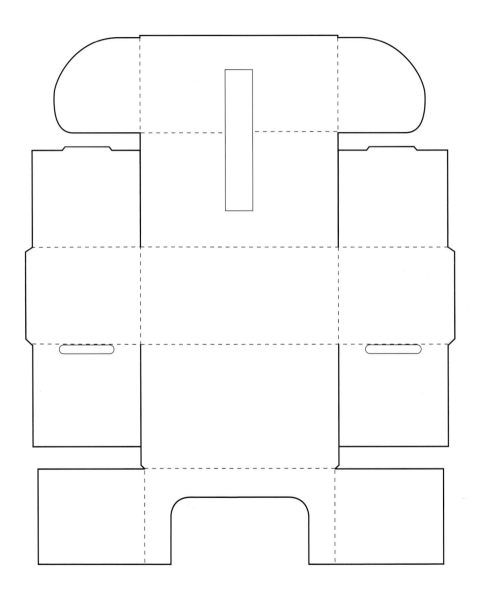

Box with Display Slit

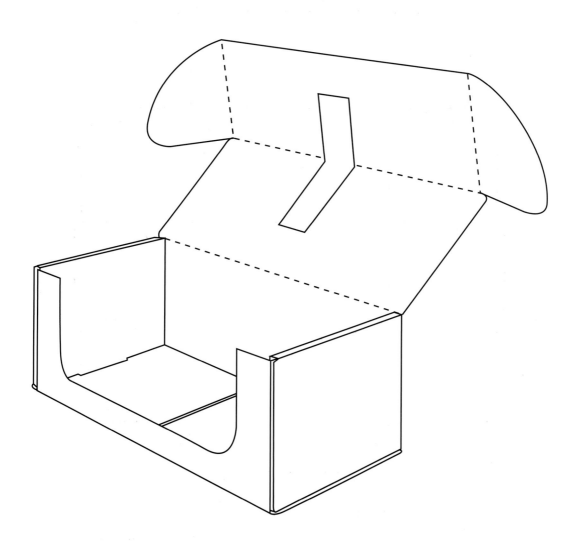

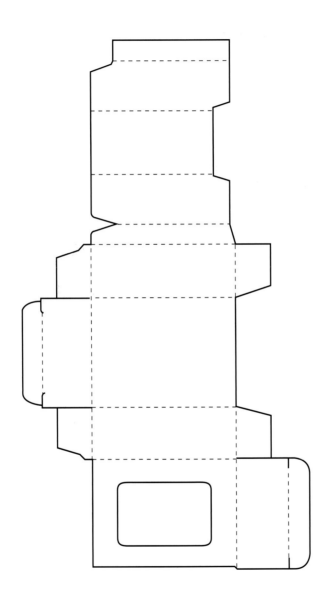

Reverse Tuck Window Box

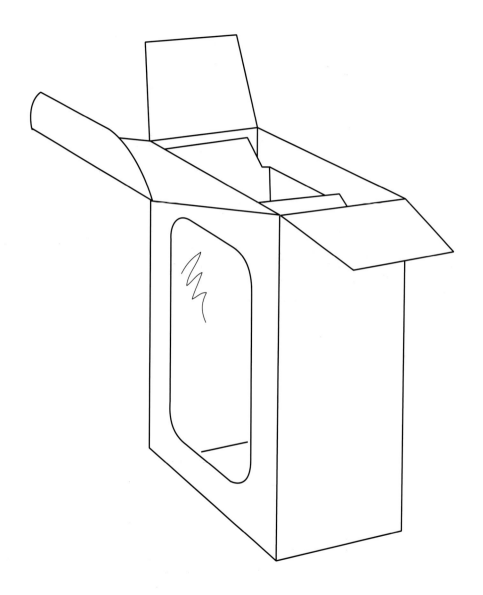

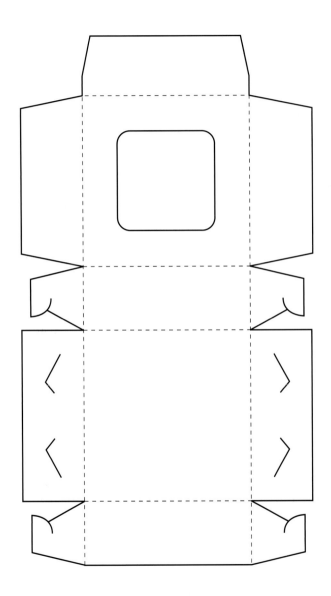

Side-locking Cake Box with Window

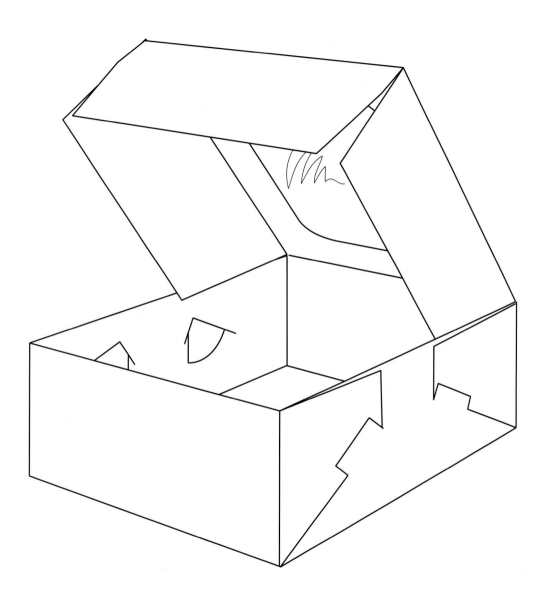

Side-locking Cake Box with Window 341

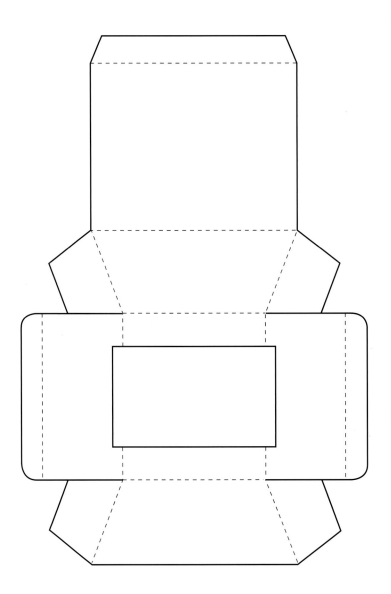

Window Box with Tapered Sides

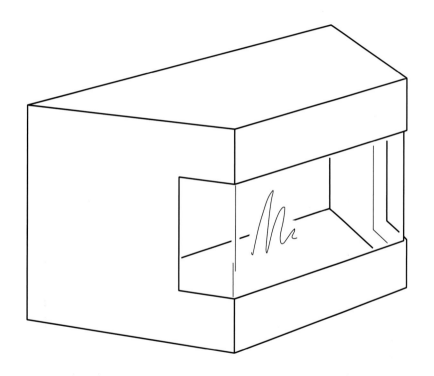

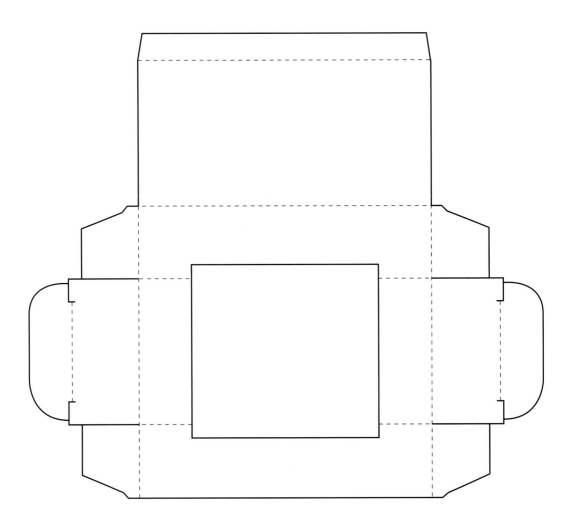

Straight Tuck Window Box

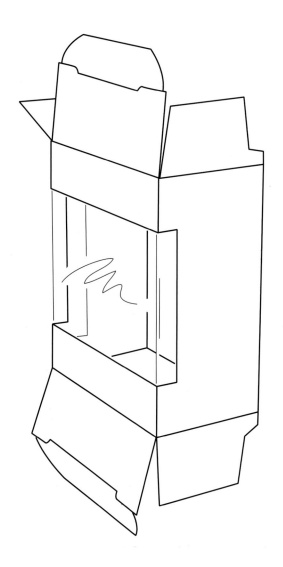

Straight Tuck Window Box 345

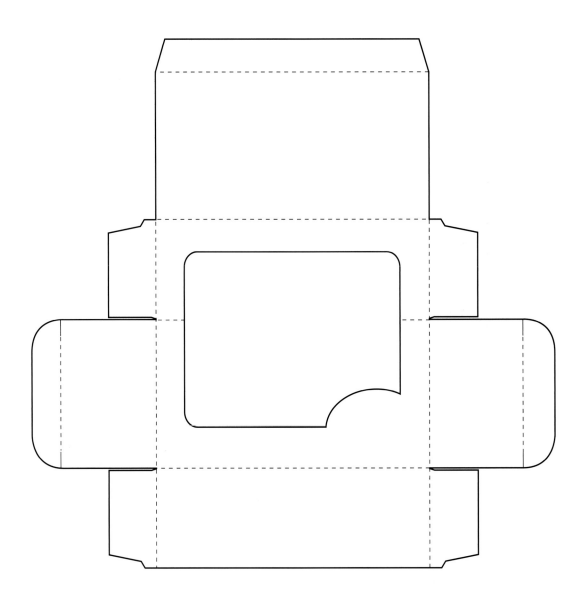

346 Display Box

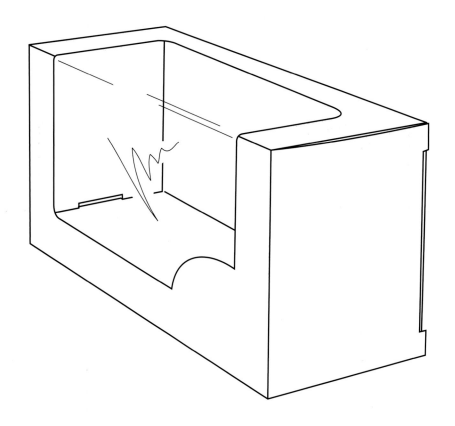

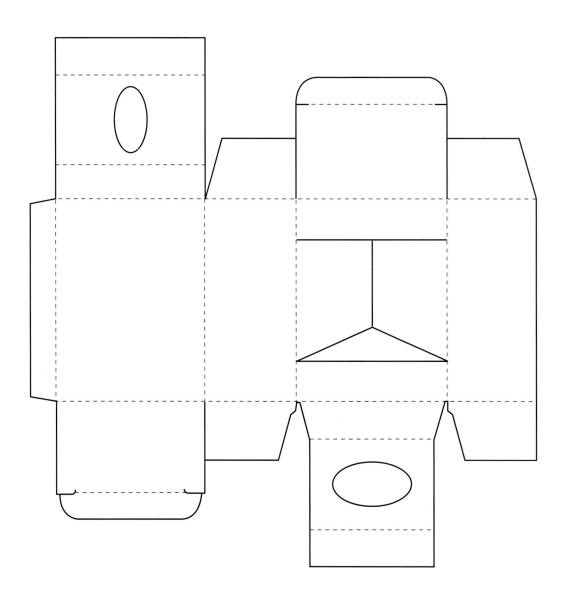

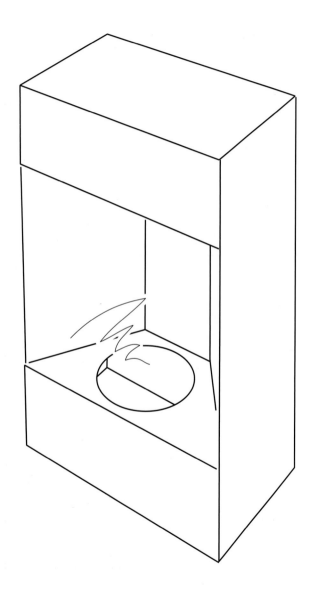

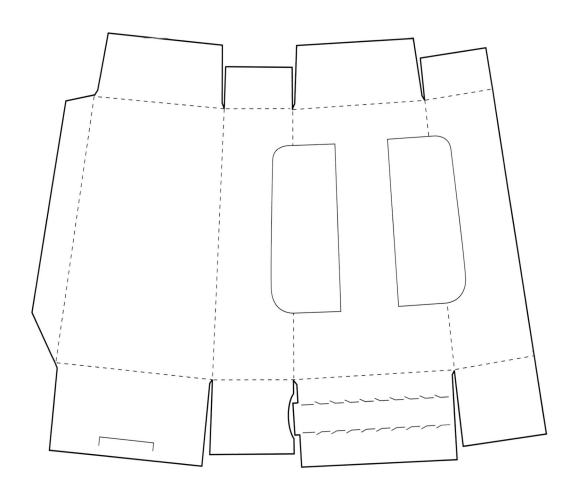

Tapered Display Box with Zipper

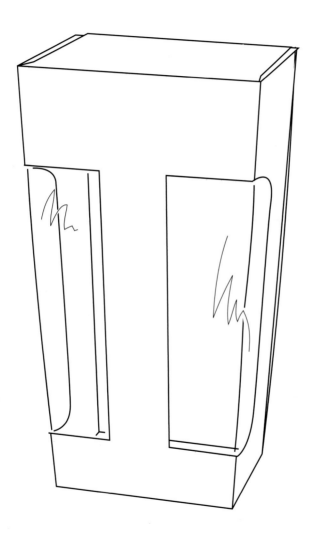

Tapered Display Box with Zipper 351

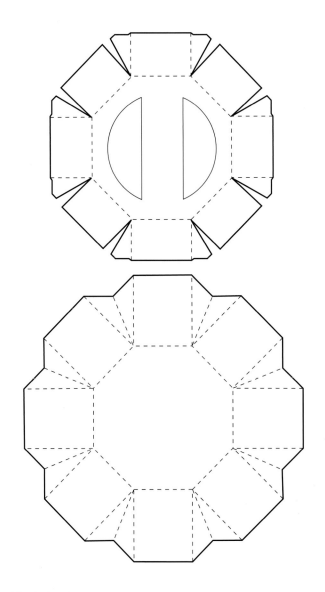

Octagonal Tray with Window Cover

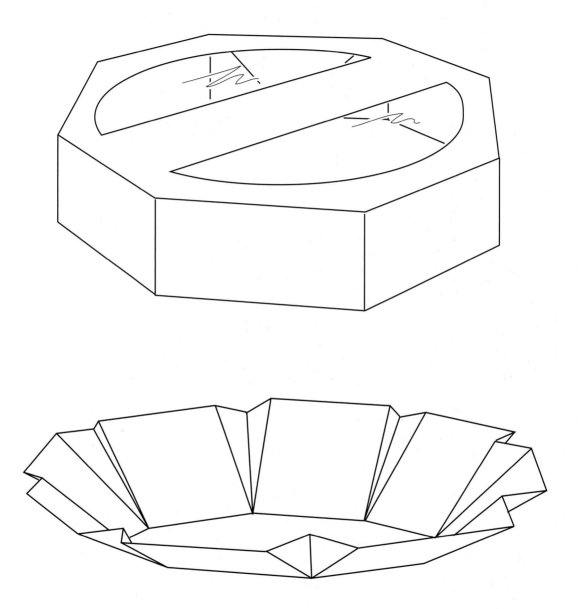

Octagonal Tray with Window Cover 353

354

Supports and Dividers

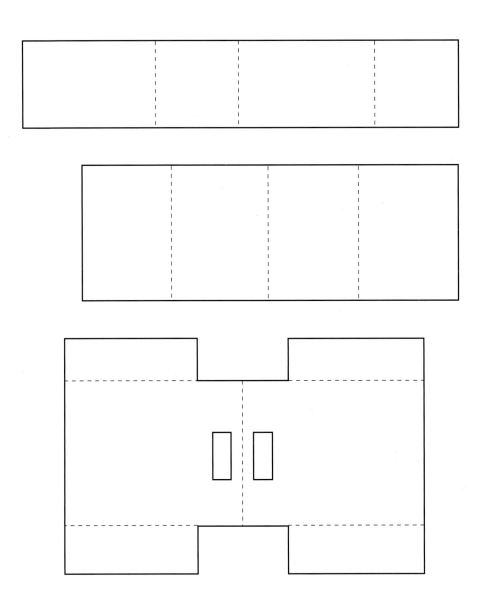

Support and Divider

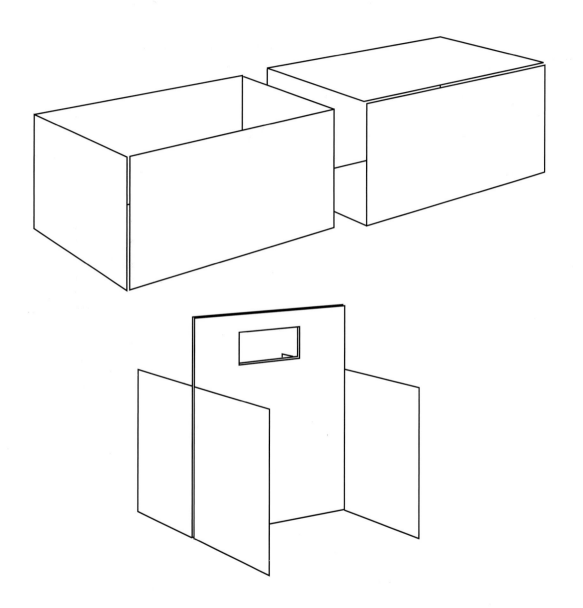

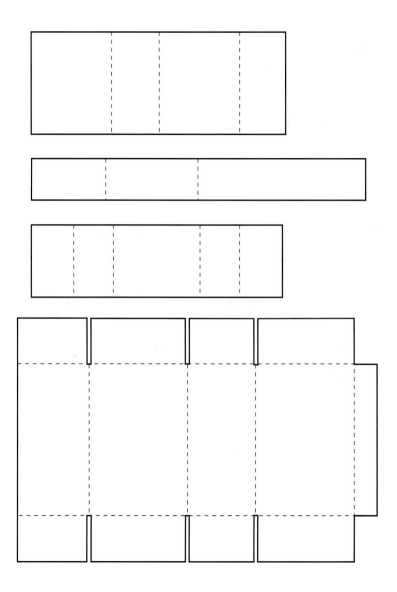

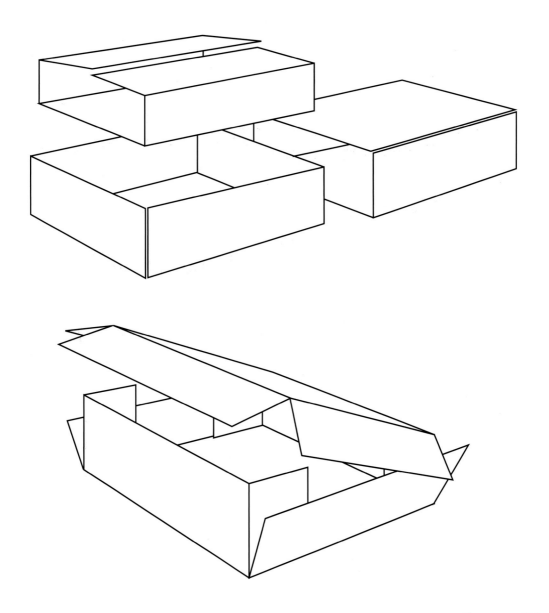

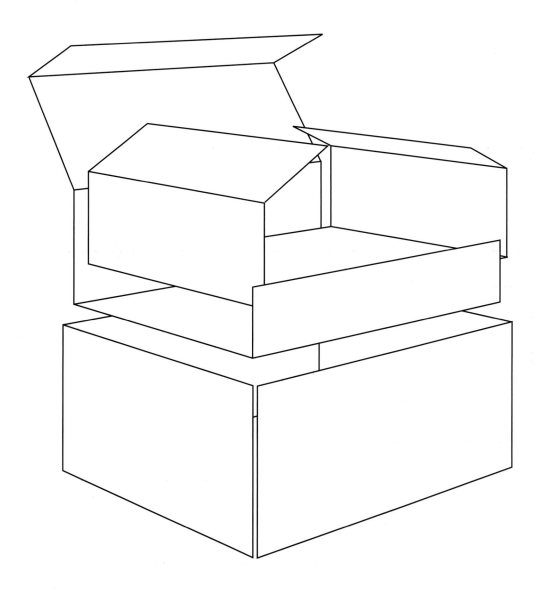

Anchor Pads

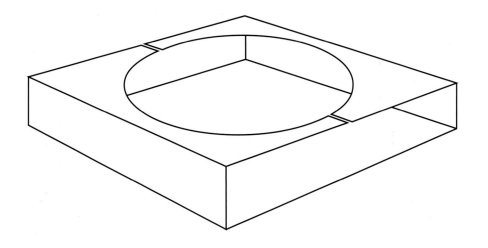

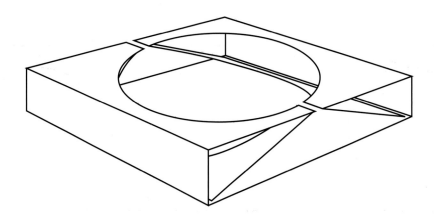

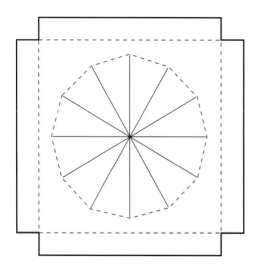

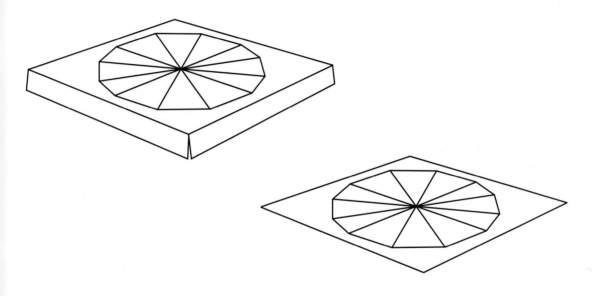

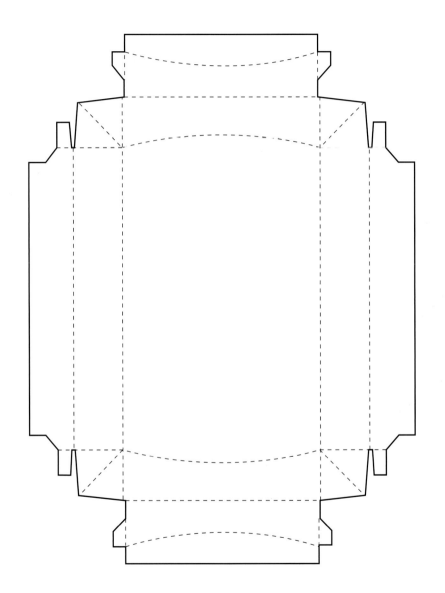

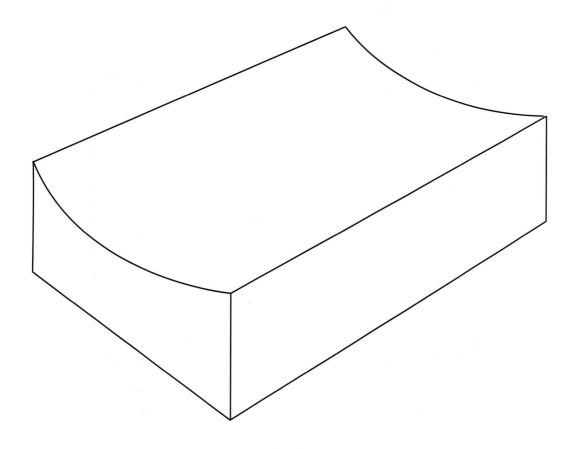

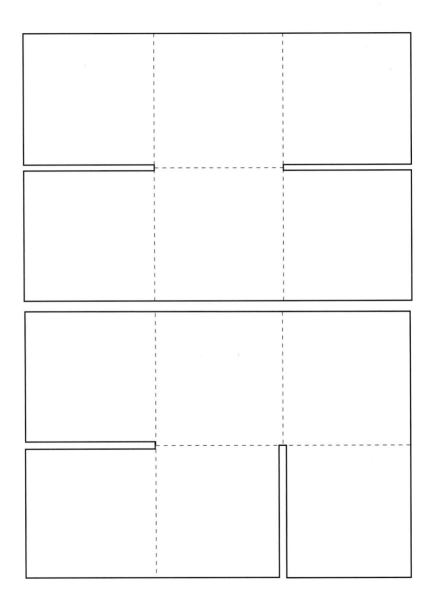

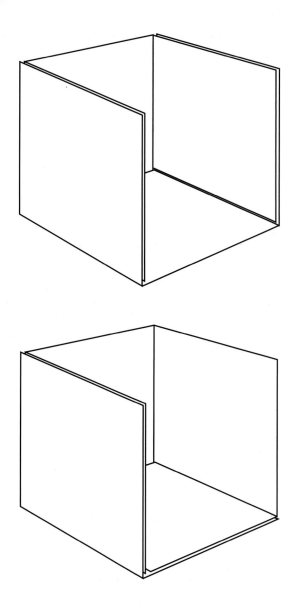

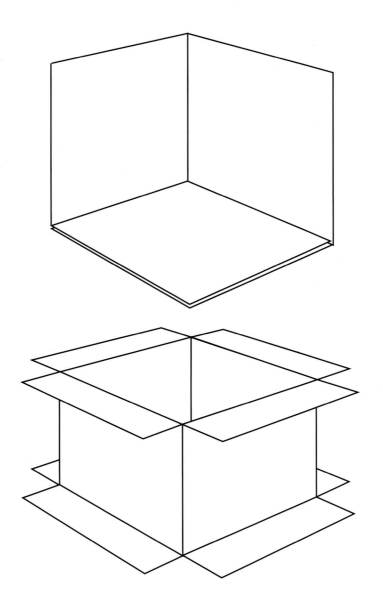

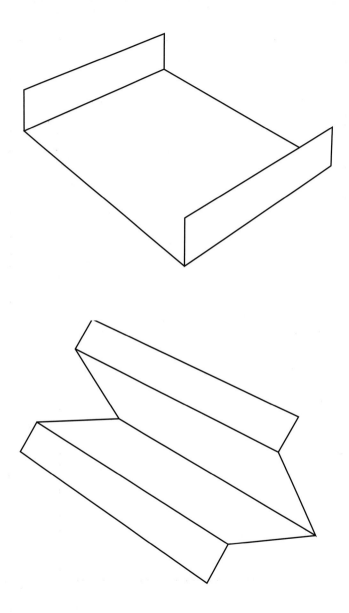

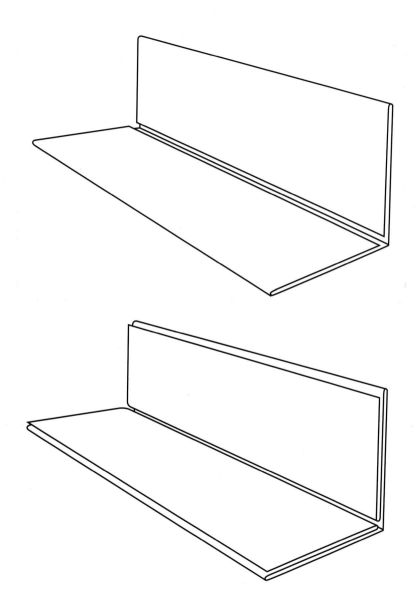

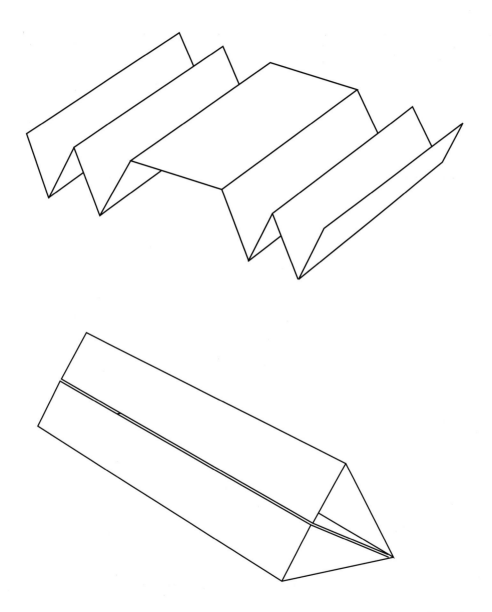

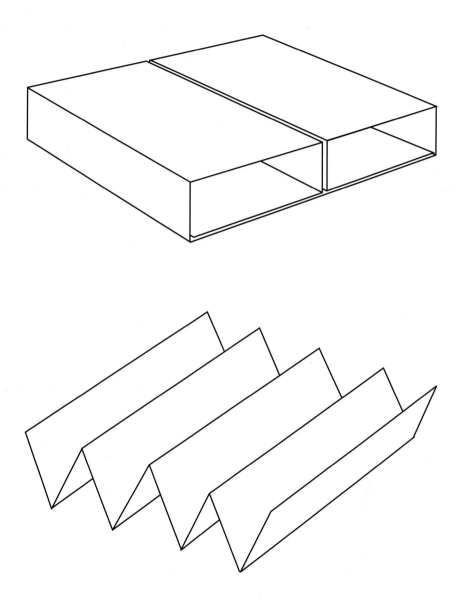

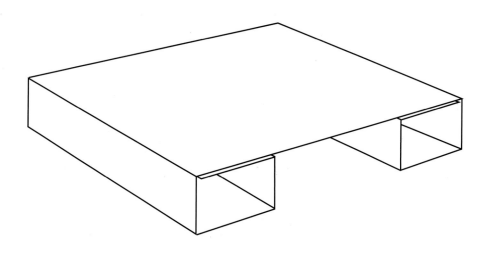

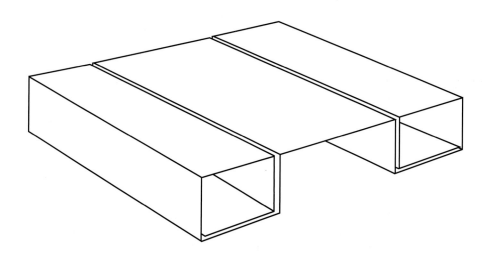

Folded Liners

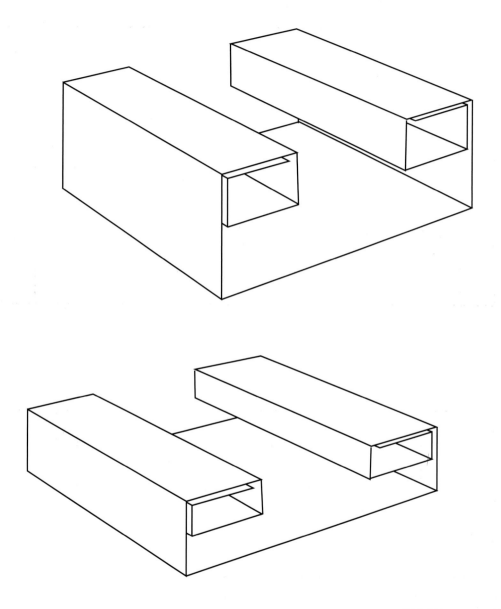

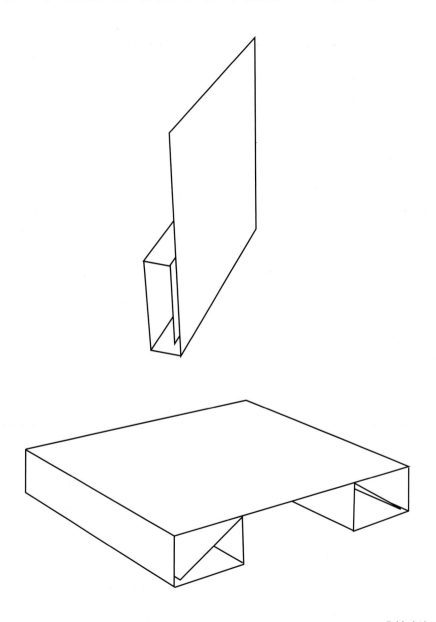

Pads

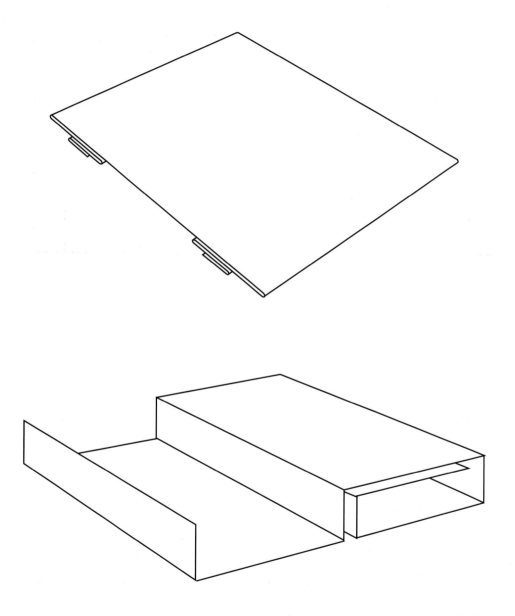

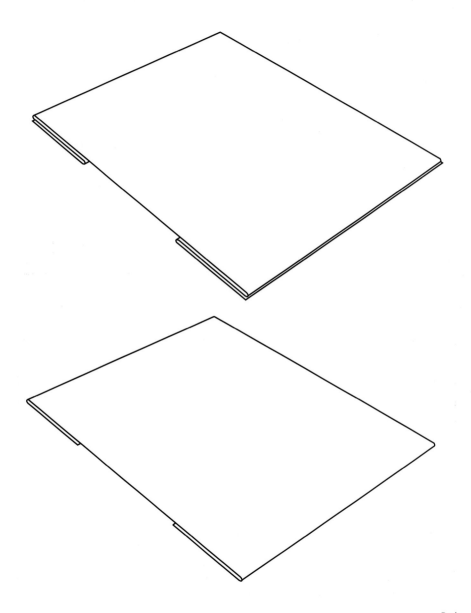

Liners

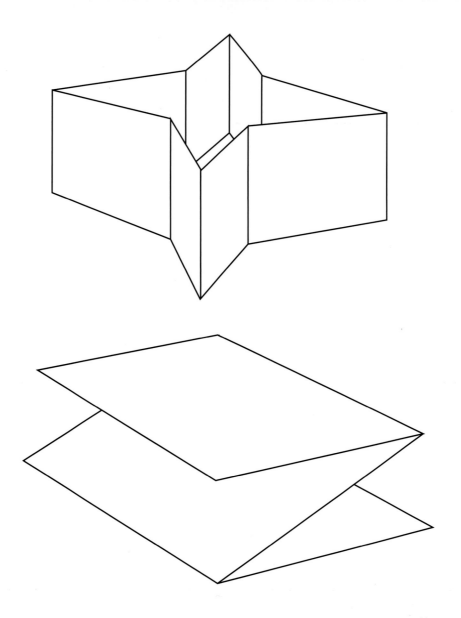

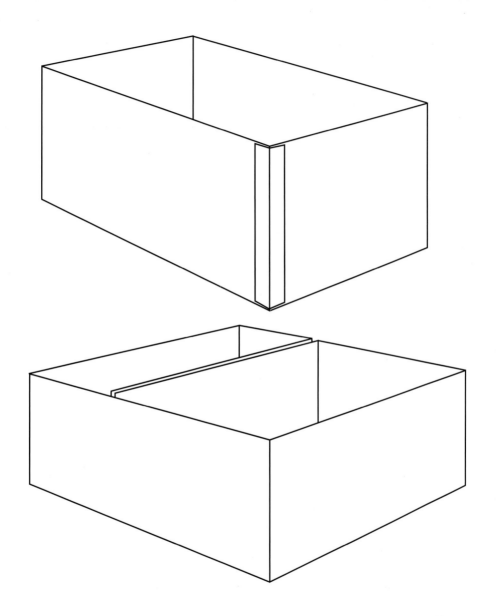

One and Two Cell Liners

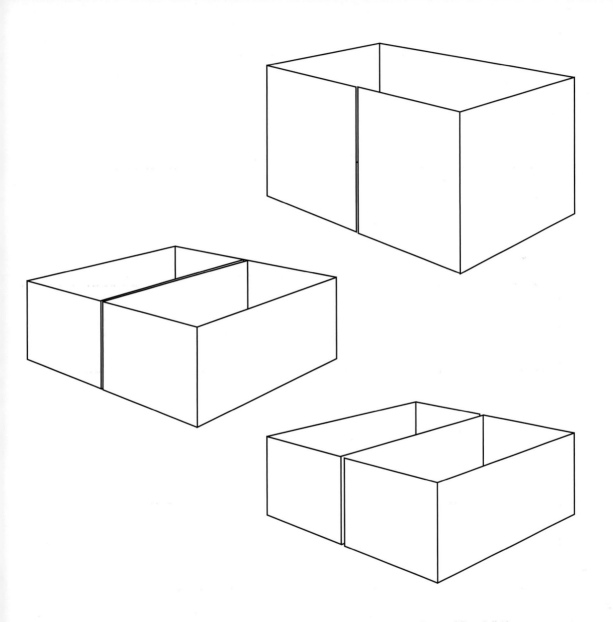

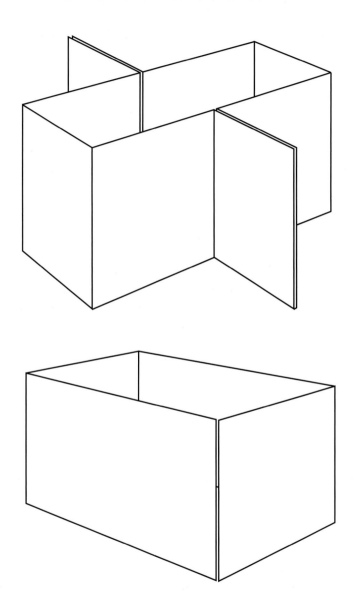

Two and Four Cell Dividers

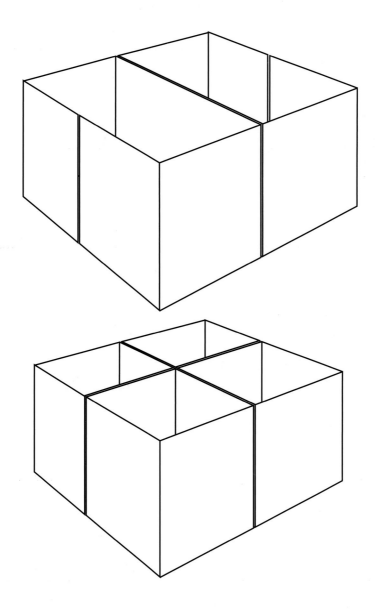

Three and Four Cell Dividers

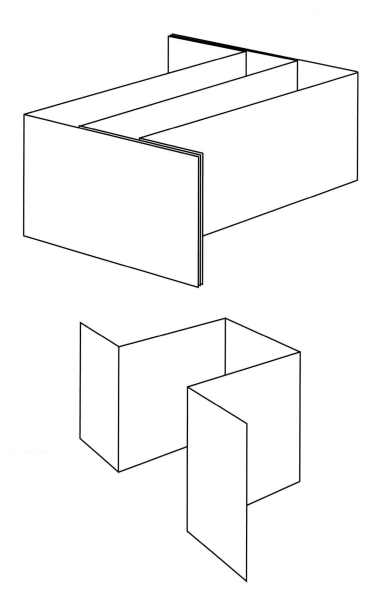

Dividers

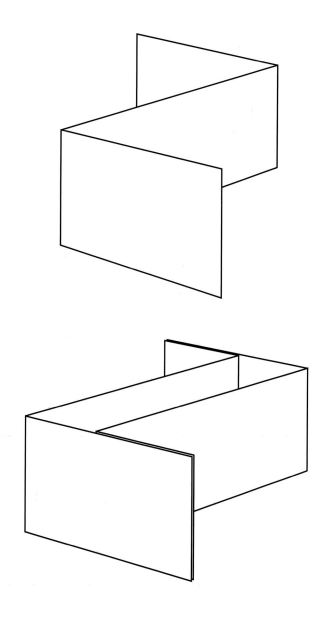

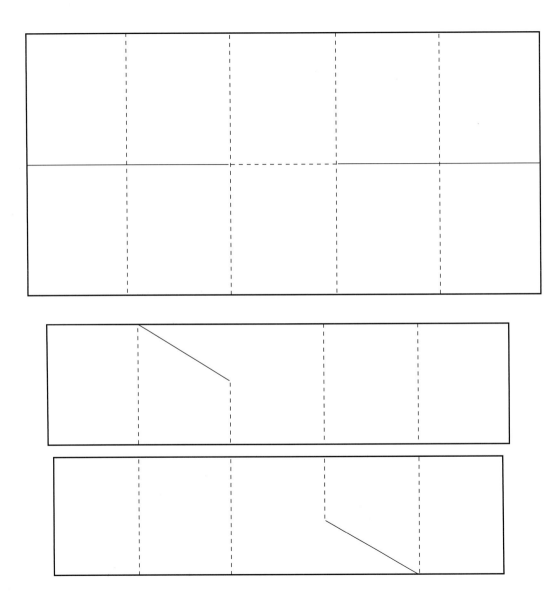

404 Folded Partitions

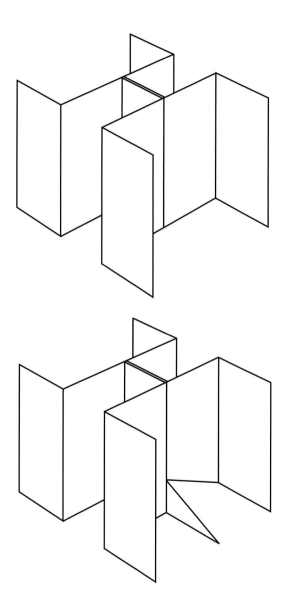

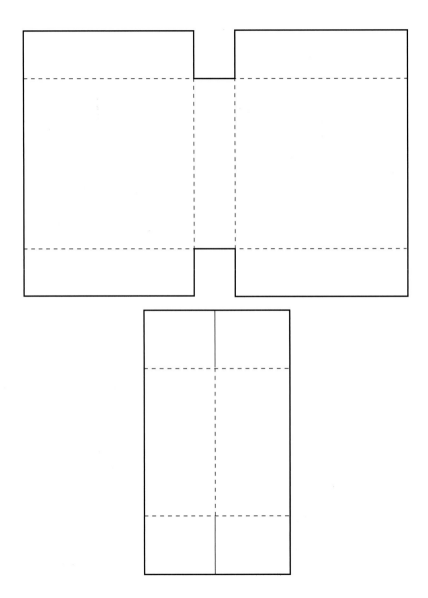

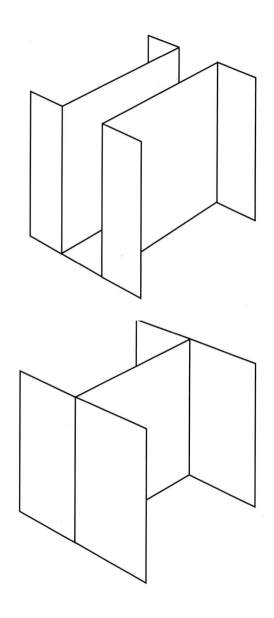

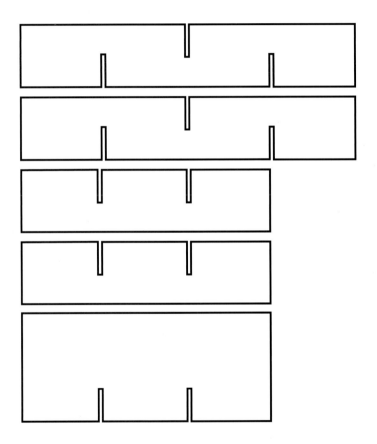

Multi-cell Partition and Divider

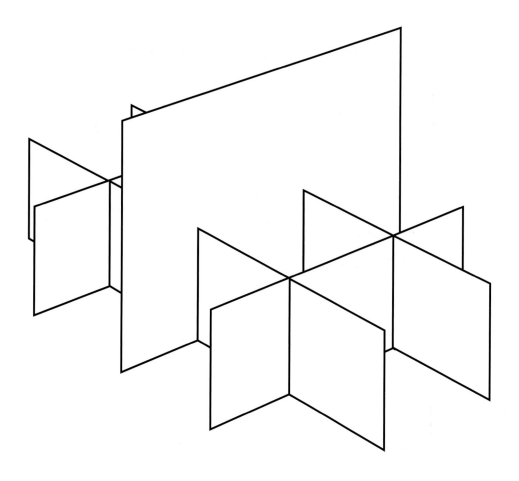

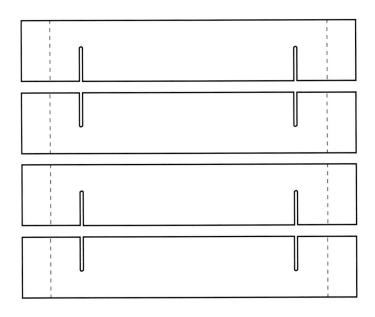

Partitions

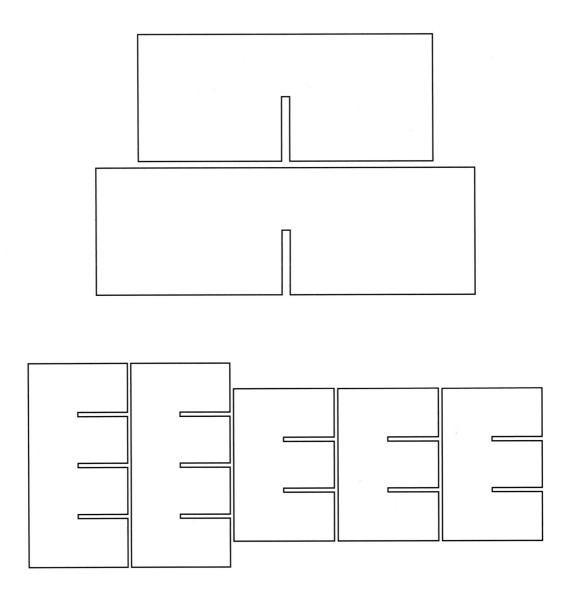

Partitions

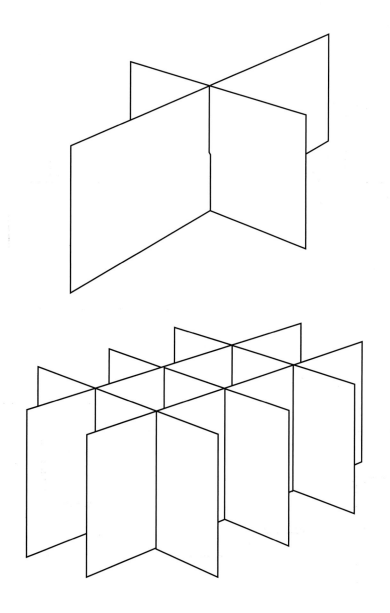

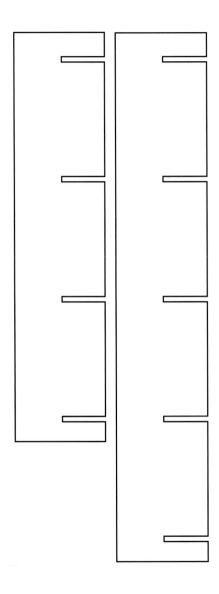

12-Cell Partition

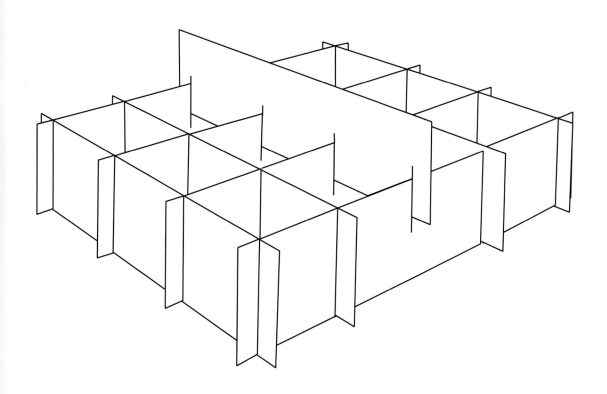

12-Cell Partition

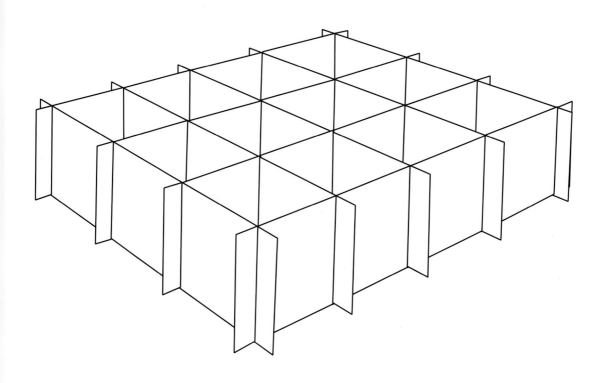

12-Cell Partition

6-Cell Partition

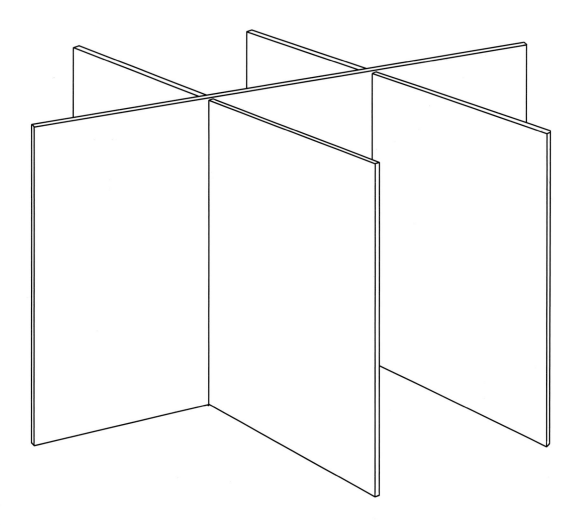

Divider

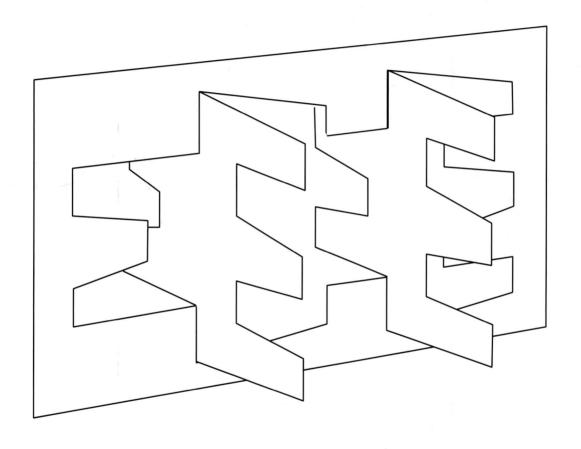

Also available:

FOLDING PATTERNS FOR
DISPLAY & PUBLICITY

90 5768 040 8
424 pages (180 x 180 mm)
soft cover with free CD-Rom

English, French, German, Spanish,
Italian, Portuguese, Japanese and
Chinese

MAIL IT

90 5768 053 x
c. 128 pages (220 x 220 mm)
soft cover with free CD-Rom

English, French, German, Spanish,
Italian, Portuguese, Japanese and
Chinese

HOW TO FOLD

90 5768 039 4
408 pages (180 x 180 mm)
soft cover with free CD-Rom

English, French, German, Spanish,
Italian, Portuguese, Japanese and
Chinese

STRUCTURAL PACKAGE DESIGNS

90 5768 044 0
424 pages (180 x 180 mm)
soft cover with free CD-Rom

English, French, German, Spanish,
Italian, Portuguese, Japanese and
Chinese

In addition to these titles, The Pepin Press / Agile Rabbit
Editions publishes a wide range of titles on
art, design, architecture, applied art and fashion.

Visit www.pepinpress.com and www.agilerabbit.com
for more information.